SACRAMENTO PUBLIC LIBRARY
828 "I" STREET
SACRAMENTO, CA 95814
12/2009

WITHDRAWN FROM COLLECTION
OF SACRAMENTO PUBLIC LIBRARY

A 95814

D0624876

: 0680

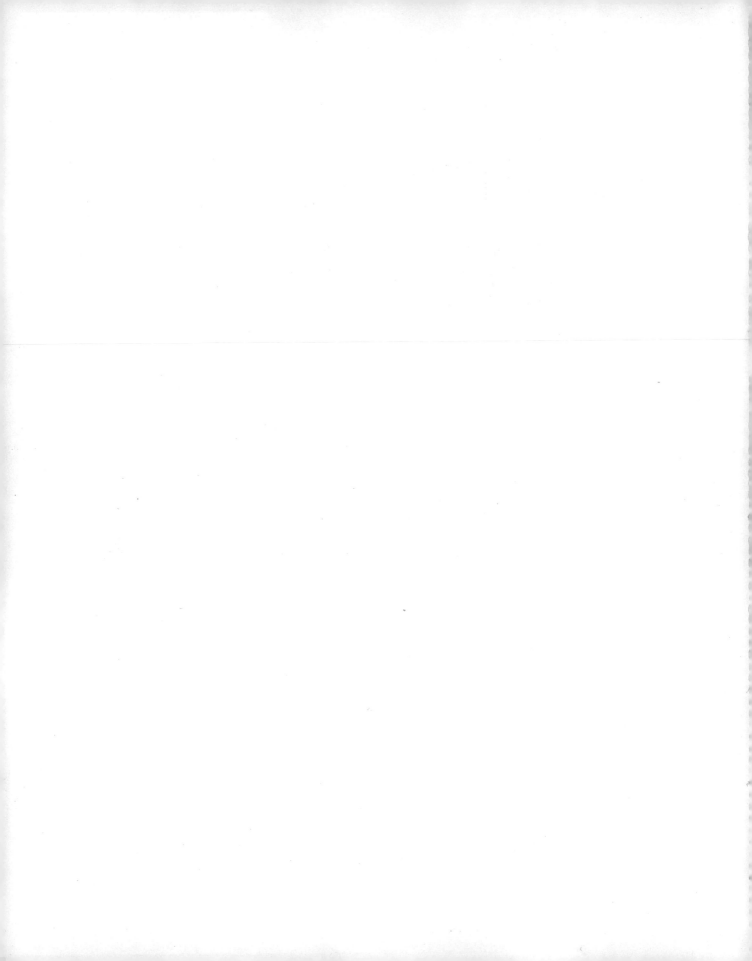

MICHELLE OBAMA

MICHELLE OBAMA

THE FIRST LADY IN PHOTOGRAPHS

DEBORAH WILLIS *and* EMILY BERNARD

W. W. NORTON & COMPANY

New York | *London*

Copyright © 2010 by Deborah Willis and Emily Bernard
"Michelle Obama in Photographs" copyright © 2010
by Deborah Willis
"Native Daughter: Michelle Obama in Context"
copyright © 2010 by Emily Bernard

All rights reserved
Printed in the United States of America
First Edition

For information about permission to reproduce selections from
this book, write to Permissions, W. W. Norton & Company, Inc.,
500 Fifth Avenue, New York, NY 10110

For information about special discounts for bulk purchases,
please contact W. W. Norton Special Sales at
specialsales@wwnorton.com or 800-233-4830

Manufacturing by Courier Kendallville
Book design by Judith Stagnito Abbate / Abbate Design
Production managers: Sue Carlson and Julia Druskin

Library of Congress Cataloging-in-Publication Data

Willis, Deborah, 1948–
Michelle Obama : the first lady in photographs / Deborah Willis
and Emily Bernard. — 1st ed.
p. cm.
Includes bibliographical references and index.
ISBN 978-0-393-07747-6 (hardcover)
1. Obama, Michelle, 1964– —Pictorial works. 2. Presidents'
spouses—United States—Biography—Pictorial works.
I. Bernard, Emily, 1967– II. Title.
E909.O24W55 2009
973.932092—dc22
[B]
2009035165

W. W. Norton & Company, Inc.
500 Fifth Avenue, New York, N.Y. 10110
www.wwnorton.com

W. W. Norton & Company Ltd.
Castle House, 75/76 Wells Street, London W1T 3QT

1 2 3 4 5 6 7 8 9 0

For my nieces Jaydn, Malaya, Lyra, Jahna, Jordon;
my nephews Masani, Michael, and William

— D W

In memory of my mother

— E B

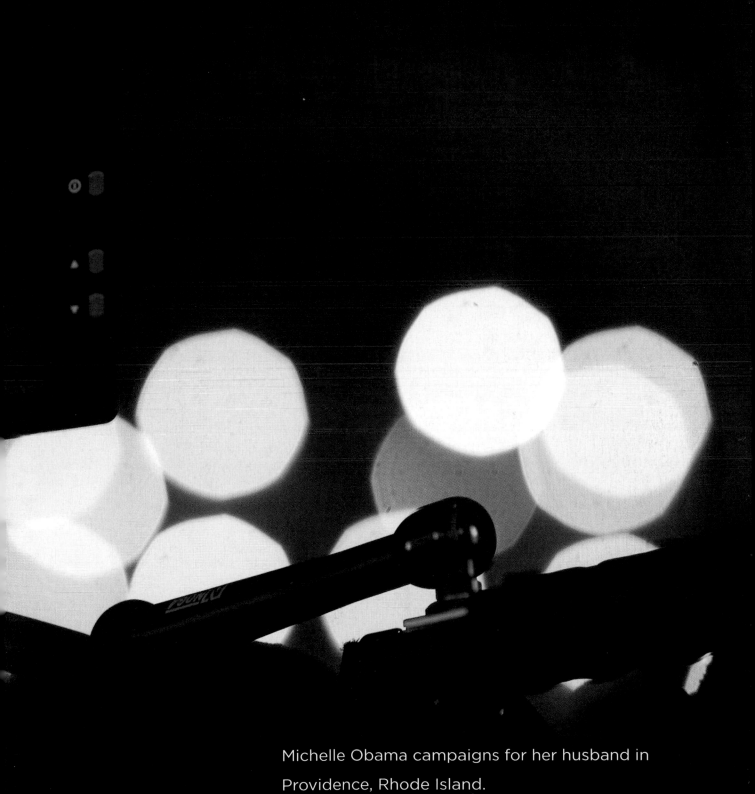

Michelle Obama campaigns for her husband in
Providence, Rhode Island.

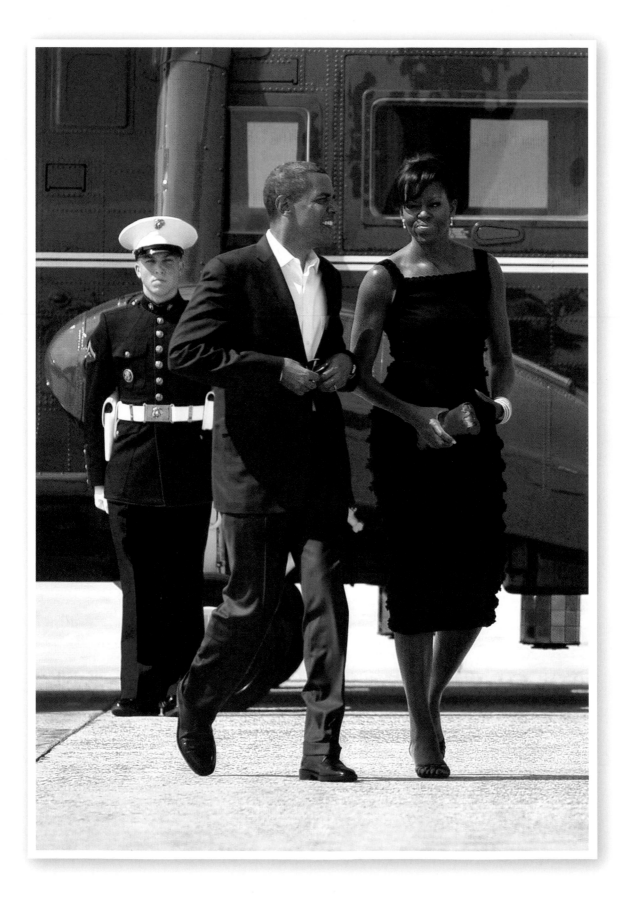

CONTENTS

———————

Michelle Obama in Photographs
Deborah Willis
| 13 |

PHOTOGRAPHS

White House
| 31 |

Inauguration
| 111 |

Campaign
| 131 |

Native Daughter:
Michelle Obama in Context
Emily Bernard
| 173 |

Photo Credits
| 190 |

Acknowledgments
| 192 |

MICHELLE
OBAMA

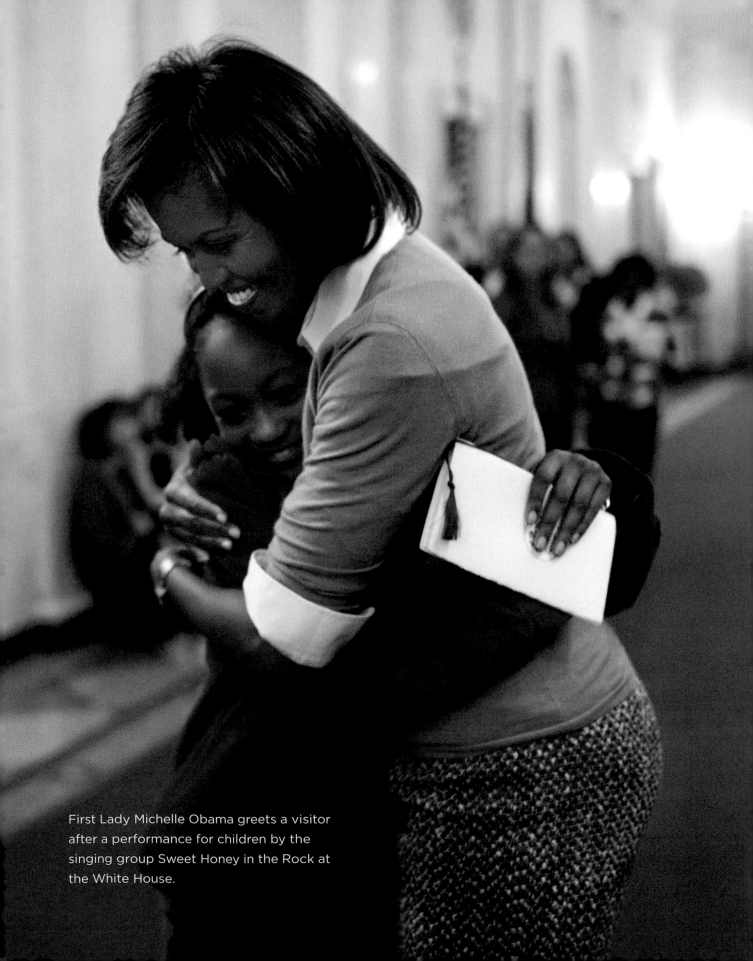

First Lady Michelle Obama greets a visitor after a performance for children by the singing group Sweet Honey in the Rock at the White House.

MICHELLE OBAMA IN PHOTOGRAPHS

DEBORAH WILLIS

Michelle Obama is a full-blown, grown-up woman. An authentically empowered real woman who looks and feels like a modern woman in the twenty-first century, allowing us to see the best of ourselves in her. [She's] bringing a sense of connection and accessibility to that position that no nation has ever witnessed.

—OPRAH WINFREY[1]

One Saturday afternoon in April 2009, I walked into a gallery in New York's Chelsea district and overheard a smartly dressed, blonde, blue-eyed gallery assistant proudly exclaim, "Look, I'm dressed like Michelle Obama." As she smiled with pride, I stepped back to see if she was, in fact, dressed like the First Lady. I observed that she was wearing a pencil skirt and a short black sweater, with a belt wrapped around her slim waistline. As I walked away, I silently agreed with her assessment. Indeed, Michelle Obama has that transcendent ability that allows us to connect with her, and as the playwright Richard Wesley notes, "The First Lady is herself a fascinating and unique embodiment of the nexus of beauty, race, class and gender and how it affects the perceptions of so many people, including those who are so often dismissed as 'others.'"[2]

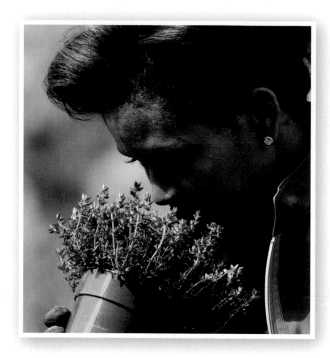

Mrs. Obama sniffs thyme as she plants herbs in the White House kitchen garden on the South Lawn of the White House, April 9, 2009.

evident during Obama's first visit as First Lady to England:

Mrs. Obama clearly made an impression with the 82-year-old monarch so much that the smiling queen strayed slightly from protocol and briefly wrapped her arm around the first lady in a rare public show of affection. It was the first time Mrs. Obama, who is nearly a foot taller, had met the queen. The first lady also wrapped her arm around the monarch's shoulder and back. Mrs. Obama visited an all-girls school in north London on Thursday afternoon. She told the 240 girls about growing up on Chicago's south side, and urged them to think of education as "cool." "I never cut class. I liked being smart. I liked getting A's," she said. "You have everything you need. Everything you need to succeed you already have right here."[3]

In light of Michelle Obama's burgeoning impact on world consciousness—with her photographs appearing on the covers of *Vogue, New York, O, Newsweek, Essence,* and *Ebony* and on the front pages of newspapers worldwide—this is an exciting time to reflect on America's new First Lady. The notion of "seeing the best of ourselves in her" is reflected in gazes from young girls everywhere, from Washington, DC's Anacostia neighborhood to students at the Elizabeth Garrett Anderson Secondary School in London. Inevitably, she is admired by an extraordinary and diverse range of people—from inner-city schoolchildren to the Queen of England. This was particularly

Previously, historical impressions of America's First Lady, with few exceptions, largely reflected carefully cultivated images of womanhood and motherhood; invariably, wives of presidents were duty-bound to support their husbands' political and cultural agendas and ideals, and they were more often viewed as adjuncts rather than as individuals. Suddenly, with Michelle Obama's arrival, the East Wing, the historic domain of the First Lady, is mentioned more often in the press than ever before. She has engaged the imagination

First Lady Michelle Obama speaks with Britain's Queen Elizabeth during a G20 reception at Buckingham Palace in London.

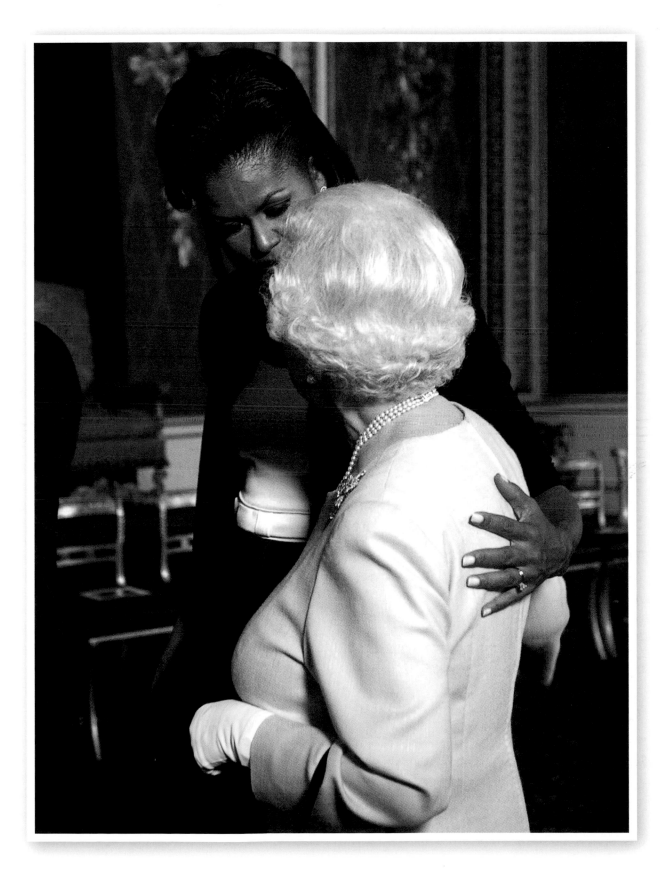

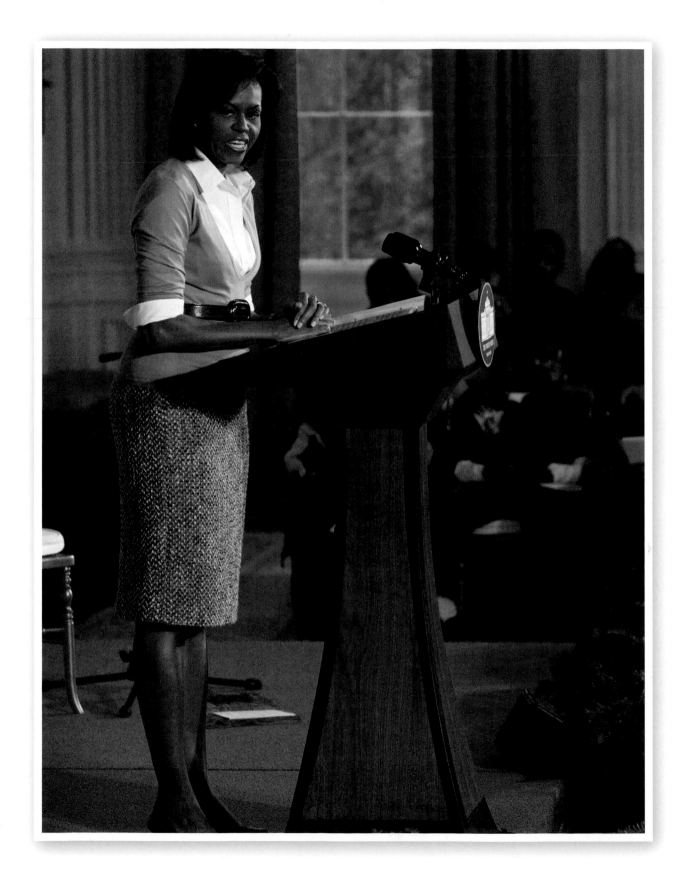

of a new generation of writers and artists as they chronicle the commanding role the First Lady now plays in American *visual* culture. Robin Givhan of the *Washington Post* observes: "The rise of first lady Michelle Obama as an icon—of fashion, black womanhood, working motherhood and middle-class success—has propelled her onto a pedestal that would surely give the average person vertigo. She is Jackie Kennedy, Sojourner Truth, Hillary Clinton and a Horatio Alger character all rolled into one J. Crew–clad package."[4]

This book examines this phenomena through photographs, including nearly two hundred

White House in a cultural and historical context. Like her husband, President Barack Obama, she is a person of immense curiosity—no one has seen world leaders like them before. Television viewers, schoolchildren, and even the most imperturbable academics are all mesmerized by images of the First Couple. Journalists gush in all candor that wives nationwide are now nudging their husbands about getting more romantic affection after following the details of the Obamas' so-called date night on Broadway. Implicit in this is the notion that if the president has time to take his wife out for a whirlwind

Michelle Obama is a mother who can exude humor and love, who provides a bulwark of support for her family and for the American public.

images of Michelle Obama—First Lady, wife, mother, daughter, lawyer, sister, friend, mentor, campaigner, and icon—a woman who appears both smartly dressed and equally aware of politics, education, world affairs, fashion, and decorum. It includes an essay by writer Emily Bernard, focusing on Michelle Obama's early life through the campaign as well as life in the

First Lady Michelle Obama speaks to 6th and 7th grade schoolchildren from around the Washington, DC, area during an event celebrating African American History Month in the East Room of the White House.

evening, other career husbands, hopelessly mired in their jobs, should take the time to "date" their underappreciated wives. Photographs of the Obamas further suggest that they strive for a balance between work and family. It becomes obvious that Michelle Obama is a mother who can exude humor and love, who provides a bulwark of support for her family and for the American public.

So what is new here? First, the historic visualization of a black woman in the White House, one who is cherished by her husband. It is not unusual to see the president showing

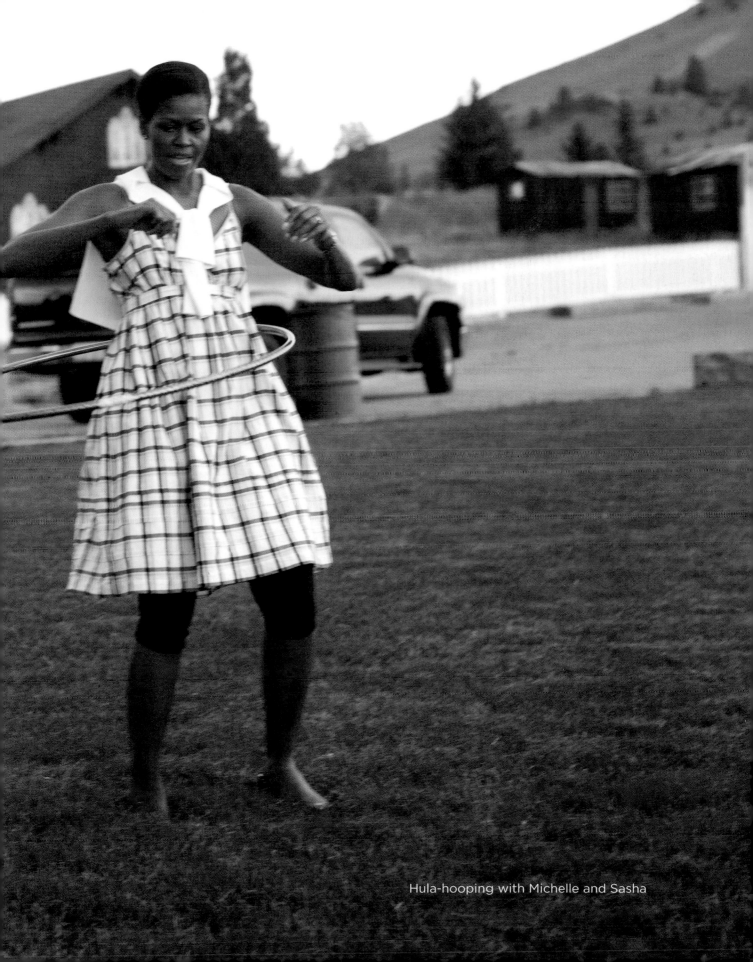

Hula-hooping with Michelle and Sasha

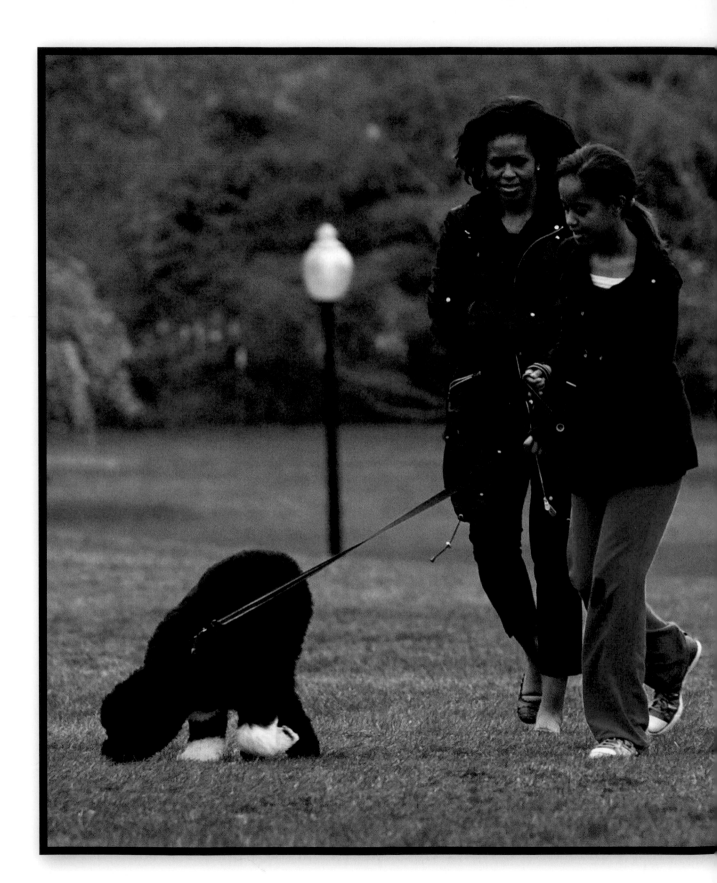

Malia Obama walks her new six-month-old Portuguese water dog, Bo, alongside her father, mother, and younger sister, Sasha, on the South Lawn of the White House, April 14, 2009.

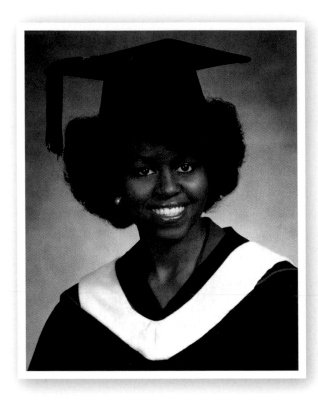

Michelle Robinson Obama's Princeton University yearbook photo.

enthusiastic mother who herself came from a home with two parents, she is clearly devoted to her family.

Her biography is familiar to many of us. Born Michelle LaVaughn Robinson on January 17, 1964, on Chicago's South Side to Fraser Robinson III and Marian Shields Robinson, she grew up in a loving and supportive working-class family with older brother Craig Robinson. Raised in this environment, Michelle, like her parents, believes in discipline and values education. As Mom-in-Chief, or First Mom, she is photographed reading to children in classrooms, playing with her own children, planting an organic garden, hugging her dog, and organizing an Easter egg hunt on the White House lawn. These photographs bring the grandeur of the White House down to a level where the Obamas' lives, while still fairy-tale in some respects, can be appreciated by a large number of American families. The images are both humanizing and affirmative at the same time.

Robin Givhan astutely comments that Michelle Obama "has slipped into that rarefied world in which normal human behavior—concern for one's children, a preference for wearing jeans on the weekend, the ability to look other people in the eye while they're speaking to you—is perceived by many as an incomparable example of graciousness, familial commitment and kindness."[5] Again, her behavior is not unusual! When she hugs girls in appreciation for their admiration of her, she clearly reinforces their sense of themselves. She represents, in effect,

affection, touching or hugging her. The photographs in this book show the First Couple holding hands, caressing, sharing a kiss, laughing, and relaxing. Furthermore, it is historic for a president to be physically affectionate in the first place. One can hardly visualize, say, Franklin Roosevelt, Richard Nixon, or George W. Bush behaving publicly with such tenderness toward their spouses. Michelle Obama likes how she looks and what she wears. There is a sense of joy in the images of her balancing a Hula Hoop with her daughter during the campaign or walking with the family's hypoallergenic Portuguese water dog, Bo, on the South Lawn. A good and

First Lady Michelle Obama listens to retired Air Force Brigadier General Wilma L. Vaught while visiting Arlington National Cemetery's Women in Military Service for America Memorial Center on March 3, 2009.

a new vision of womanhood, one so different from first ladies of the past. Her position and the naturalness with which she handles herself allows people of any background to relate as they imagine their futures. In responding to a reporter's question about her affectionate hugs, she says, "I'd be intimidated too to meet the First Lady. That's why I'm so touchy with kids, because I think if I touch them and I hug them, that they'll see that it's real, and then they'll relax and breathe and actually kind of enjoy the time and make use of it."[6]

While comparisons with the fictional Clair Huxtable of *The Cosby Show* abound, we have rarely seen this before in a real person in the public sphere. The Huxtable character, portrayed by Phylicia Rashad, like Obama, is an active lawyer and mother, but Obama flips the historical script and becomes the *nation's* mom—with two Ivy League degrees, no less (Princeton University and Harvard Law School). It is important to note that, because of Obama's universal appeal, she has been photographed with a variety of people during the campaign and as First Lady: white, black, Native American, Asian, and Latino/a. The celebrities who come into her photographic orbit are numerous: governors, mayors, Barbara Walters, Alicia Keys, Lisa Leslie, Debra Lee, and Carla Bruni-Sarkozy, among many others. Her

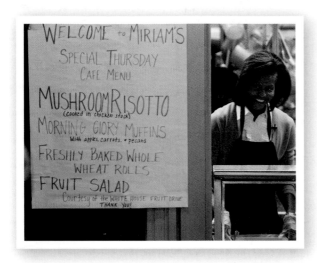

The First Lady serves lunch at Miriam's Kitchen, a nonprofit organization that provides meals, case-management services, and housing support to nearly 250 homeless men and women in Washington, DC.

intellectual curiosity and role as supporter—of her husband, other women, and indeed all of us who are open to this vision—are revealed in the photographs. Her brilliance and tenacity offer a revised portrait of women in contemporary society.

Like one of her many predecessors, Jacqueline Kennedy, she is an avid supporter of the arts. She has hosted a spoken word / slam poetry night at the White House with up-and-coming as well as established actors, poets, and musicians. At a time when we fear a corruption or collapse of the arts, she inspires others to explore them with her. She appears excited and pleased as she is photographed cutting the ribbon during the opening of the Metropolitan Museum of Art's new American Wing.

It is apparent that she does not shrink from controversy or new opportunities. Obama has opened the entire White House to employees who have worked there for thirty or forty years but have never been in the living quarters. Even though she has been invited to speak at countless institutions, she chose to speak at the graduation ceremonies not of an Ivy League institution but at the University of California, Merced, a new state school in an economically challenged region, where she shared stories about her desire to attend college and "evoked the struggles of California's founders, settlers and former slaves, trailblazers and immigrants to encourage the 493 members of the school's senior class to use their newfound skills to lift up those around them."[7] During Women's History Month, Obama, who recognizes the challenges women still face, invited celebrities to the White House and lectured to employees at government agencies. She has attended gatherings for military families, many of which are stationed overseas, and has worked to raise consciousness about the homeless. Like her husband, she is an active listener, something that is evident in her photographs. Her humor, not canned or totally controlled, can be both disarming and pointed. "After joking in January that her new job 'doesn't pay much,' Mrs. Obama now typically describes the job of First Lady as the best in the White House, saying that even her husband is often jealous of what she gets to do."[8] The photographs in this book often capture Michelle Obama saying something that

is making other people laugh. The photographers capture her humor and her serious concerns. Her appearances or remarks can occasionally cause controversy. When she simply quipped that she is happy now to select meals for her family as opposed to preparing the meals, she created a minor stir. News commentators and journalists, so sensitive to even the smallest nuances of her remarks, criticized her for failing to use the occasion to encourage people everywhere to cook healthy meals for themselves and their families. The truth, however, is that she, married to Barack Obama since 1992, spent years planning and preparing meals for her husband and their two daughters, Sasha and Malia. Unlike these comments, which seemed to imply that the First Lady may be pretentious in her new role, the photographs reveal that she is at ease with her staff, who take pride in the work they perform in the White House. The photographs of Michelle Obama in the large kitchen talking with her pastry chef or in her garden reveal her hands-on style. Here, she communicates not only the value of organic gardening but also the need to take responsibility for our nutrition and daily health.

This book is a visual compilation of Michelle Obama and who she is today. It is an assemblage that chronicles the portrayal of an entirely new First Lady, one who has—through her activities and visual messages—created a new, iconic stamp that has already changed our cultural perspectives. So pervasive are Michelle Obama's photographs that they have been critiqued in the media, preserved in family albums, and discussed in chat rooms and on the Internet through blogs, Twitter, and Facebook. Ironically, the First Lady's beauty is rarely discussed, which is why I find this one comment so intriguing:

Funny you should mention Michelle Obama's arms. I was just accosted by a white man in the laundry mat who just asked me out of the blue what I thought about Michelle's arms. He told me his daughter loves that she is into wellness. I mentioned that Jackie O also did

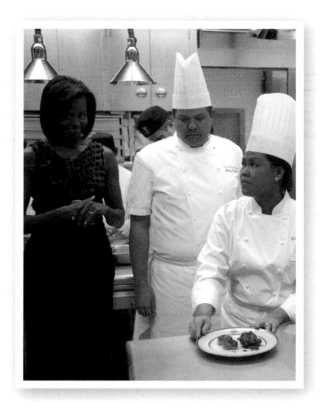

First Lady Michelle Obama watches as White House Chef Cristeta Comerford (right) displays a proposed course for the 2009 Governors' Dinner on February 22.

sleeveless and he said "but hers didn't look like THAT! she is beautiful." Clearly he loves them. You know, when I saw her sleeveless I just reveled in the fact that she was beautifully toned and acclimated to her surroundings enough to not have to wear a sweater or jacket. There is SO MUCH MORE to her than arms that I really can only spend the time responding to this on them.[9]

It is noteworthy, indeed revealing, that the larger American public has never come to know so intimately an African American woman *who*

called proud, strong, beautiful, smart, angry, accomplished, elegant, authentic, militant, baby mama, articulate, statuesque, and scary.[10] Such diverse labels force us to look at these compelling images and reevaluate all that we see. We need to find a way to connect the dots in order to define our own understanding of Michelle Obama and, in fact, of ourselves. Her presence in these images affords us a visual vocabulary—ways of seeing and appreciating beauty in black women that heretofore may not have been possible. This book reveals that Obama invariably changes the script, rewriting the so-called typical roles

Obama has been called proud, strong, beautiful, smart, angry, accomplished, elegant, authentic, militant, baby mama, articulate, statuesque, and scary.

is not a performer or an athlete. This reality has changed the way Americans view such a woman. She is hardly Harriet Tubman, canonized from the remove of several centuries in history books, nor does she follow in the tradition of Josephine Baker, Ella Fitzgerald, Diana Ross, Aretha Franklin, Serena Williams, or Oprah Winfrey. Michelle Obama's body type has been described and discussed ad infinitum by men as well as women—all looking for ways to understand how to accept and view an African American woman who appears comfortable with her body, intellect, and beauty. Obama has been

of the black female and of American women in general. Rachel L. Swarns perceptively observed in the *New York Times* that "the new first lady is methodically shaping her public image, and in ways that extend far beyond fashion. She has given coveted interviews primarily to women's magazines and news outlets that have allowed her to highlight her domestic side: her focus on motherhood and her efforts to settle her family in the White House; her interest in gardening and healthy living; her affinity for mixing off-the-rack and designer goods; and her efforts to open up the White House to ordinary Americans."[11]

Connecting the dots

As a professor of photography and visual studies, I often listen to my New York University students engaging in critical discussions about subtly controversial images of women. As young people, they struggle to find images that represent their own lives. During the 2008 presidential campaign, these students regularly debated the ways in which Michelle Obama had been portrayed and covered by the media. To them, she had already become iconic, her images invariably representing the desires of both undergraduate and graduate students.

As a result of this extensive media inundation, new historical connections and observations are being made all the time. For example, it is fascinating for us to acknowledge that the White House was, in fact, built by enslaved African Americans—something, while obvious in retrospect, most of us have not realized before. It's worth noting that the White House continues to be a must-see destination for tourists in Washington. It remains on the one hand the official residence of the president of the United States, and on the other the home of Barack, Michelle, Malia, Sasha, and Bo. The reader of this book will glean other insights beyond what I can briefly discuss here, associations that will become evident as they view Michelle Obama engaging with celebrities, diplomats, heads of state, leaders, veterans, and schoolchildren.

History not only abounds in these photographs but also has been reinvigorated. Fashion history is being made at the same time.

The "Michelle brand" has had a profound effect on the fashion industry, especially on her favorites, such as J. Crew, Black Market/White House, Jason Wu, Narciso Rodriguez, Isabel Toledo, and Michael Kors. Just by wearing certain fashion accessories—such as high-waisted belts, cocktail rings, earrings, and pearls—she can ignite a trend and influence the look of the street and the runway. She is a fashion icon who is not afraid to go high-, low-, or middlebrow. These photographs suggest that the First Lady cannot be reduced to one vision; she appears equally chic wearing Gap or haute couture.

Michelle Obama has clearly achieved super-celebrity status, at the same time enhancing the respectability and prestige of the role of First Lady. Carmen Phillips, a student in one of my graduate seminars, wrote: "Michelle Obama has been recently referred to by a variety of pundits as the 'Cover Girl–in–Chief,' a characterization perhaps not too far removed from reality. Within the last 18 months she has been on no less than 20 nationally distributed magazine covers and appeared as the main feature of countless newspaper headlines. This proliferation has been met with quite a large bit of economic success for the companies that feature her."[12] These images, then, as well as so many others, transport us to a new future, one both pathbreaking and endlessly exciting. They change the way we think about beauty, success, womanhood, and what it is to be American.

NOTES

1 *Vogue,* March 2009.

2 E-mail message from playwright Richard Wesley to author, March 2, 2009.

3 Posted by Jennifer Quinn / Associated Press, April 2, 2009, 4:02 p.m.

4 *Washington Post,* February 15, 2009.

5 Ibid.

6 *Time,* June 1, 2009.

7 http://cbs5.com/local/uc.merced.michelle.2.1011447 .html.

8 *New York Times,* April 24, 2009.

9 Anonymous comment on *The Kitchen Table* (princetonprofs.blogspot.com).

10 *New York,* March 23, 2009.

11 *New York Times,* April 24, 2009.

12 Unpublished research paper, "Michelle Obama, The One Woman Stimulus Package: Considering the Creation of an Icon and the History of Commodifying the Black Woman's Body," May 8, 2009.

OVERLEAF: The First Lady exudes characteristic elegance—and shows off her famous arms—as she poses for her official portrait in the Blue Room of the White House in February 2009. The first official First Lady portrait to be captured digitally, this photograph represents change in our culture in more ways than one.

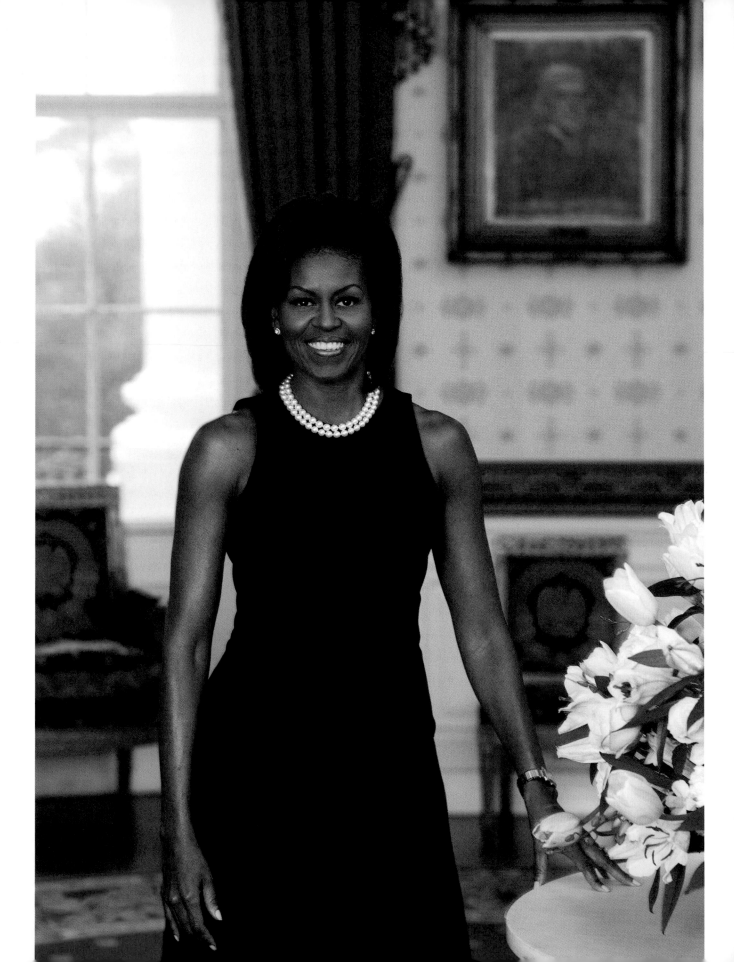

PHOTOGRAPHS

WHITE HOUSE

Michelle Obama, wife of potential Democratic presidential candidate Barack Obama, waits in the wings of Milwaukee's Pabst Theater to deliver a speech promoting her husband's campaign.

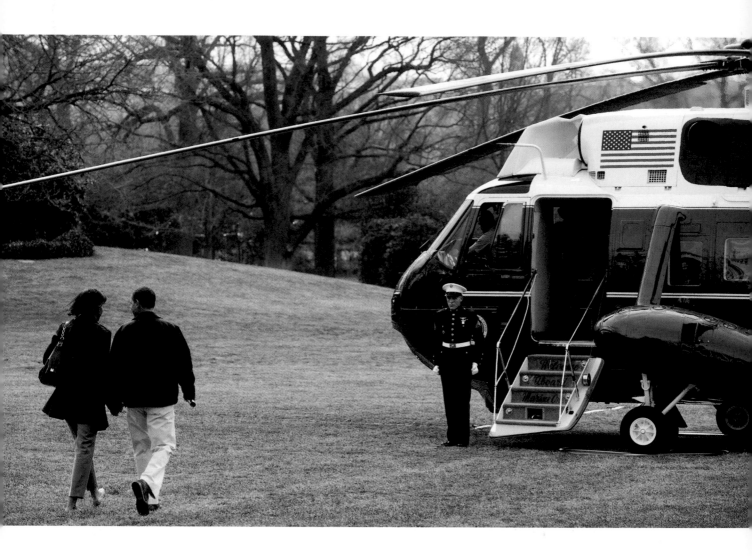

The First Lady accompanies her husband across the South Lawn of the White House to board Marine One on March 7, 2009. President Obama and the First Lady were traveling to Camp David, the presidential retreat in Frederick County, Maryland, to spend the weekend.

———————————————

OPPOSITE: Michelle Obama in a photo shoot for *Ebony* magazine.

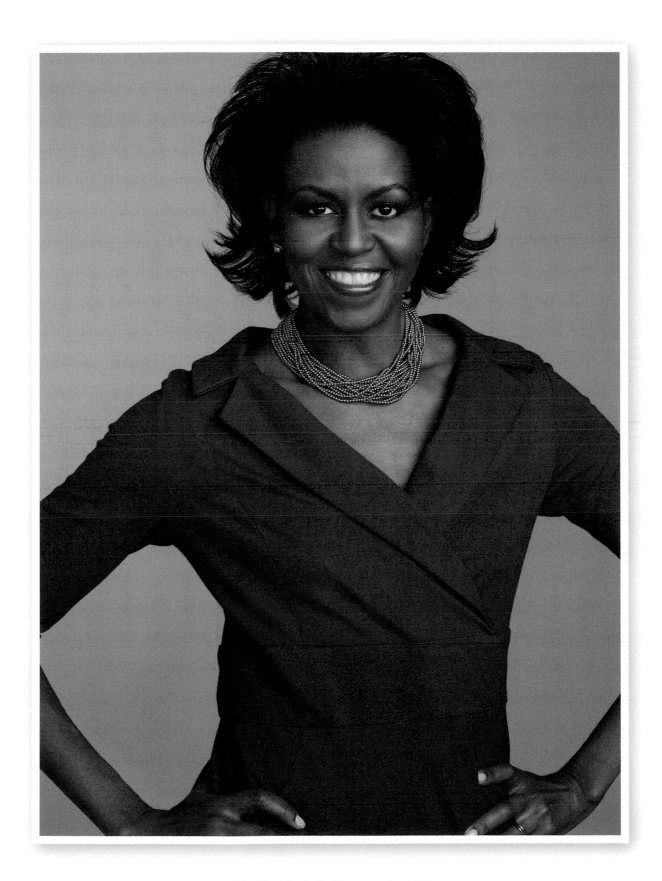

After the president inspired yet another national conversation by announcing, in his acceptance speech, that his daughters, Malia and Sasha, had "earned the new puppy that's coming with us to the White House," the Obama family chose Bo, a six-month-old Portuguese water dog, whose hypoallergenic coat played an important role in the Obamas' choice. Bo is a gift from Senator Edward Kennedy, who owns several water dogs, including one from Bo's litter. Here the First Lady and Bo get acquainted on April 14, 2009.

The First Lady introduces Stevie Wonder at the White House on February 25, 2009. Wonder was there to receive the Library of Congress Gershwin Prize for Popular Song, a lifetime achievement award for American songwriters. Obama told the audience that the first album she ever bought was Stevie Wonder's *Talking Book.* Years later, the First Couple chose "You and I" as their wedding song. Wonder performed at the Democratic National Convention.

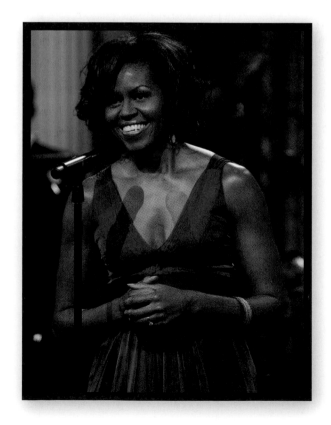

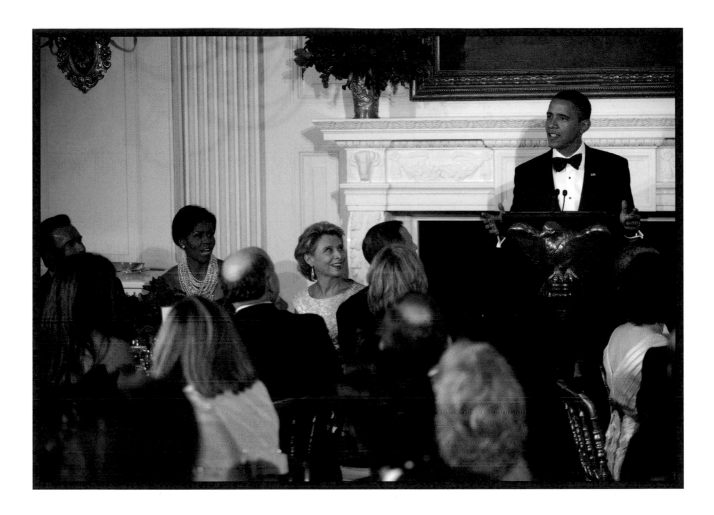

Michelle Obama looks on as President Barack Obama addresses a black-tie audience at the 2009 Governors' Dinner in the State Dining Room of the White House on February 22. "The last thing I want to do is hold up the food, so Michelle and I want to say welcome," Obama told the governors before turning to more serious topics. The First Lady is seated between California Governor Arnold Schwarzenegger (left) and Washington Governor Christine Gregoire (right).

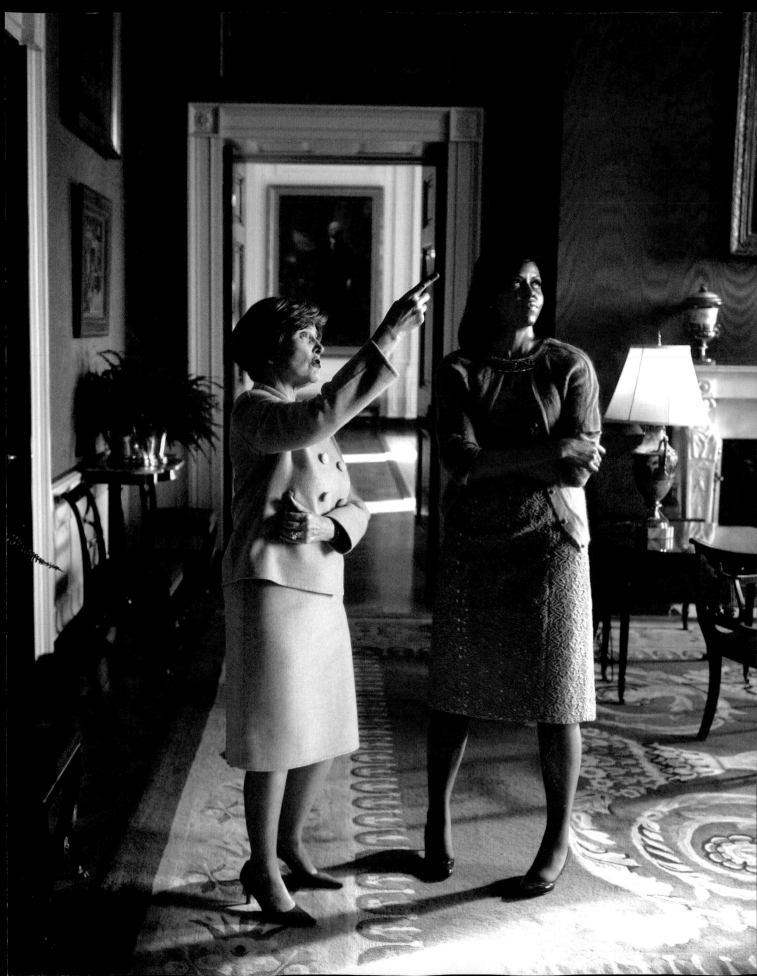

First Lady Laura Bush introduces Michelle Obama to the artwork in the East Wing, "the historic domain of the First Lady," writes Deborah Willis. Later the same day, January 20, 2009, Barack Obama was sworn in on the West Front of the Capitol as the forty-fourth president of the United States.

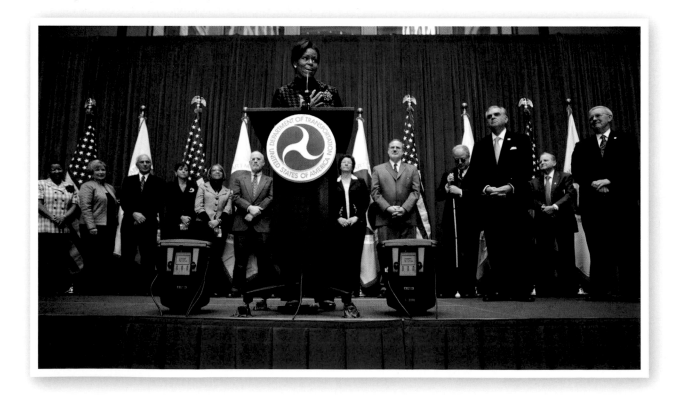

OPPOSITE TOP: In honor of Women's History Month, Michelle Obama surprises thirteen students at southeast Washington's Anacostia High School on March 19, 2009. The First Lady drew parallels between her own childhood experiences and those of the students, telling them that she grew up near the University of Chicago but never set foot inside as a child. "It was a fancy college, it had nothing to do with me," she said. "Maybe there's a lotta kids who feel that way about the White House," she suggested, pointing out that the White House was only ten minutes away from where the students lived. "I want to take off the veil and say, this is what's going on there, and eventually [have you] come see me in the White House," she told the students.

OPPOSITE BOTTOM: Michelle Obama represents the new administration during a visit to the Department of Transportation on February 20, 2009. This was her fifth in a round of such visits to government agencies that month. Obama recognized the hard work of department employees. "I'm here to say thank you," she said to a round of applause. White House staff received a barrage of phone calls concerning Mrs. Obama's choice to pull back her hair for the event—a topic on which they declined to comment.

ABOVE: The First Lady selected twenty-one billionaires, actresses, philanthropists, athletes, and businesswomen for a gathering in recognition of Women's History Month on March 19, 2009. Guests included singer Alicia Keys and BET Holdings CEO Debra Lee (center and right, respectively), actor Kerry Washington, and WNBA star Lisa Leslie. "This was one of my dreams," Obama told the high-profile women assembled in the White House Diplomatic Reception Room. Later they visited DC schools in order to inspire kids—to "make the kids understand where we stand is not an impossibility," said Obama.

Mrs. Obama makes her debut as a commencement speaker at the University of California, Merced, on May 16, 2009. Twelve thousand people, including the five hundred members of the school's first full graduating class, listened as the First Lady praised the school's tireless efforts to bring her to campus for their graduation. Students and their families wrote thousands of letters to her office, friends, and family and even started a "Dear Michelle" Facebook campaign that showered her with nine hundred Valentine's Day cards. "This type of activism and optimism speaks volumes about the students here, the faculty, the staff, but also about the character and history of Merced," she told the crowd.

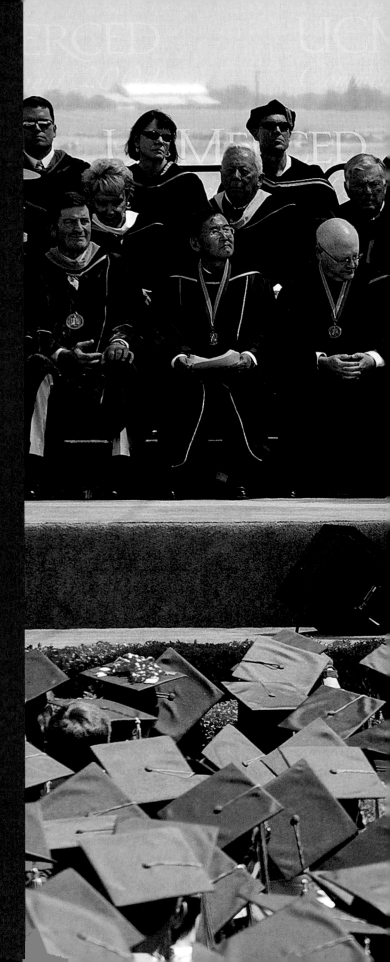

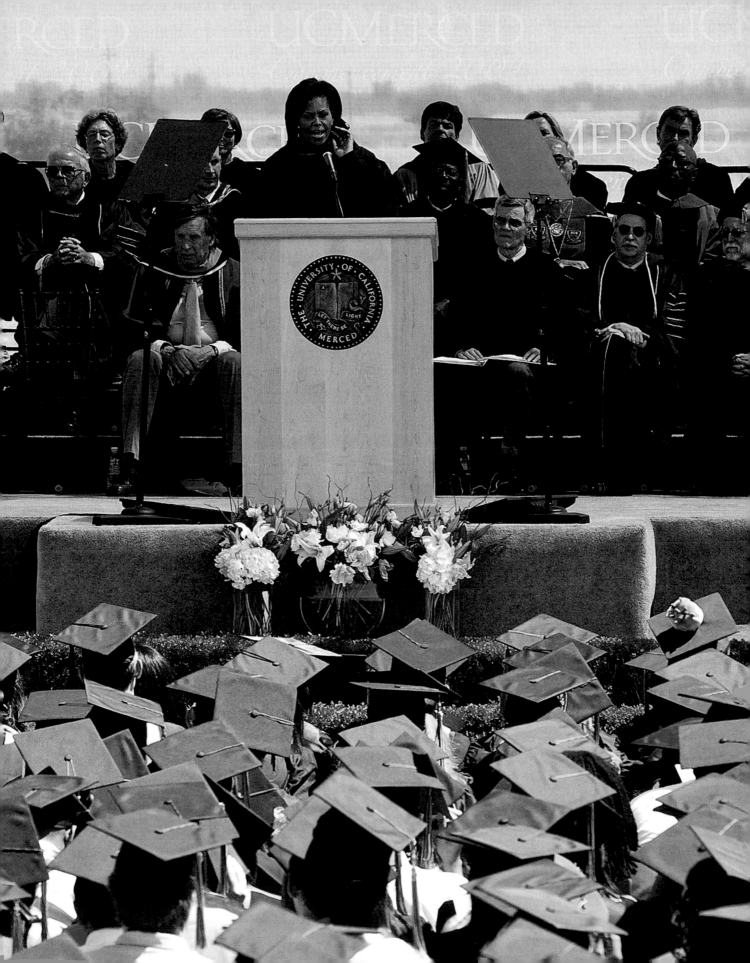

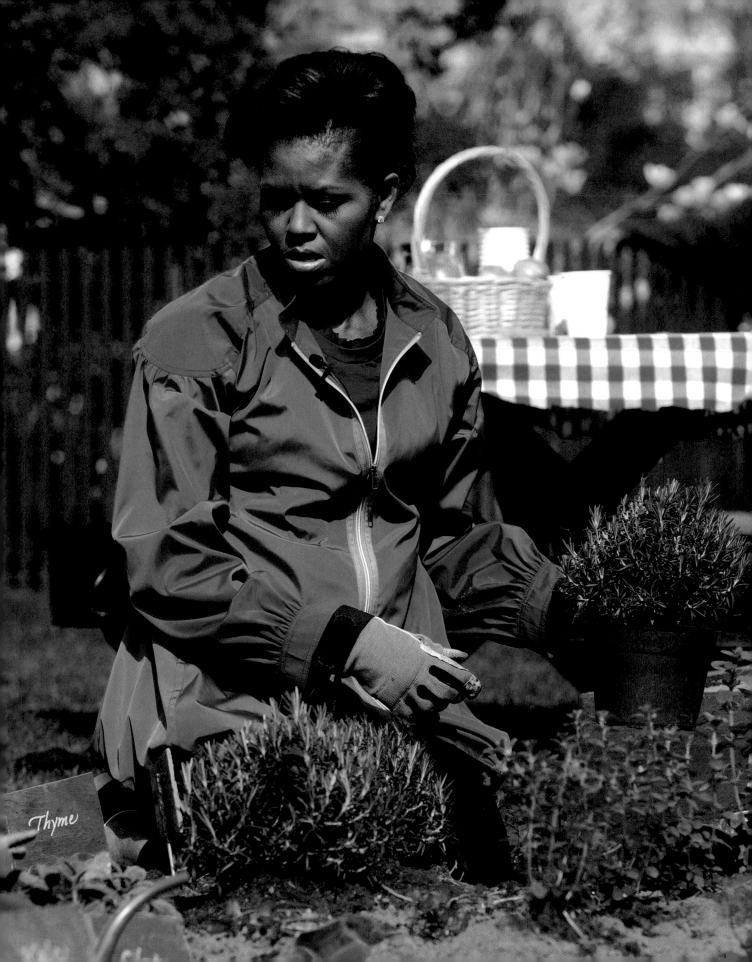

President and Mrs. Obama greet well-wishers in the Blue Room of the White House during an open house on their first day in their new home. Two hundred people won passes to the event on a first-come, first-served basis.

OPPOSITE: The First Lady, along with Bancroft Elementary School students (not pictured), plants the first seeds in the White House Kitchen Garden on April 9, 2009. The four-season herb, fruit, and vegetable garden features twenty-five varieties of heirloom, or non-hybrid, seeds planted in raised beds. These plantings include Brown Dutch and Tennis Ball lettuce, Savoy cabbage, and prickly-seeded spinach—all reportedly favorites of President Thomas Jefferson. The White House kitchen garden, measuring about 102 square meters, is on the west side of the South Lawn.

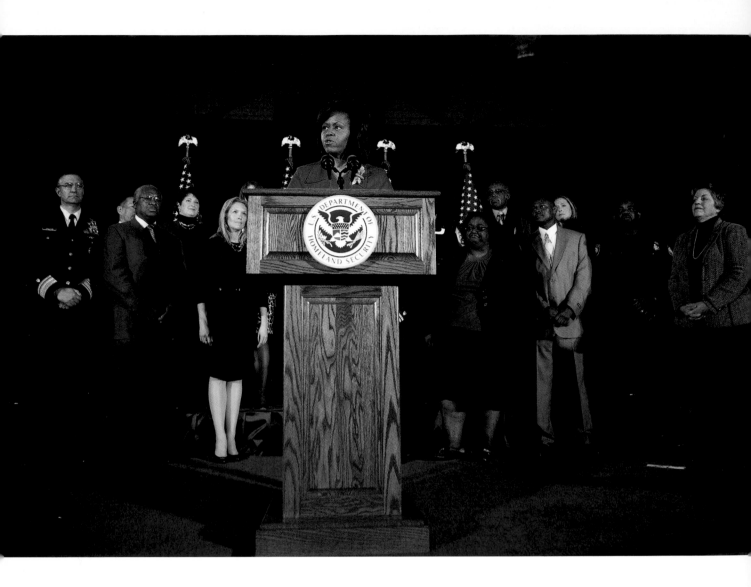

First Lady Michelle Obama, joined by Homeland Security Secretary Janet Napolitano (right), delivers remarks at the Department of Homeland Security after meeting with representatives of the department's various branches in Washington on April 14, 2009.

The First Lady speaks to young people at Mary's Center, a Washington nonprofit health clinic that provides a predominantly Hispanic community with after-school programming and other services, on February 10, 2009. "Why did you want to come out and meet us?" one student asked. "I think it's real important for young kids, particularly kids who come from communities without resources, to see me," she responded, saying that she didn't become First Lady courtesy of any magic dust. "We were kids much like you who figured out one day that our fate was in our own hands," she said of herself and her husband.

Michelle Obama congratulates Hadizatou Mani of Niger, one of the 2009 winners of the Secretary of State's Award for International Women of Courage at the State Department on March 11, 2009. Eight women from around the world were honored, including Mani, who was sold into slavery at age twelve and later struggled to prove that the Government of Niger had not successfully protected her rights under its antislavery laws. Secretary of State Condoleezza Rice established the International Women of Courage awards in 2007.

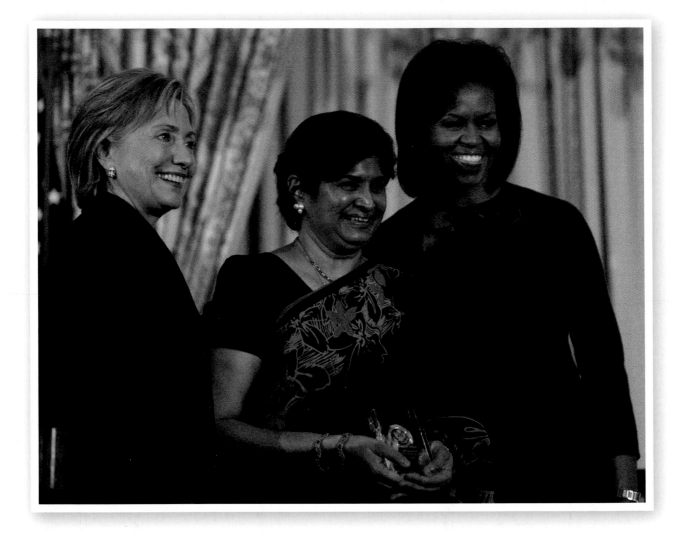

Norma Cruz of Guatemala receives the Secretary of State's Award for International Women of Courage, on March 11, 2009, from Secretary of State Hillary Clinton and First Lady Michelle Obama. Cruz is the cofounder and director of the nongovernmental organization (NGO) Survivors Foundation. The *Guatemala Times* applauded Cruz for having offered "emotional, social and legal support to hundreds of victims of domestic violence and sexual abuse and to the families of murdered women."

OPPOSITE: Secretary of State Hillary Clinton and First Lady Michelle Obama flank Ambiga Sreenevasan, a winner of the Secretary of State's Award for International Women of Courage, on March 11, 2009. In her remarks, Clinton described Sreenevasan's "remarkable record of accomplishment in Malaysia. She has pursued judicial reform and good governance, she has stood up for religious tolerance, and she has been a resolute advocate of women's equality and their full political participation."

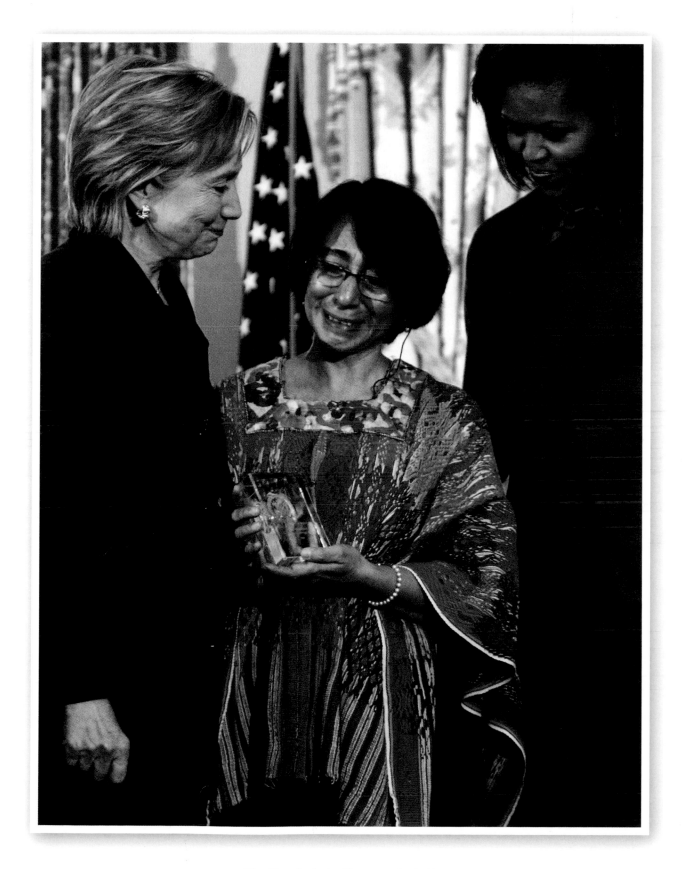

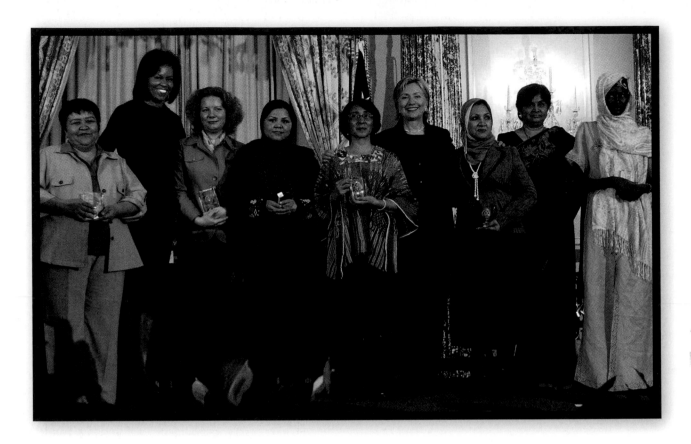

First Lady Michelle Obama and Secretary of State Hillary Clinton stand with seven of the eight recipients of the third annual Secretary of State's Award for International Women of Courage at the State Department on March 11, 2009. The honorees (left to right) are: Muatabar Tadjibayeva of Uzbekistan; Veronika Marchenko of Russia; Wazhma Frogh of Afghanistan; Norma Cruz of Guatemala; Suaad Abbas Salman Allami of Iraq; Ambiga Sreenevasan of Malaysia; and Hadizatou Mani of Niger. Reem Al Numery of Yemen was unable to attend the ceremony.

———————————

OPPOSITE: The First Lady, here with actors Richard Thomas, Jeffrey Wright, and Cheryl Freeman (left to right), celebrates the grand reopening of the historic Ford's Theatre in Washington, DC, on February 11, 2009. The renovation of the theater—site of the 1865 assassination of Abraham Lincoln—took eighteen months, cost $25 million, and included the installation of more comfortable seats, a modern lobby, and a new dressing room. The reopening occurred on the eve of Lincoln's 200th birthday. In his remarks to the audience, President Obama praised the sixteenth president for his "unyielding belief that we were, at heart, one nation, and one people."

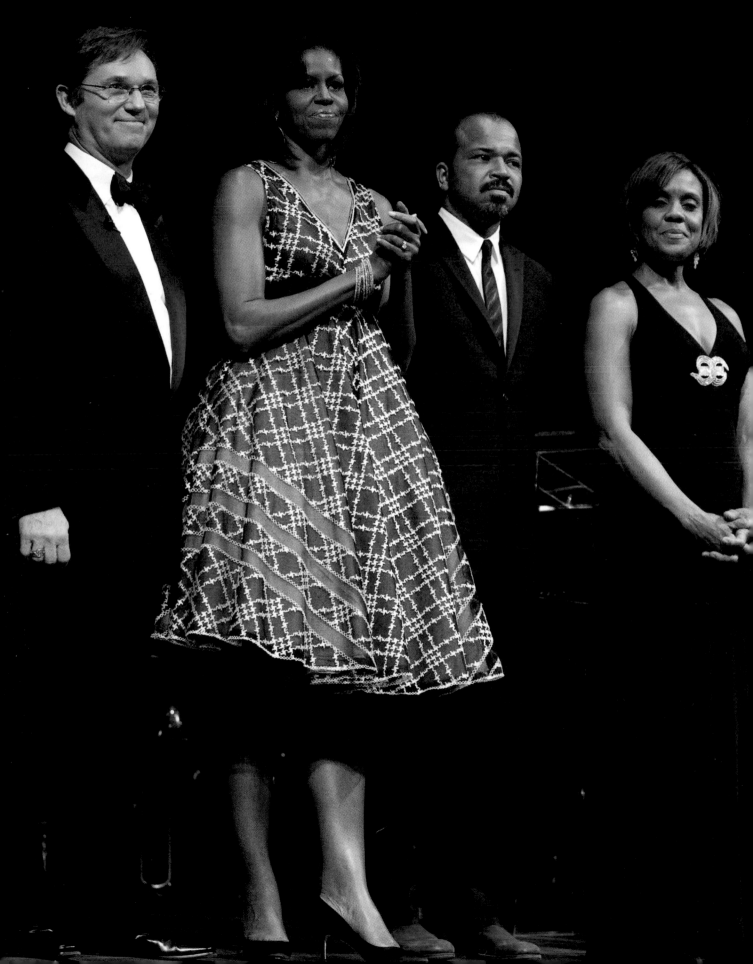

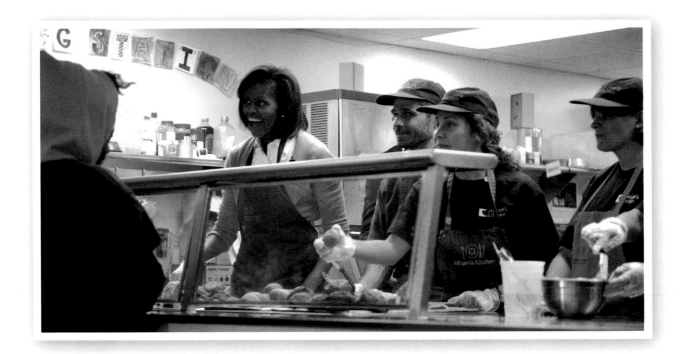

"Would you like risotto?" asks the First Lady of fifty guests at Miriam's Kitchen in Washington, DC, on March 5, 2009. Founded in 1983, Miriam's Kitchen provides free, high-quality meals and support services to the homeless. Samuel Hinton, 52, a Vietnam veteran, counted himself among those impressed by the First Lady: "There have been a lot of first ladies. But none ever touched base like this."

The First Lady embraces basketball champion Lisa Leslie on March 11, 2009. The occasion was a ceremony in honor of Women's History Month, when President Obama signed an executive order to create the first White House Council on Women and Girls. Later, on her blog, Leslie described meeting the First Lady: "Aside from my husband, I cannot remember another person that made me feel like I was the only person in the room when they were talking to me, until meeting Michelle Obama."

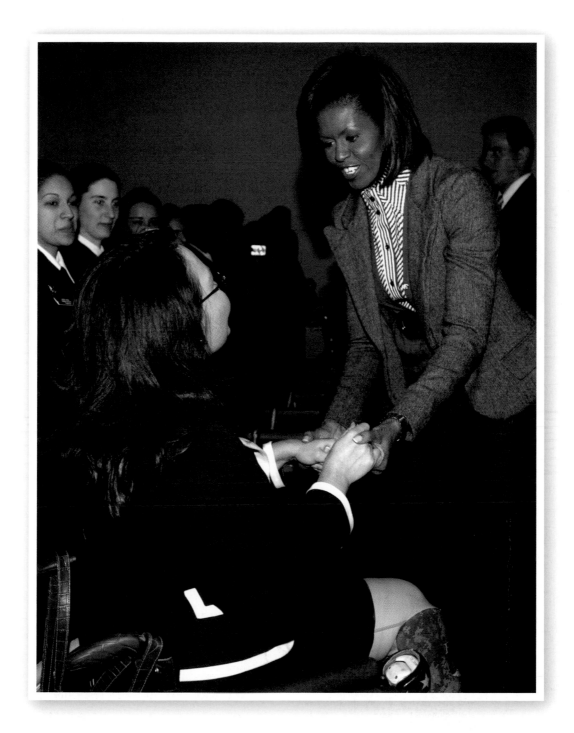

The First Lady greets a wounded veteran at Arlington National Cemetery's Women in Military Service for America Memorial Center in Washington, DC, on March 3, 2009. This event, her first to celebrate Women's History Month, highlighted Mrs. Obama's focus on military families. "Military families have done their duty, and we as a grateful nation must do ours. We must do everything in our power to honor them by supporting, not just by word but by deed," said Obama.

Michelle Obama visits Arlington National Cemetery's Women in Military Service for America Memorial Center in Washington on March 3, 2009. During her husband's presidential campaign, Mrs. Obama made it a point to visit military bases to meet with spouses left at home.

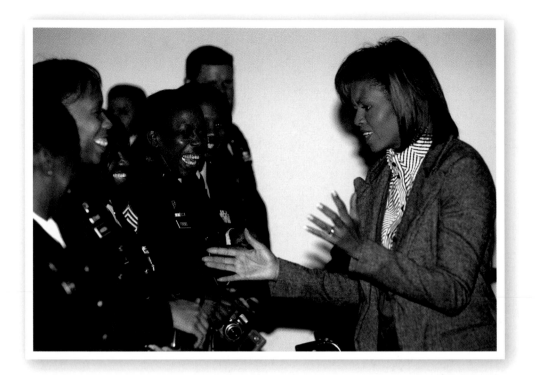

The First Lady charms military personnel during her visit to Arlington National Cemetery's Women in Military Service for America Memorial Center in Washington on March 3, 2009.

First Lady Michelle Obama waves to an enthusiastic crowd of Homeland Security Department employees after delivering remarks that included many expressions of gratitude. "One of the president's greatest concerns and priorities is the safety and security of the American people," she said. "He couldn't do it without you." Mrs. Obama visited the Homeland Security Department on April 14, 2009, as part of a series of visits to federal agencies to thank employees for their service.

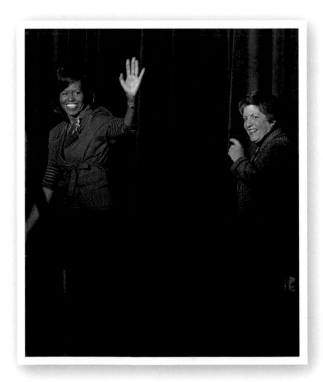

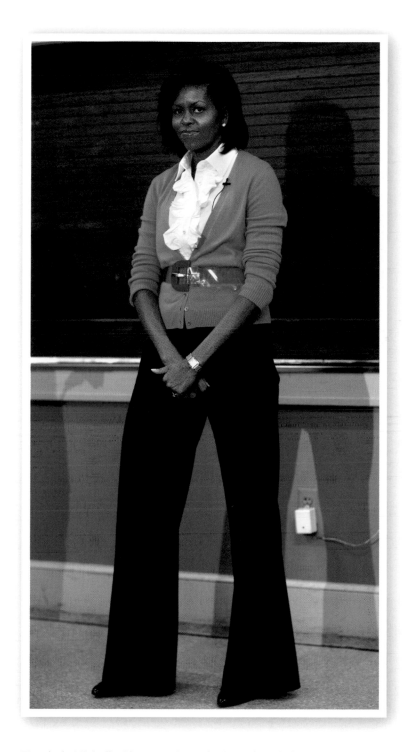

First lady Michelle Obama waits to be introduced after serving lunch during her visit to Miriam's Kitchen on March 5, 2009. The center provides meals, case-management services, and housing support to nearly 250 homeless people in Washington, DC.

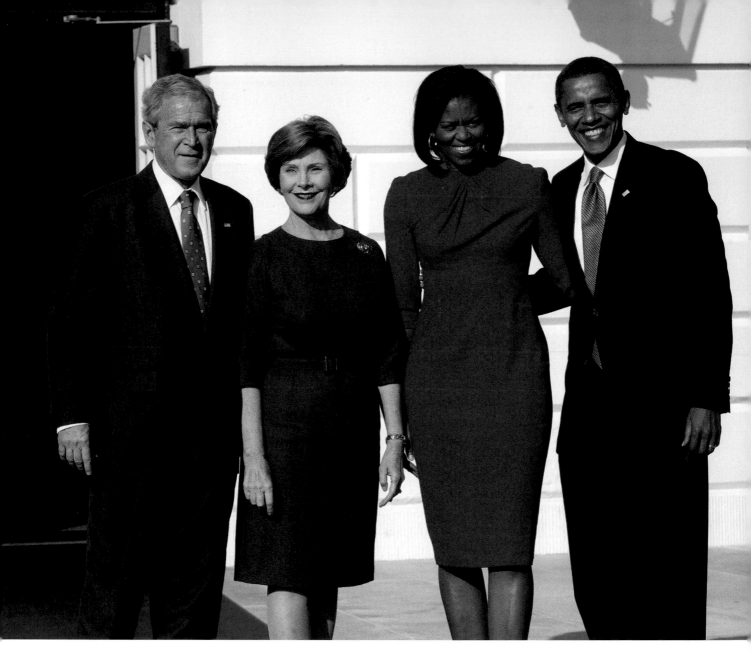

President-elect Barack Obama and Michelle Obama are welcomed by President George W. Bush and First Lady Laura Bush at the South Portico of the White House on November 10, 2008. This was Obama's first visit to the White House before he was sworn into office as president of the United States. First Lady Laura Bush took Mrs. Obama on a tour of the White House as President Bush and former Senator Obama walked along the colonnade to the Oval Office for a meeting.

OPPOSITE: First Lady Michelle Obama—in the Heroes and Icons category—was among the 100 honorees at *Time* magazine's World's Most Influential People Gala at Rose Hall in New York City on May 5, 2009. Here she greets Barbara Walters of *The View,* where Obama was a guest on June 18, 2008. Joy Behar and Elisabeth Hasselbeck, two cohosts of the show, and photographer Timothy Greenfield-Sanders look on.

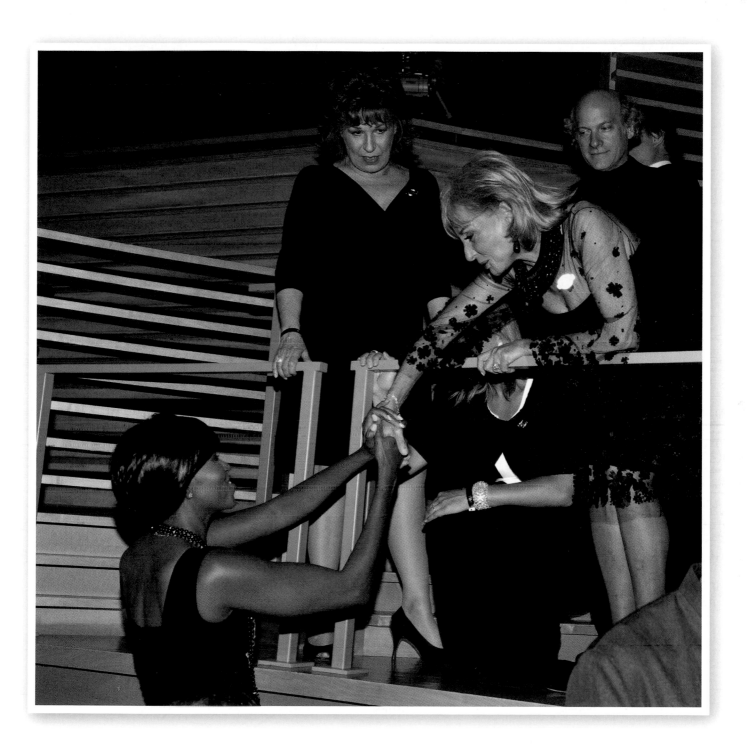

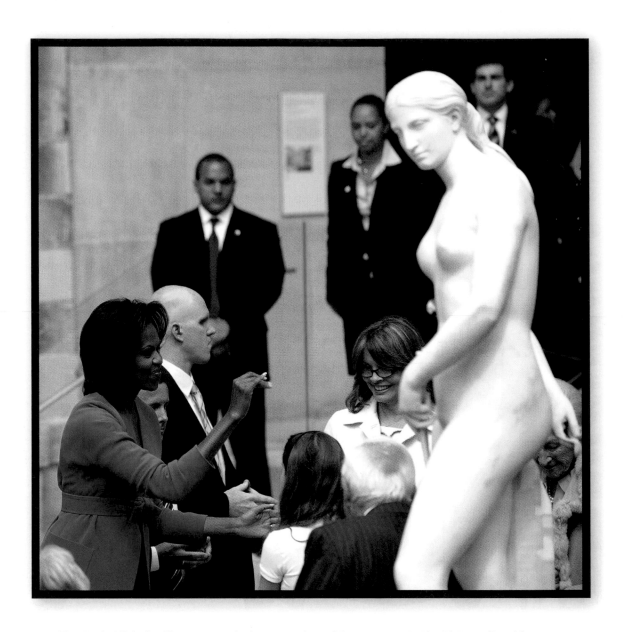

First Lady Michelle Obama attends the reopening of the entrance to the Metropolitan Museum of Art's American Wing, the Charles Engelhard Court, in New York City on May 18, 2009. Obama wears a sheath and coat from the prefall 2009 collection of Isaac Mizrahi.

———————————————————

OPPOSITE: Michelle Obama cuts the ribbon that officially opens the newly renovated American Wing at New York's Metropolitan Museum of Art on May 18, 2009. In her remarks, she said that she and the president believe in the importance of children feeling welcomed at museums like this one. "We want all children who believe in their talent to see a way to create a future for themselves in the arts community, be it as a hobby or as a profession," she said.

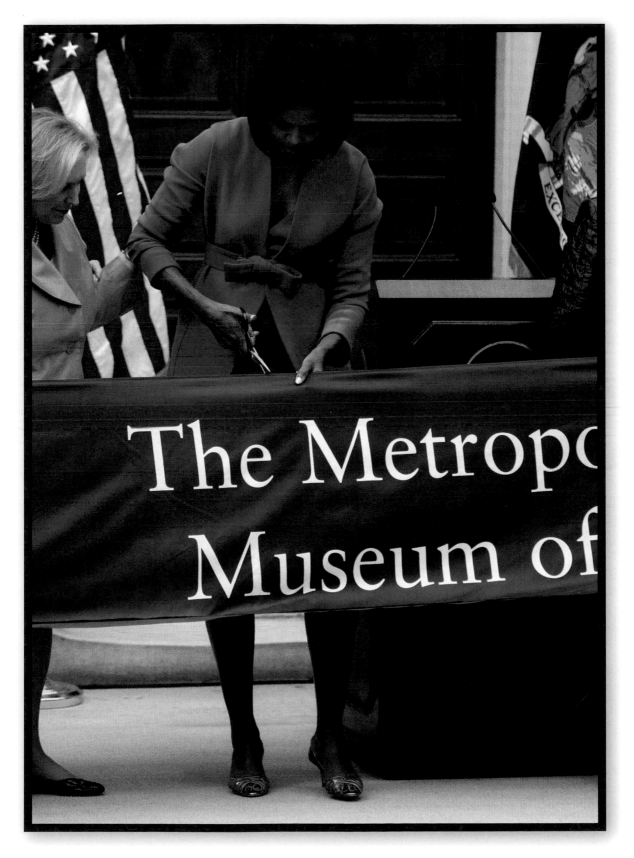

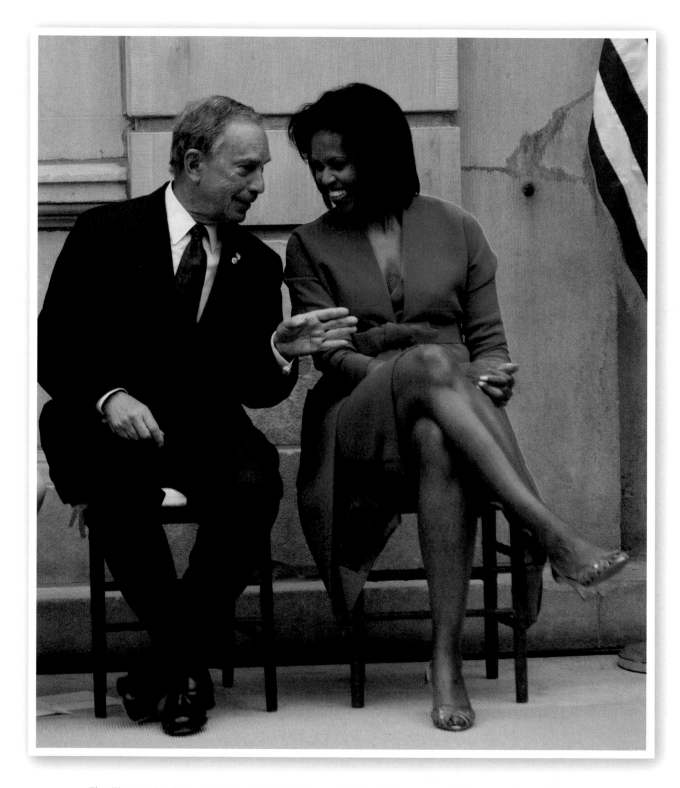

The First Lady chats with New York City Mayor Michael Bloomberg at the reopening of the entrance to the Metropolitan Museum of Art's American Wing, May 18, 2009.

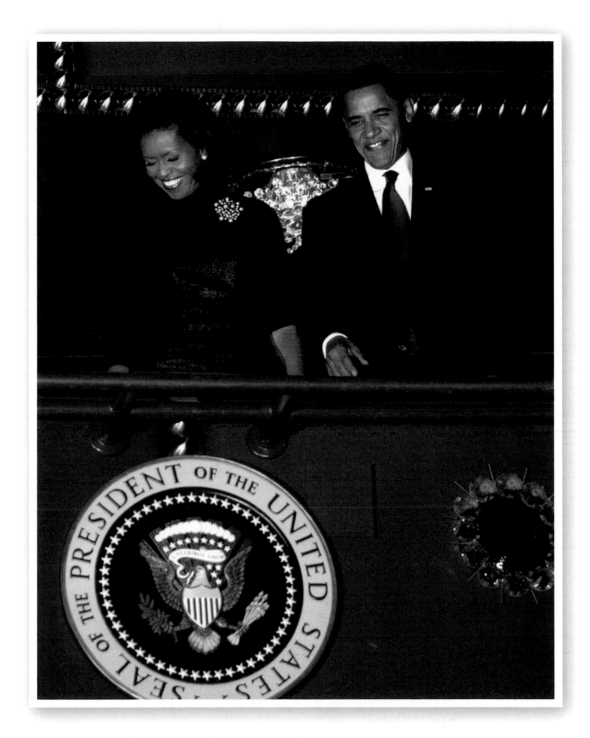

President Barack Obama and the First Lady greet the audience from the Presidential Box at the Kennedy Center in Washington on February 6, 2009. Malia and Sasha Obama (not pictured) accompanied their parents to the Kennedy Center. The sold-out event was a celebration of the Alvin Ailey Dance Theater's fiftieth anniversary.

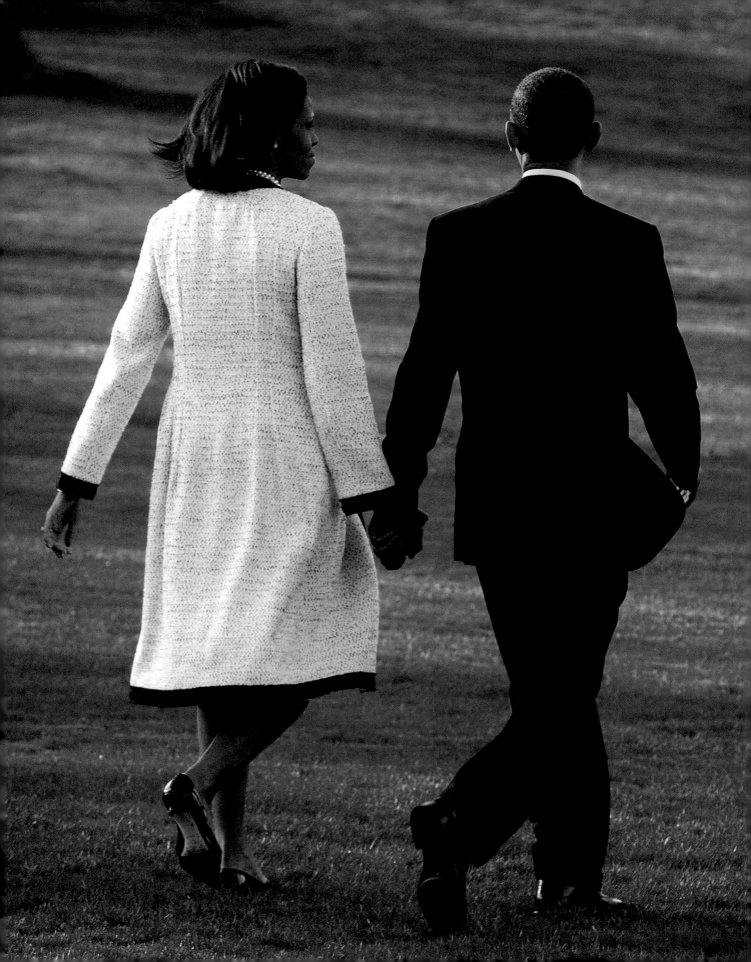

President Obama and the

First Lady depart for Europe on

March 31, 2009.

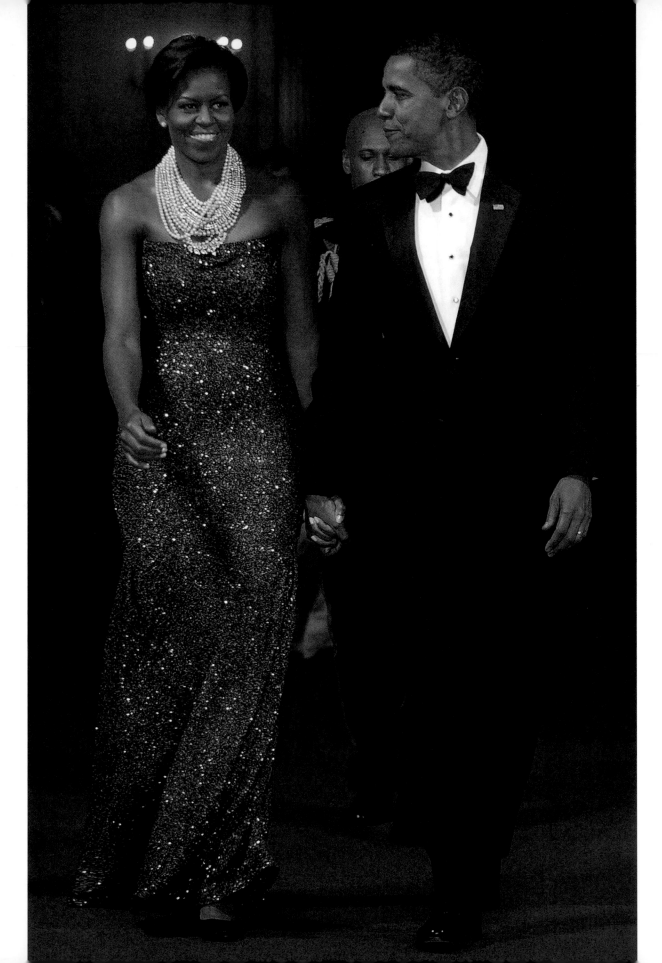

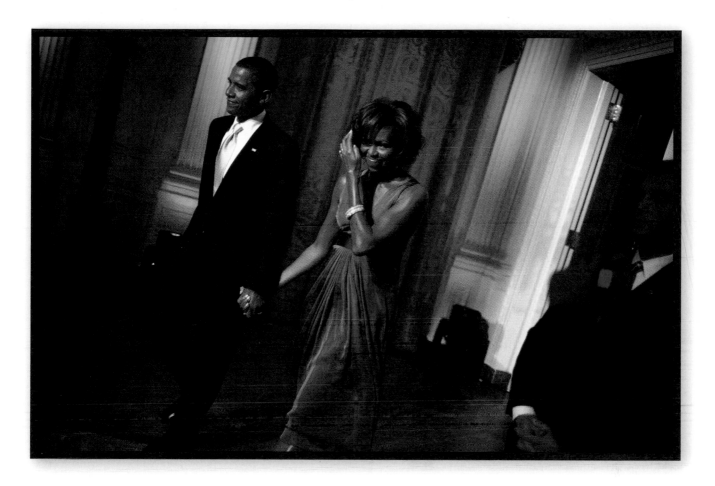

The First Couple arrives for a taping of "Stevie Wonder in Performance at the White House: The Library of Congress Gershwin Prize" in the East Room on February 25, 2009. This was the first "In Performance at the White House" program of the Obama administration.

OPPOSITE: President and Mrs. Obama at the 2009 Governors' Dinner in the State Dining Room of the White House on February 22. Here, accompanied by governors and their spouses, they make their way to the East Room for an after-dinner performance by the band Earth, Wind & Fire.

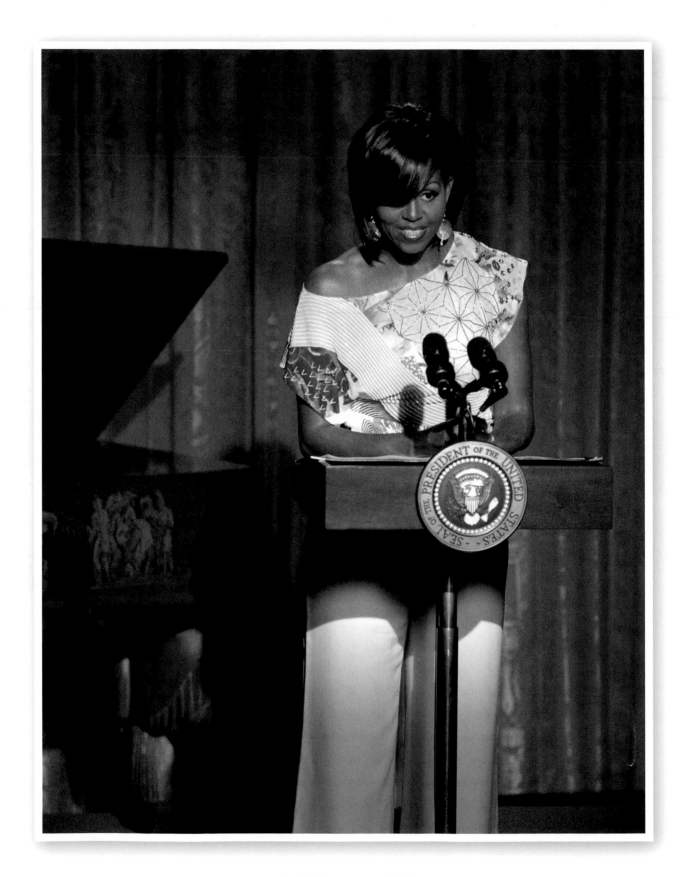

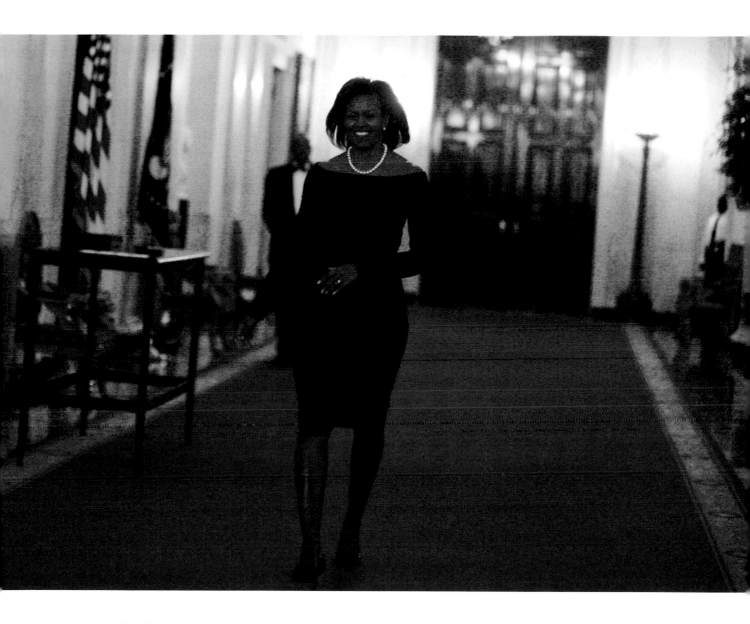

Michelle Obama, wearing a dress designed by Narciso Rodriguez, walks through Cross Hall, on the first floor of the White House, en route to a dinner in honor of Women's History Month.

———————

OPPOSITE: Michelle Obama addresses invited guests at the inaugural White House event, "An Evening of Poetry, Music and the Spoken Word," in the East Room , May 12, 2009. "I've wanted to do this from Day One," the First Lady told her audience. "It's another way to open the White House and to make it the people's home." Featured performers included: actor James Earl Jones; writer Michael Chabon; his wife, writer Ayelet Waldman; vocalist Esperanza Spalding; pianist Eric Lewis; actor/writer Lin Manuel Miranda; and poet, writer, and performer Mayda del Valle.

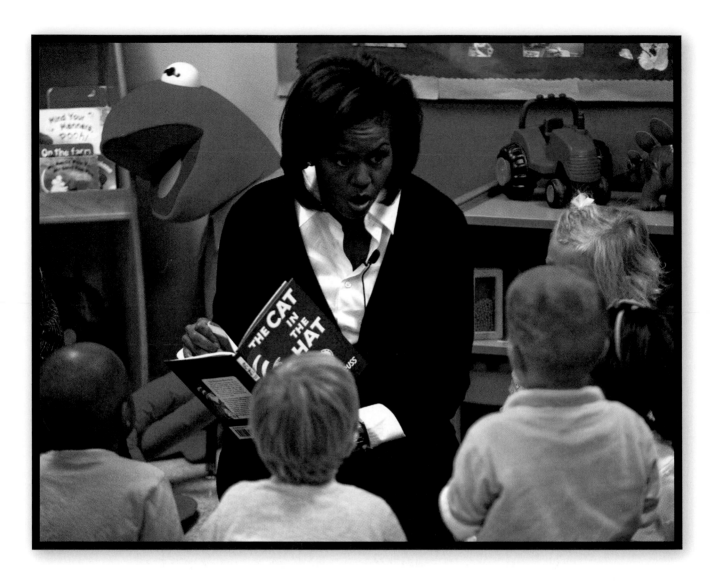

The First Lady entertains children at the Prager Child Development Center at Fort Bragg, NC, with a reading of the Dr. Seuss classic *The Cat in the Hat,* on March 12, 2009. Mrs. Obama spoke to families about her husband's plans to improve military housing and child care.

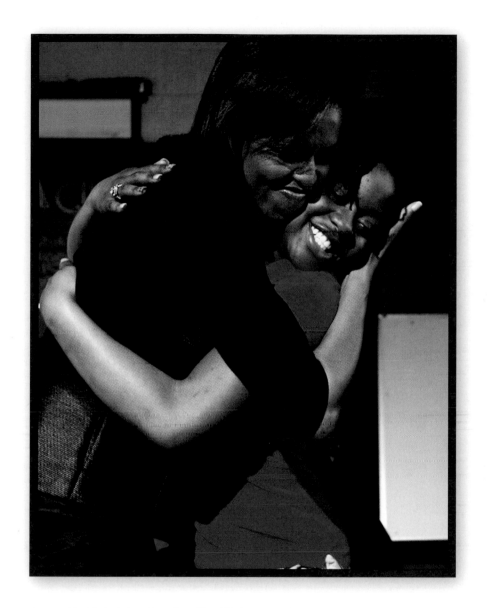

Anacostia High School student Truddie Dee Hawkins receives a patented First Lady hug on March 19, 2009, during Mrs. Obama's surprise visit to the school for Women's History Month.

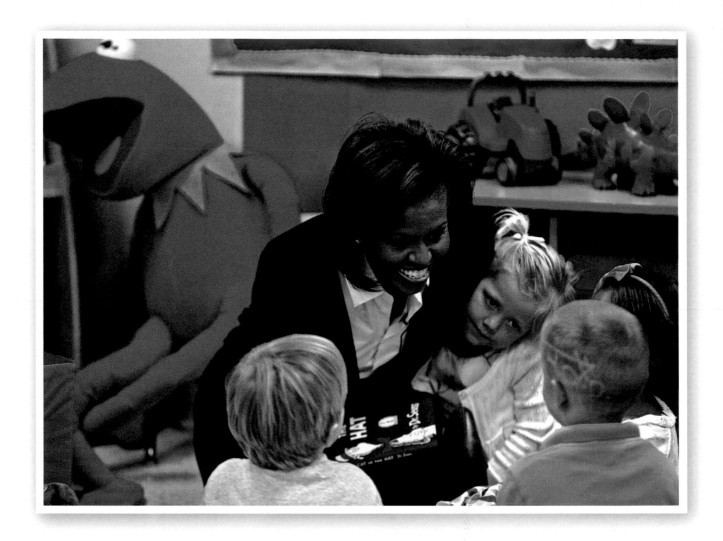

First Lady Michelle Obama snuggles with a young fan during her visit to the Prager Child Development Center at Fort Bragg, NC, on March 12, 2009.

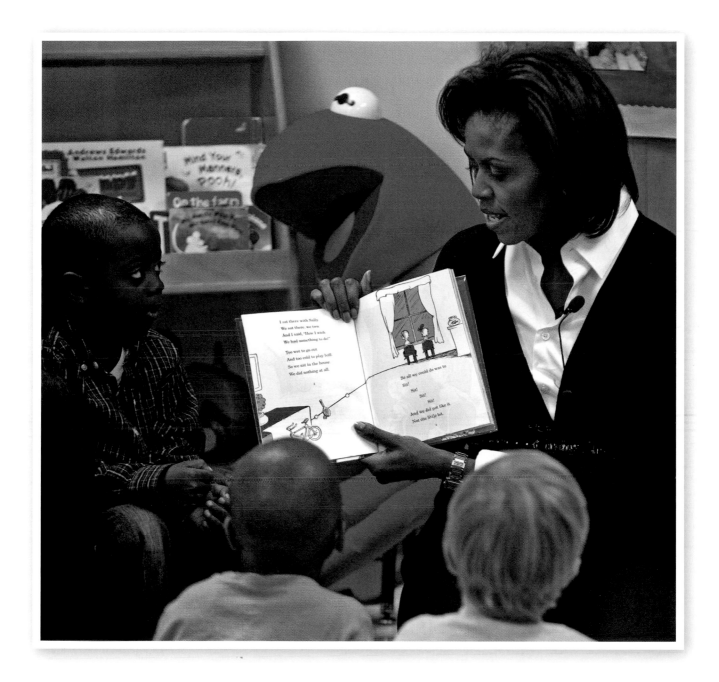

Even Kermit the Frog seems enchanted by Mrs. Obama's rendition of Dr. Seuss's *The Cat in the Hat* at the Prager Child Development Center at Fort Bragg on March 12, 2009.

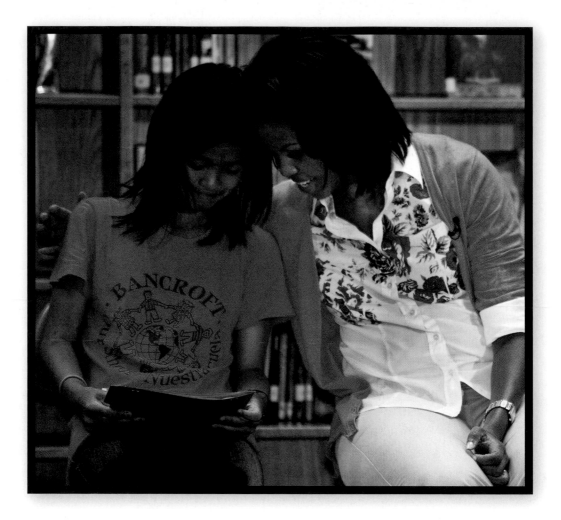

The First Lady greets forty fifth-grade fans in the library at the Bancroft Elementary School in Washington, DC, on May 29, 2009. Students at the school—which has its own established organic garden—had helped Mrs. Obama plant the vegetable garden at the White House a few months earlier, and the First Lady came to return the favor by planting a dozen cucumbers and four red bell-pepper plants in the school's garden. Four students were chosen to read to the First Lady their own words on gardening. Tammy Nguyen (pictured) discussed the carrot. "Here at Bancroft, we are big fans of carrots," she said. "We are also fans of the first lady."

———————————————

OPPOSITE: First Lady Michelle Obama accepts a handmade Native American shawl from Nedra Darling, director of public affairs for the Bureau of Indian Affairs and member of the Prairie Band of the Potawatomi tribe, during a visit with employees at the Department of the Interior in Washington on February 9, 2009. Interior Secretary Ken Salazar said the shawl honored a woman of high achievement. The Black Bear Singers, a drumming group, performed a traditional song in honor of the First Lady.

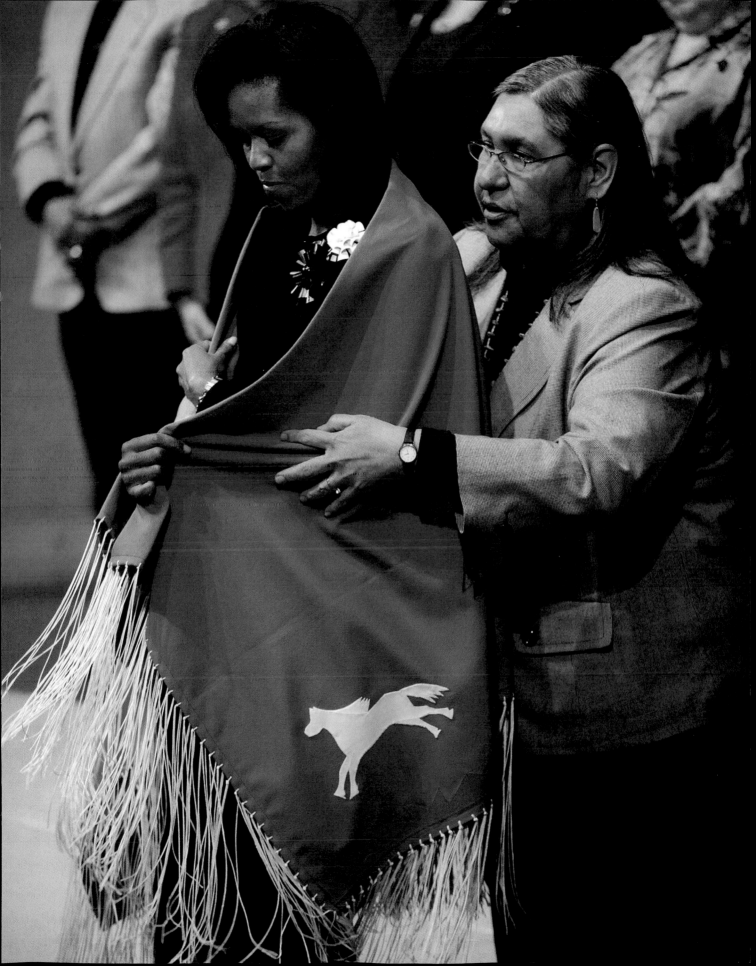

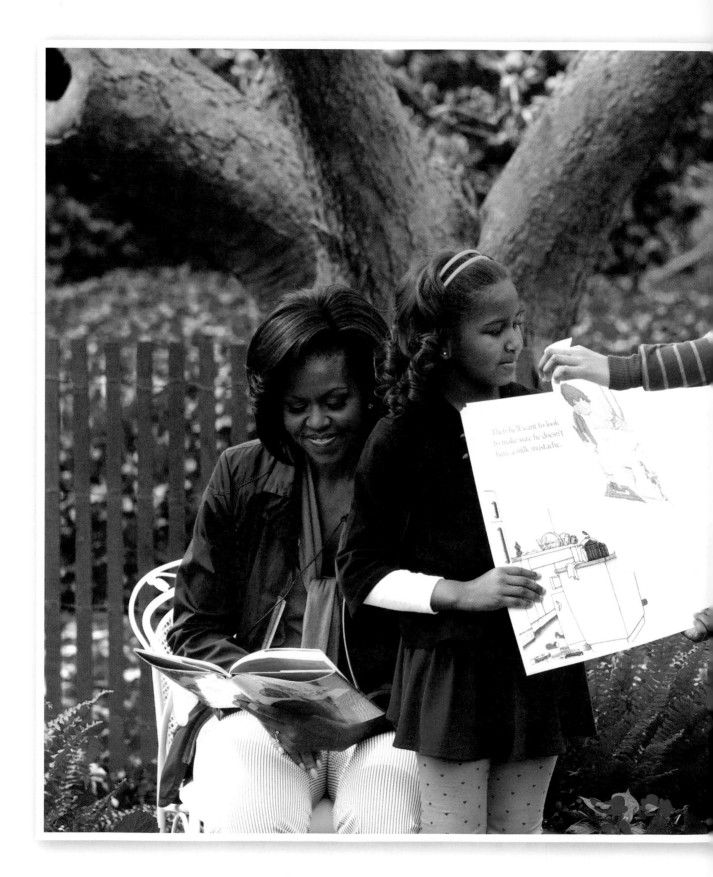

Mrs. Obama and her mother, Marian Robinson (not pictured), take turns reading *If You Give a Mouse a Cookie,* by Laura Joffe Numeroff, at the annual White House Easter Egg Roll on the South Lawn of the White House on April 13, 2009. Sasha and Malia turn the pages of an oversize copy of the book to show the illustrations. The theme of the day was "Let's go play," and the focus was on nutritious food, physical exercise, and healthy living—issues that Mrs. Obama has placed at the top of her list of policy interests.

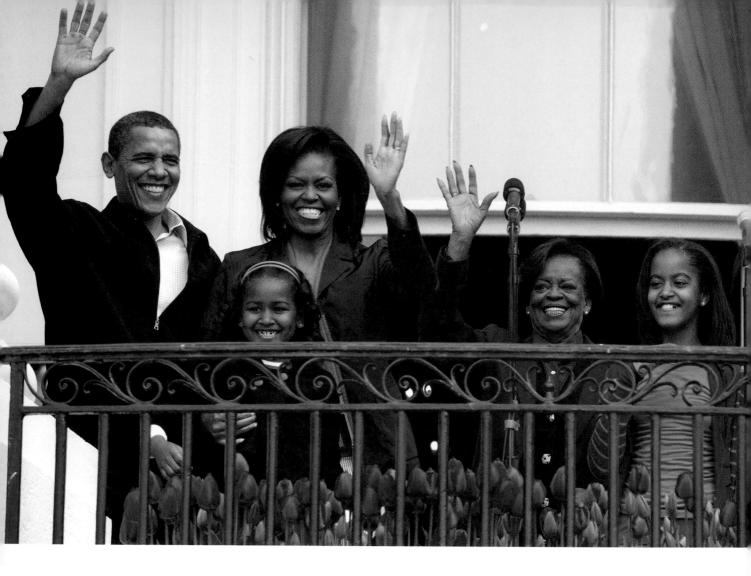

The First Family, including Marian Robinson, Michelle's mother, waves to onlookers during the annual White House Easter Egg Roll on the South Lawn on April 13, 2009. More than 30,000 families from forty-five states, as well as residents of Washington, DC, attended the event, a tradition since 1878. The Obamas brought the event up to date by allocating tickets for gay and lesbian families for the first time.

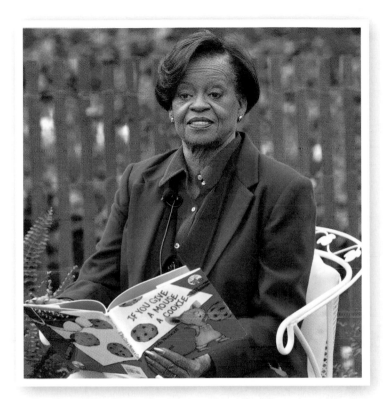

Marian Robinson, the First Lady's mother, takes her turn reading *If You Give a Mouse a Cookie,* by Laura Joffe Numeroff, at the April 13, 2009, Easter Egg Roll at the White House.

First Lady Michelle Obama walks with her daughter Malia during the annual Easter Egg Roll on the South Lawn of the White House, April 13, 2009.

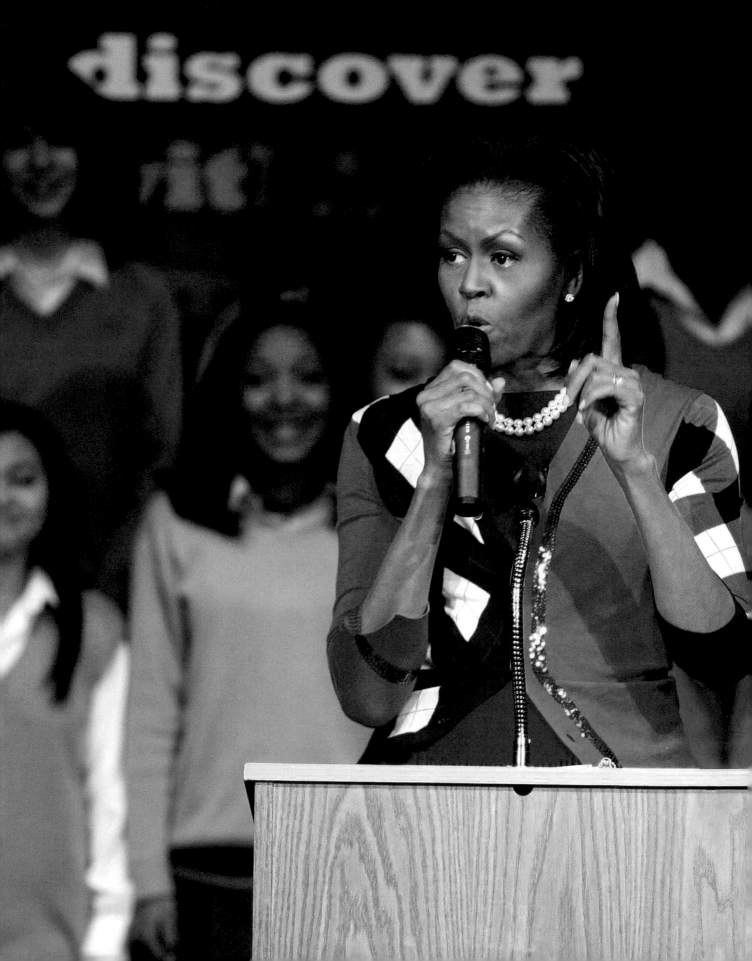

The First Lady surprises students at the Elizabeth Garrett Anderson Secondary School in London, England, on April 2, 2009. The girls had no idea they would be playing host to the First Lady that day, which was the culmination of the Obamas' first visit to England, where world leaders gathered at London's Docklands for the G20 summit on "Financial Markets and the World Economy."

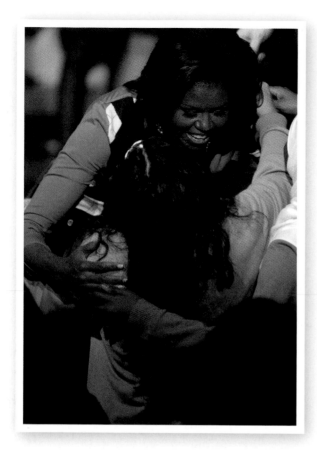

"She hugged us!" said fifteen-year-old Nuria Afonso. "Can you believe that? She. Hugged. Us! It was amazing. Amazing." Like all the other members of the choir at Elizabeth Garrett Anderson Secondary School, Afonso had been informed only that she would be performing for a "very special guest."

"All of you are jewels," said Mrs. Obama after the choir at Elizabeth Garrett Anderson Secondary School performed in her honor on April 2, 2009. The students were as moved by the event as the First Lady was. "I mean, out of 2,500 schools in London, Michelle Obama chose us. That makes us feel pretty special, I tell you," said sixteen-year-old soloist Brenda Mensah.

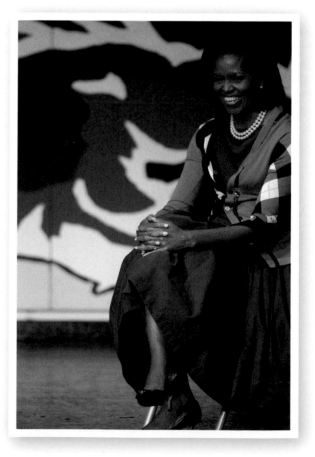

Students spent weeks preparing for a performance that dazzled the First Lady, who appeared to tear up during her remarks. Twenty percent of the students at Elizabeth Garrett Anderson Secondary School are the children of refugees or asylum-seekers; fifty-five languages are spoken at the school. Characteristically, the press focused its comments on the First Lady's wardrobe, particularly the blue argyle cardigan she wore during her visit. Three days after the event, the sweater was the topic of 1,925 of its own news articles.

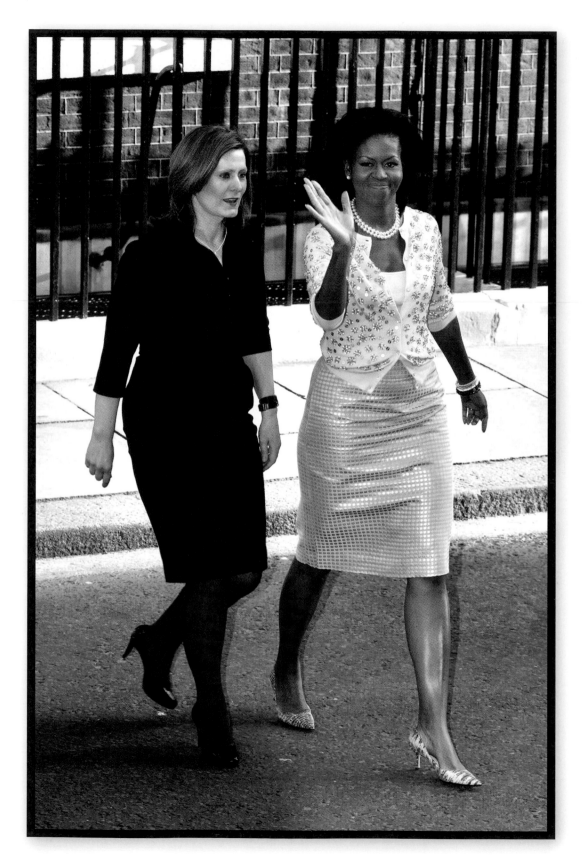

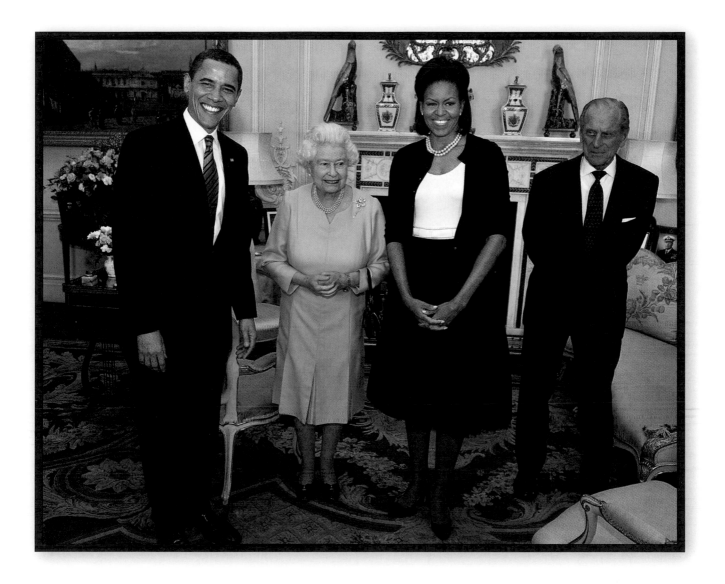

President Barack Obama and First Lady Michelle Obama pose for a photograph with Queen Elizabeth II and Prince Philip, the Duke of Edinburgh, at Buckingham Palace in London on April 1, 2009. The queen hosted the Obamas during their visit to London, where the president was attending the G20 summit. It was during this palace meeting that the queen strayed from protocol and reciprocated the First Lady's show of affection by briefly wrapping her arm around Mrs. Obama.

———————————————

OPPOSITE: The First Lady is pictured here on April 1, 2009, with Sarah Brown, wife of British Prime Minister Gordon Brown, outside of 10 Downing Street in London, where their husbands held talks on the eve of the G20 summit meeting on the global economy.

Michelle Obama is shown here with Sarah Brown (right), wife of British Prime Minister Gordon Brown, and Laura Lee, CEO of Maggie's Cancer Caring Centres, in London on April 1, 2009. It was the first birthday for this center, which Mrs. Brown opened in 2008. The First Lady had a private session with the family of a cancer patient and presented a gift to Laura Lee. "This is pretty incredible," said Obama. "It's an oasis that's necessary for people who are struggling."

OPPOSITE: President Barack Obama kisses the First Lady during a town hall meeting at Rhenus Sports Arena in Strasbourg, eastern France, on April 3, 2009. President Obama spoke to the crowd about the urgent need to combat global warming. When a woman in the audience asked whether he ever regretted running for president, he joked, "Michelle definitely asks that question."

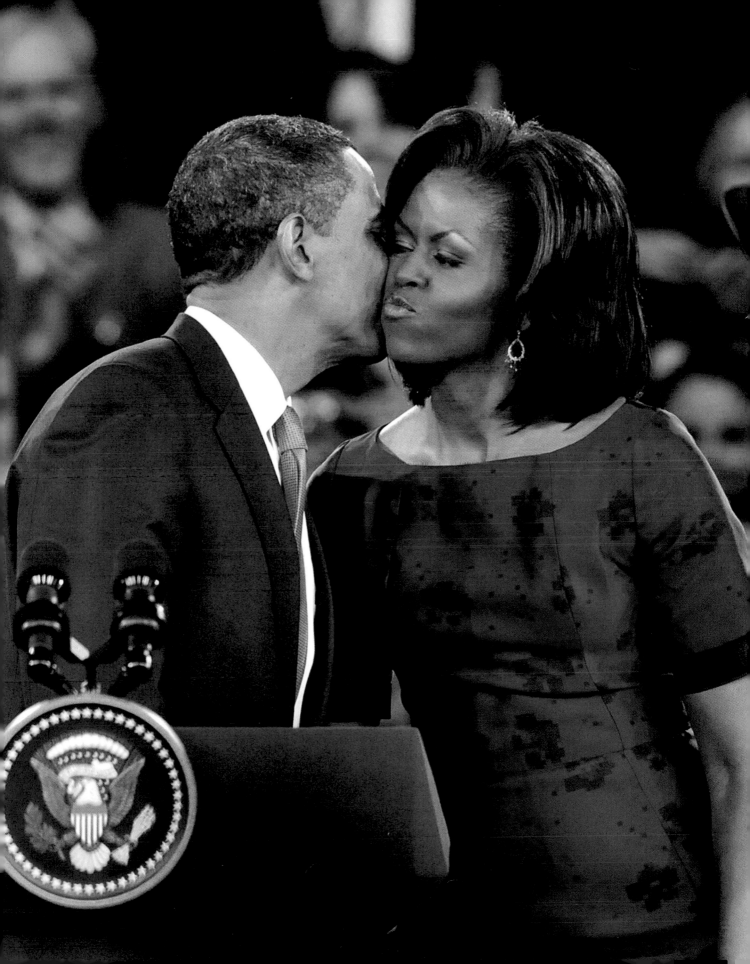

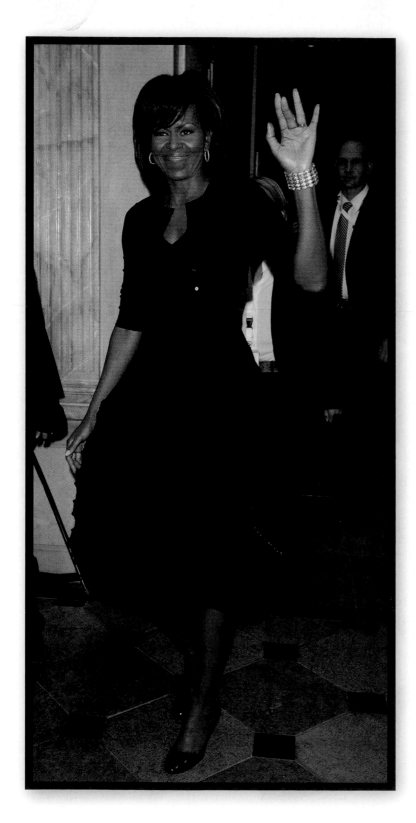

First Lady Michelle Obama waves to onlookers as she arrives to attend the spouses' evening on April 3, 2009, in Baden-Baden, Germany. President Obama, along with other heads of state of the twenty-eight NATO member countries, was participating in the NATO summit in Strasbourg (France), Kehl (Germany), and Baden-Baden to mark the sixtieth anniversary of the transatlantic military and political organization. The First Lady impressed the crowd in an outfit by French designer Azzedine Alaia, a choice some saw as a way of honoring one of the two host countries.

OPPOSITE PAGE: First Lady Michelle Obama stands with France's First Lady, Carla Bruni-Sarkozy, at the start of the NATO summit on April 3, 2009, in Strasbourg, France.

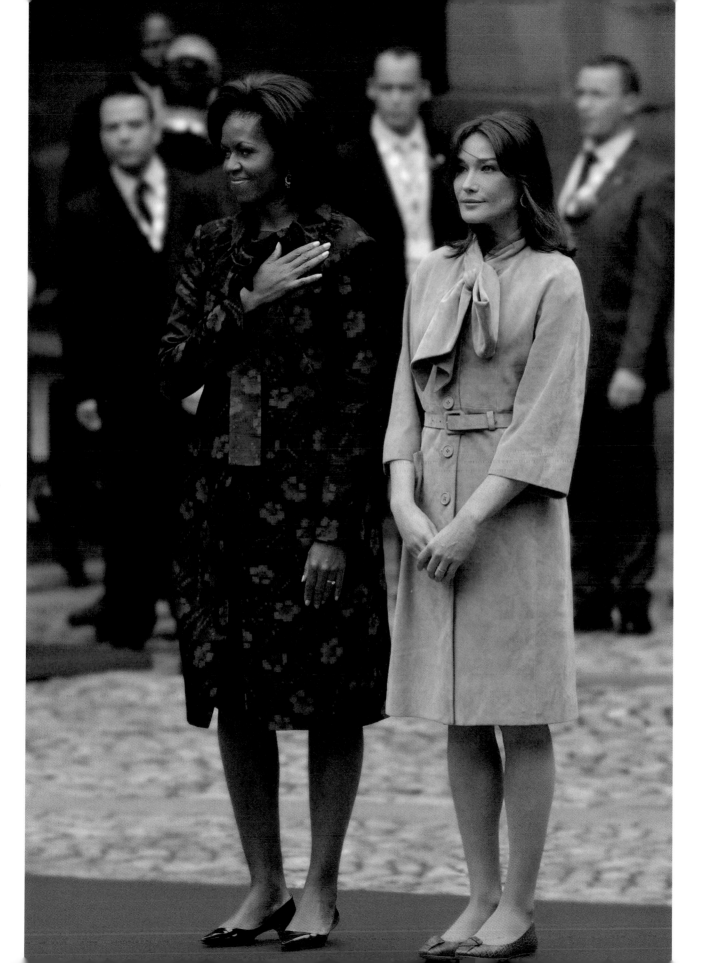

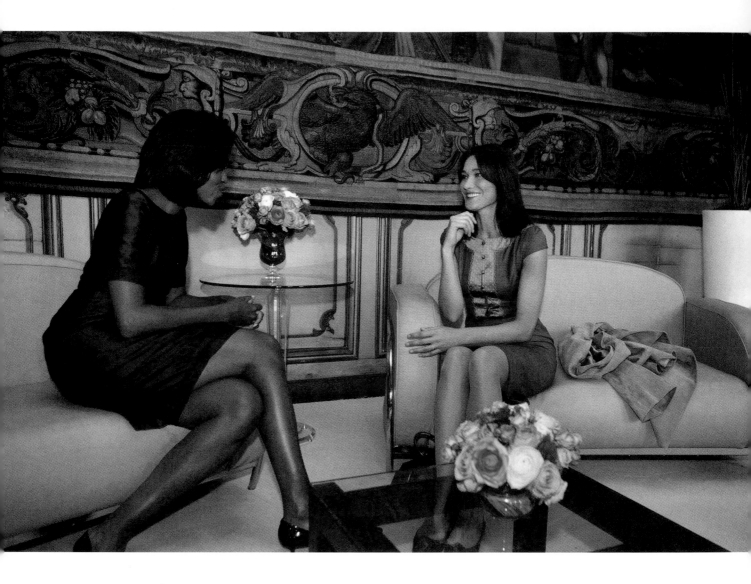

"The first encounter between two of the world's most glamorous women," read a headline on April 3, 2009, the morning of the first meeting between Michelle Obama and Carla Bruni-Sarkozy, the First Lady of France. The women got to know each other before lunch at the historic eighteenth-century Palais Rohan in Strasbourg, France.

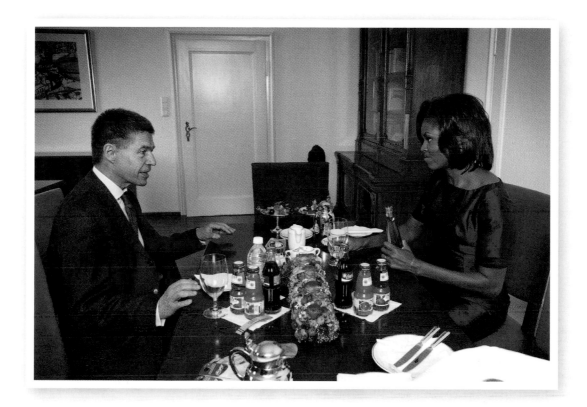

ABOVE: First Lady Michelle Obama chats with Professor Joachim Sauer, a quantum chemist and the husband of German Chancellor Angela Merkel, during the NATO summit at the Kurhaus on April 3, 2009, in Baden-Baden.

RIGHT: German Chancellor Angela Merkel invites First Lady Michelle Obama to sign the Golden Book of the city of Baden-Baden, Germany, on the occasion of President Barack Obama's arrival for bilateral talks on April 3, 2009, in Baden-Baden.

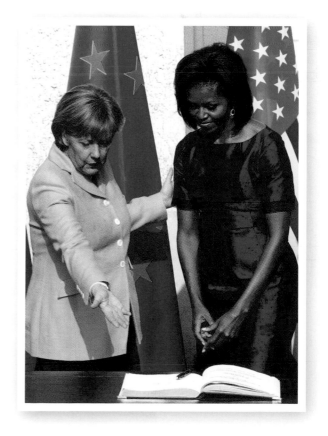

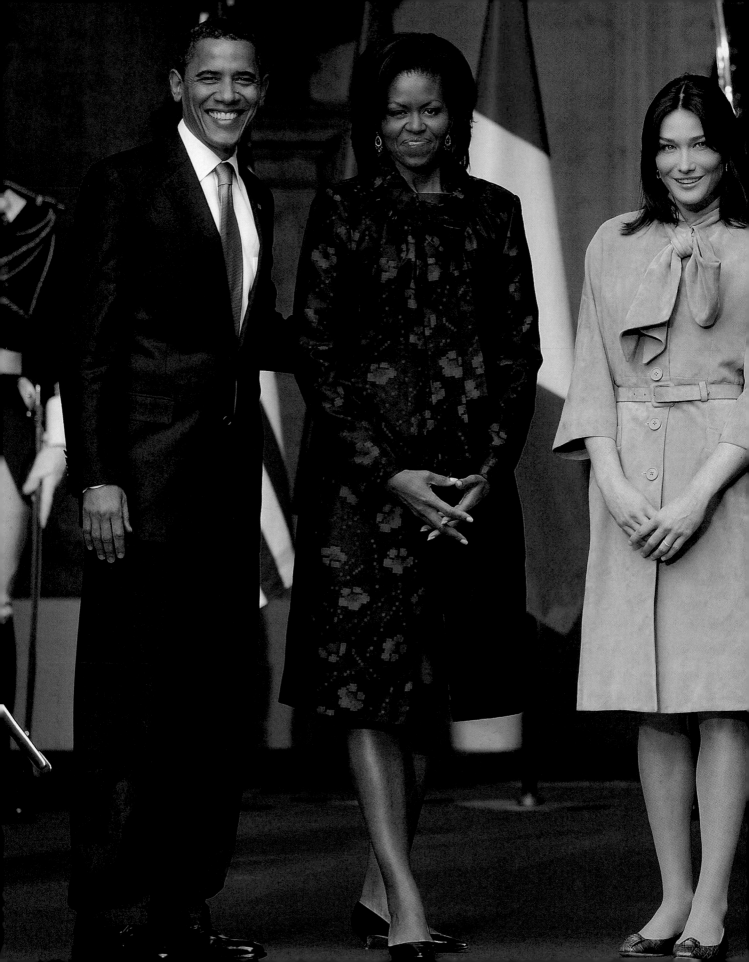

President Barack Obama,
First Lady Michelle Obama,
France's First Lady
Carla Bruni-Sarkozy, and
French President
Nicolas Sarkozy pose for
photographers in the courtyard
of the Palais Rohan on
April 3, 2009, in Strasbourg.

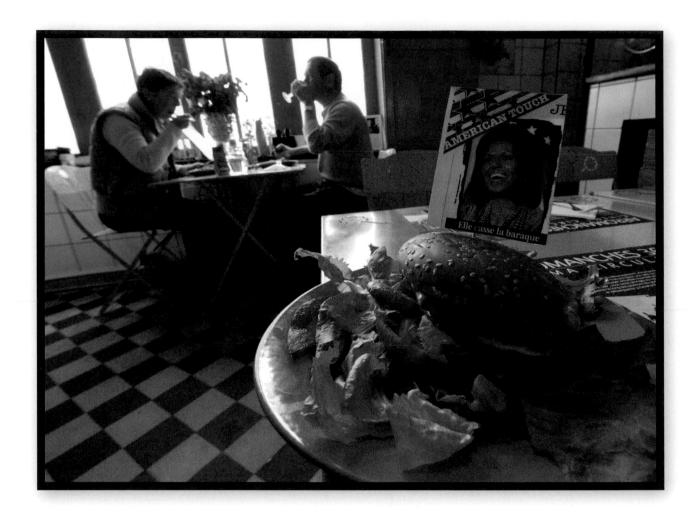

A photograph of Michelle Obama stands next to an "Obama Special Burger," proudly displayed in a snack bar in Colleville-sur-Mer, France, on April 7, 2009. Didier Touati, the proprietor of the snack bar, claims that the American specialty is based on a recipe by Michelle Obama herself.

OPPOSITE: First Lady Michelle Obama strides to the Palais Rohan in Strasbourg on April 4, 2009. Style-watchers noted that Mrs. Obama wore a fitted Azzedine Alaia jacket over black knit pants as her only pants outfit during the European trip.

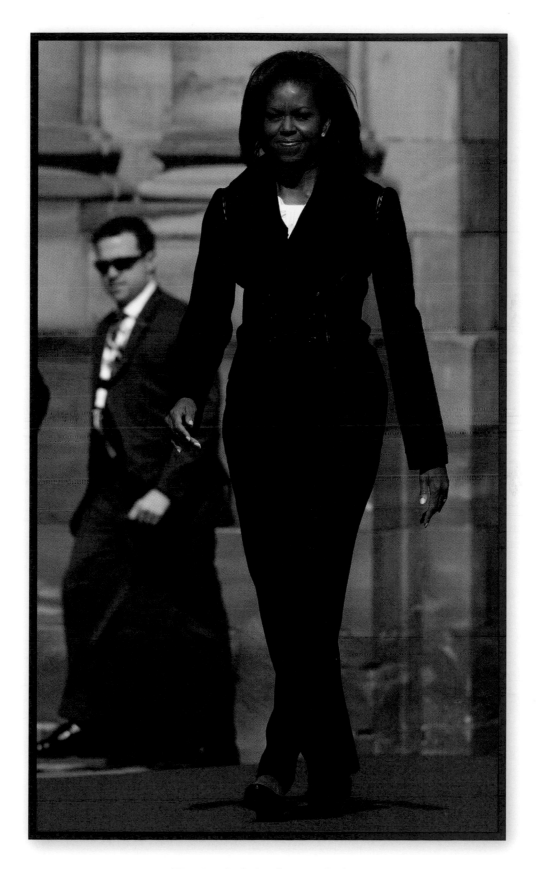

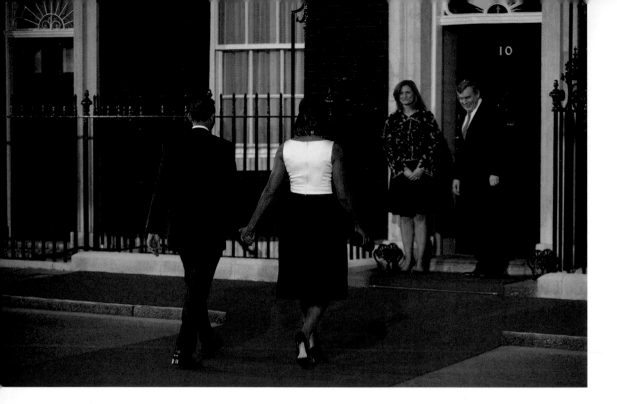

ABOVE: President and Mrs. Obama arrive on April 1, 2009, at 10 Downing Street in London, where they are greeted by British Prime Minister Gordon Brown and his wife, Sarah. The two leaders held a working dinner prior to the G20 summit on the global economy.

———————————

RIGHT: Presidents Barack Obama and Nicolas Sarkozy focus on their wives, Michelle Obama and Carla Bruni-Sarkozy, during the NATO summit arrival ceremony at the Palais Rohan on April 3, 2009, in Strasbourg.

———————————

OPPOSITE: Barack and Michelle Obama greet a crowd of 20,000 or more prior to the president's speech at Hradcanske Square in Prague, Czech Republic, on April 5, 2009, at the end of a weeklong trek across Europe. The First Lady received an overwhelmingly positive response along the route, which stretched from London to Turkey. Senior Political Advisor David Axelrod said that President Obama, whose approval ratings were not as high as his wife's, was content to bask in the First Lady's glow.

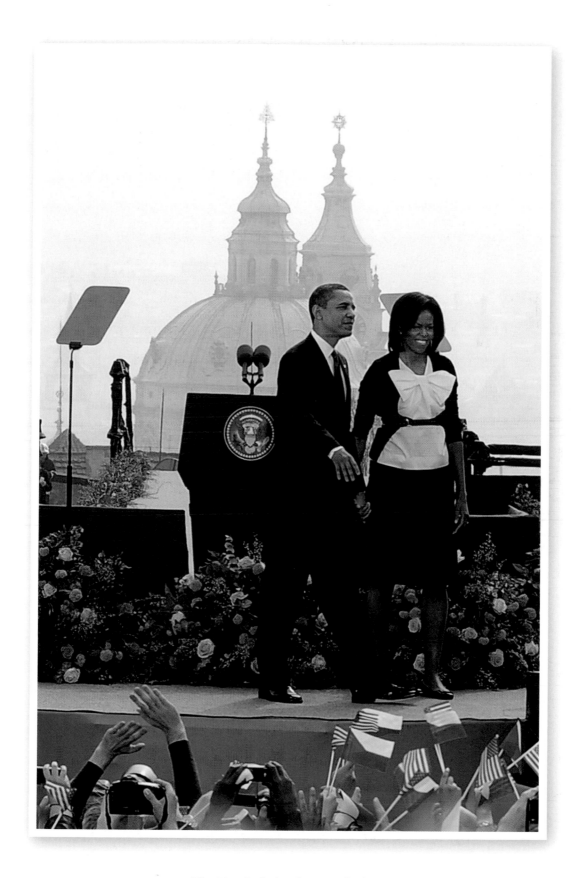

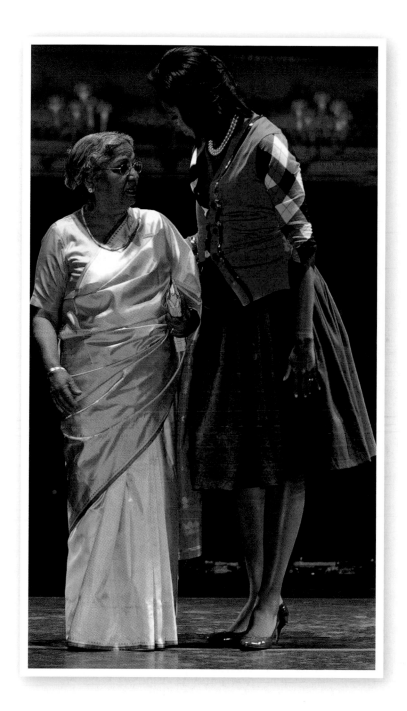

Michelle Obama talks to Gursharan Kaur, wife of Indian Prime Minister Manmohan Singh, as the G20 spouses visit the Royal Opera House in Covent Garden on April 2, 2009, in London.

OPPOSITE: First Lady Michelle Obama prepares to attend the NATO summit's spouses' evening on April 3, 2009, in Baden-Baden, Germany.

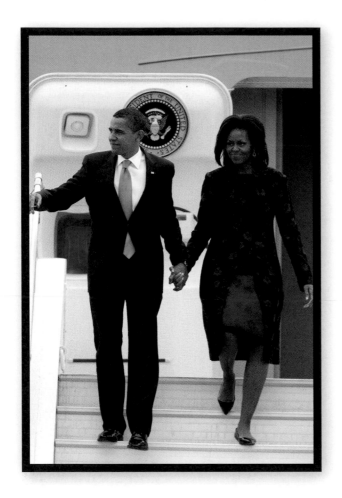

LEFT: President Barack Obama and First Lady Michelle Obama step off Air Force One in Strasbourg, France, on April 3, 2009, prior to the summit marking the sixtieth anniversary of NATO.

OPPOSITE: First Lady Michelle Obama applauds ballet dancers following a G20 spouses' visit to the Royal Opera House in Covent Garden, London, on April 2, 2009.

President Barack Obama and First Lady Michelle Obama arrive at London's Stansted Airport on March 31, 2009, to attend the G20 summit prior to his tour of Europe.

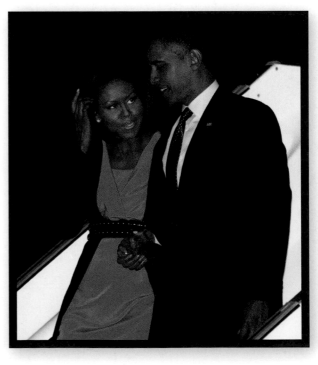

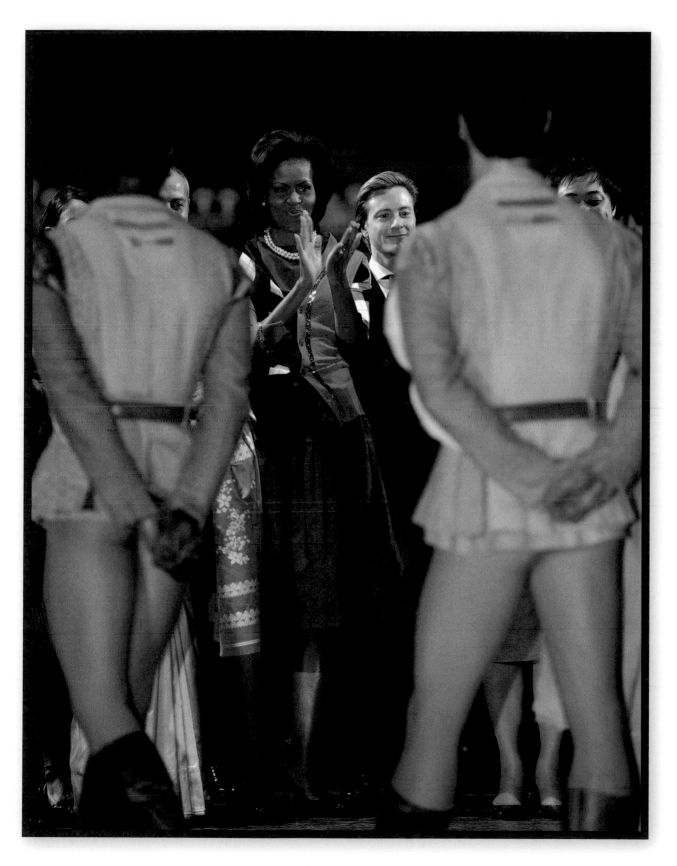

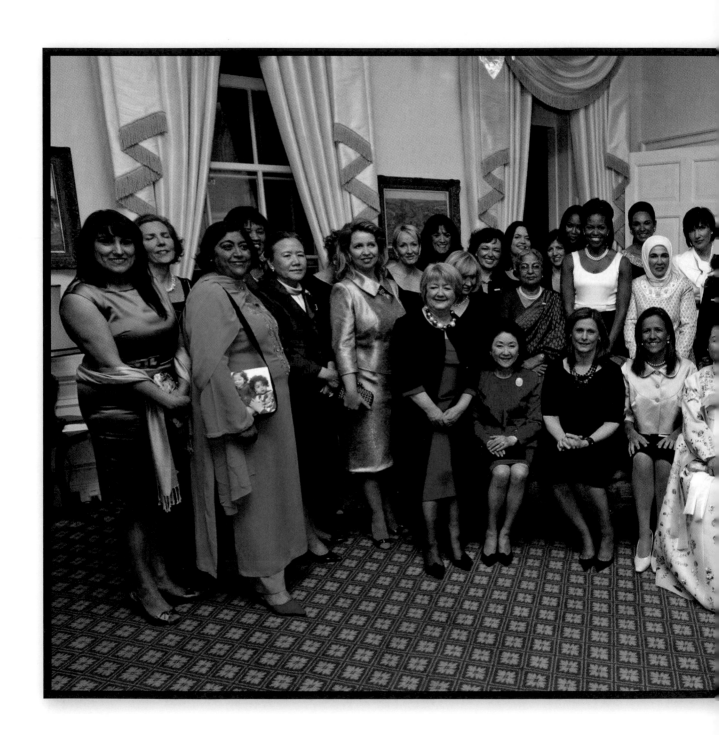

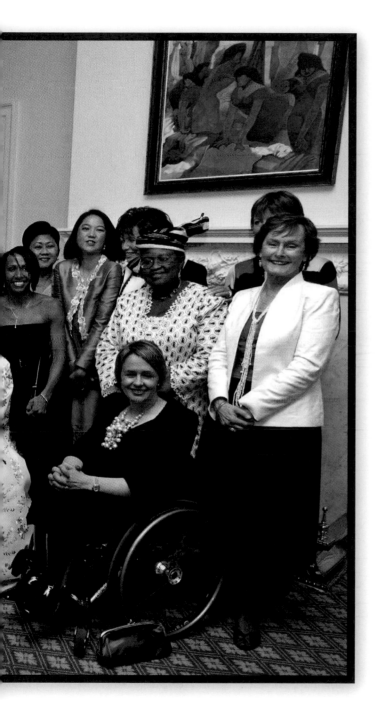

Sarah Brown (seated, center), wife of British Prime Minister Gordon Brown, poses with First Lady Michelle Obama and other G20 delegates' wives before attending a dinner at 10 Downing Street, April 1, 2009.

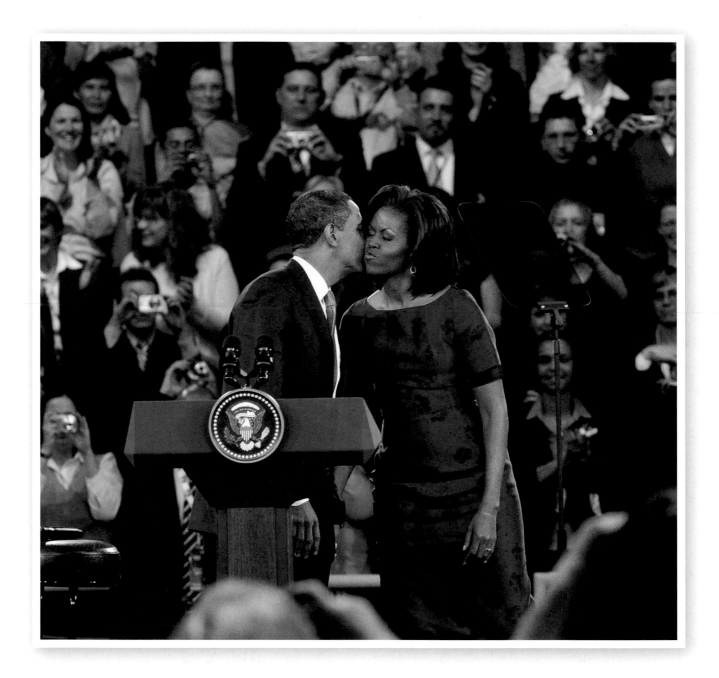

Barack Obama kisses his wife before beginning his town hall meeting with students and local residents at the Rhenus Sports Arena in Strasbourg, France, April 3, 2009, the first day of the summit marking the sixtieth anniversary of NATO.

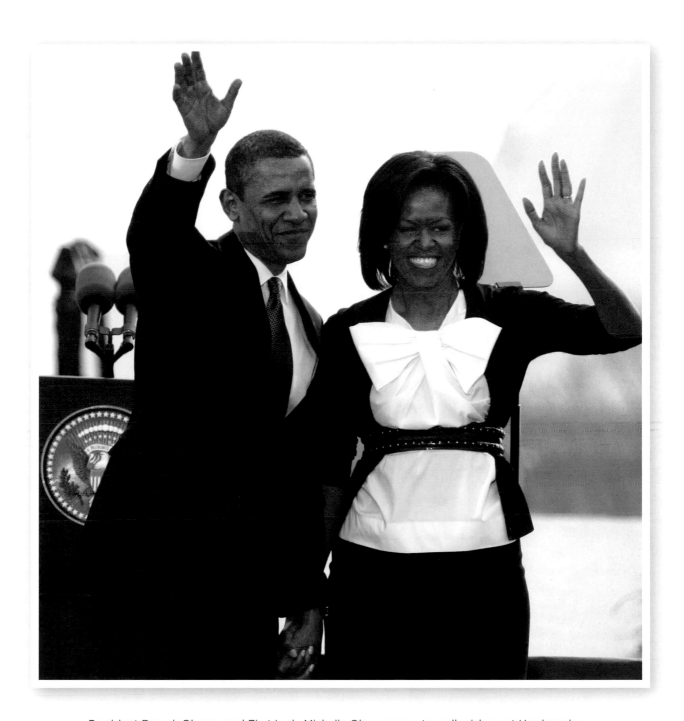

President Barack Obama and First Lady Michelle Obama wave to well-wishers at Hradcanske Square in central Prague, April 5, 2009. As long as a potential nuclear threat persists from Iran, the United States will continue pushing plans for missile defense, Obama told the thousands gathered to hear him speak.

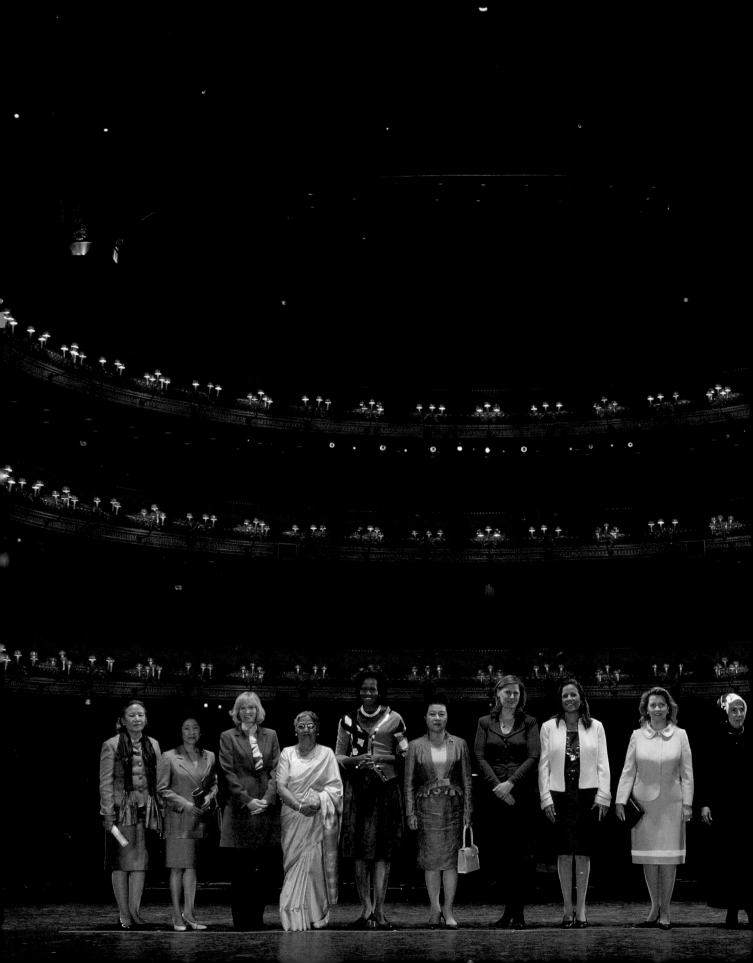

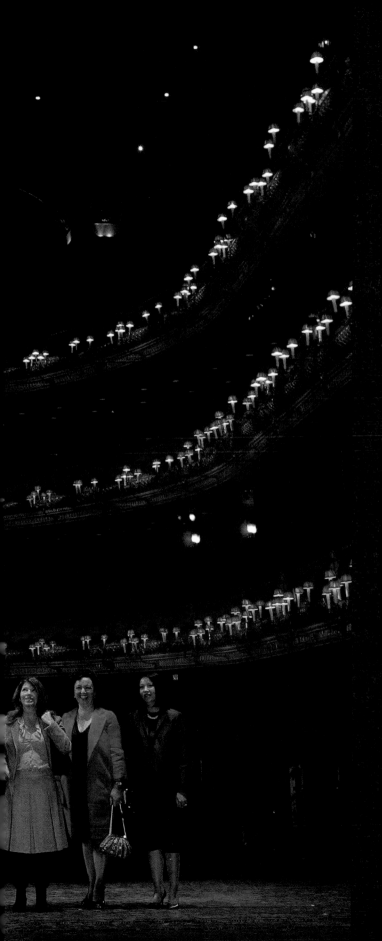

The spouses of world leaders attending the G20 summit pose together at the Royal Opera House in Covent Garden on April 2, 2009, in London. Left to right: Ban Soon-taek, wife of UN Secretary-General Ban Ki-moon; Chikako Aso, wife of Japanese Prime Minister Taro Aso; Laureen Harper, wife of Canadian Prime Minister Stephen Harper; Gursharan Kaur, wife of Indian Prime Minister Manmohan Singh; Michelle Obama, wife of U.S. President Barack Obama; Kim Yoon-ok, wife of South Korean President Lee Myung-bak; Sarah Brown, wife of British Prime Minister Gordon Brown; Margarita Zavala, wife of Mexican President Felipe Calderón; Svetlana Medvedeva, wife of Russian President Dmitry Medvedev; Emine Erdoğan, wife of Turkish Prime Minister Recep Tayyip Erdoğan; Margarida Barroso, wife of José Manuel Barroso, president of the European Commission; Thérèse Rein, wife of Australian Prime Minister Kevin Rudd; and Dr. Pimpen Vejjajiva, wife of Thai Prime Minister Abhisit Vejjajiva.

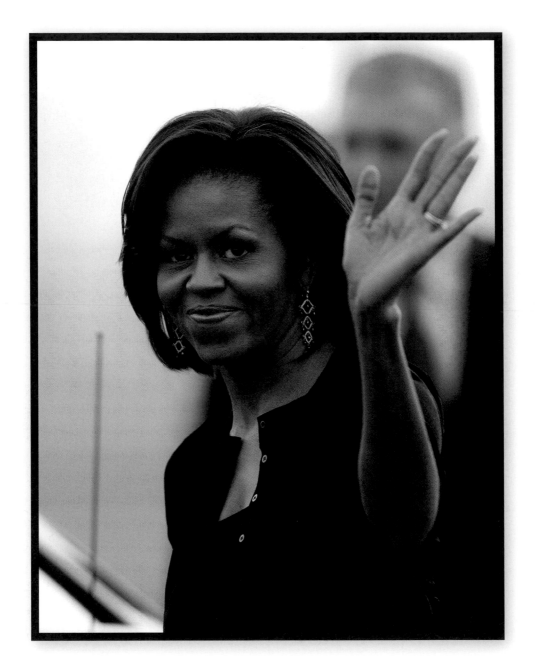

Michelle Obama waves upon arrival at Prague airport, Czech Republic, on April 4, 2009. The following day, President Obama attended a summit between the United States and the twenty-seven members of the European Union in Prague.

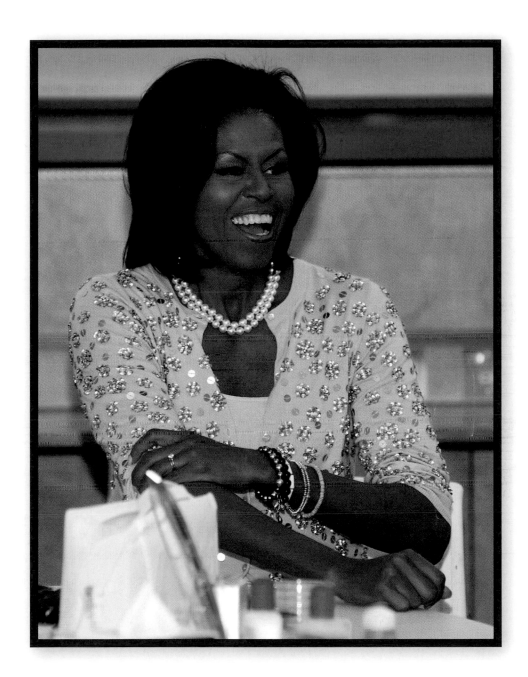

First Lady Michelle Obama laughs with staff and patients as she visits Maggie's Cancer Caring Centre in London on April 1, 2009.

───────────────

NEXT PAGE: United States President Barack Obama and First Lady Michelle Obama walk in the Inaugural Parade in Washington, DC, on Tuesday, January 20, 2009.

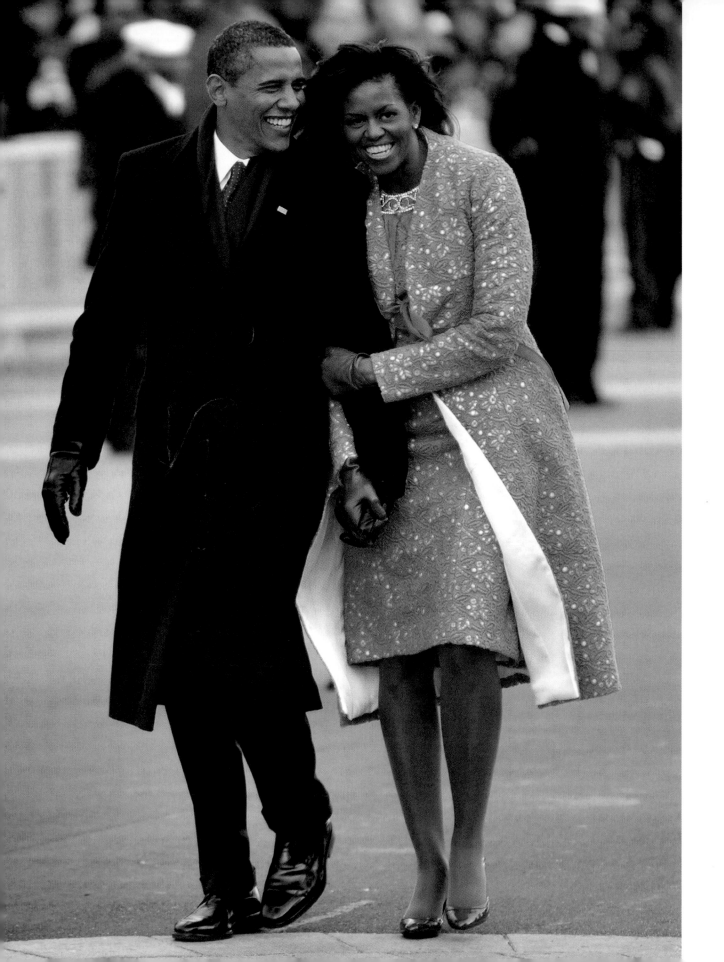

INAUGURATION

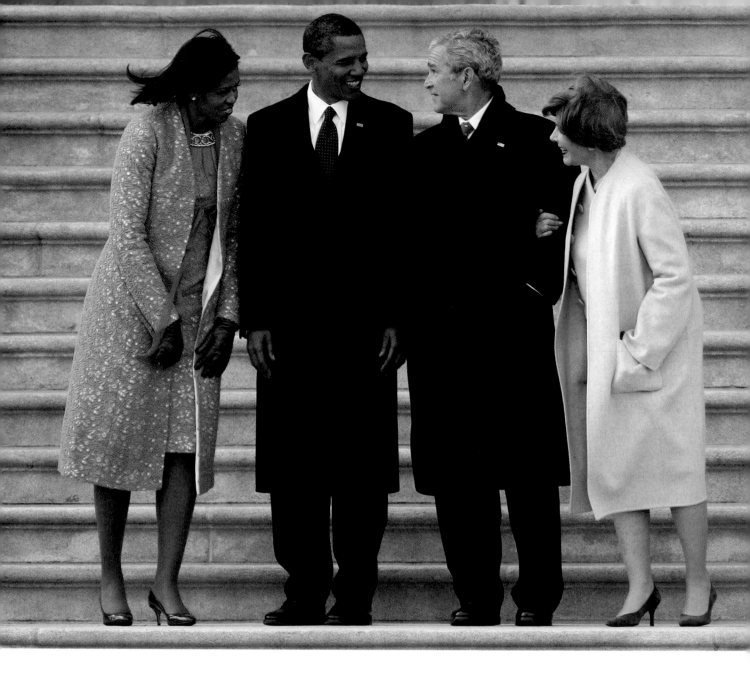

President and Mrs. Obama chat with former President George W. Bush and his wife, Laura, during the departure ceremony at the inauguration in Washington on January 20, 2009.

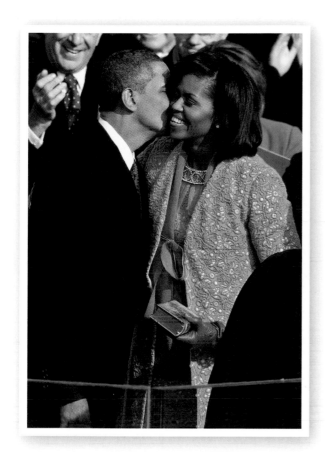

Barack Obama kisses his wife just after he is sworn in as the forty-fourth president of the United States. President Eisenhower, the thirty-fourth president, was the first to kiss his wife after the swearing-in ceremony. In 1965, Lady Bird Johnson began the custom of the First Lady's holding the Bible for her husband as he took the oath of office. (Source: Carl Sferrazza Anthony, *America's First Families: An Inside View of 200 Years of Private Life in the White House* [New York: Simon & Schuster, 2000], 28)

Vice President Joseph Biden and his wife, Jill, share thoughts with First Lady Michelle Obama and President Barack Obama on the East Front of the United States Capitol after bidding farewell to former President George W. Bush and his wife, Laura, January 20, 2009.

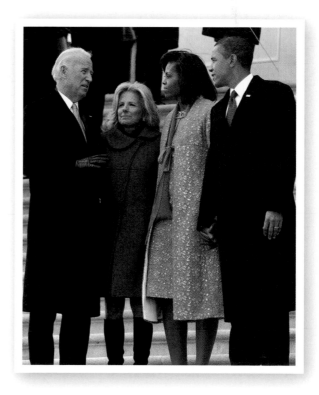

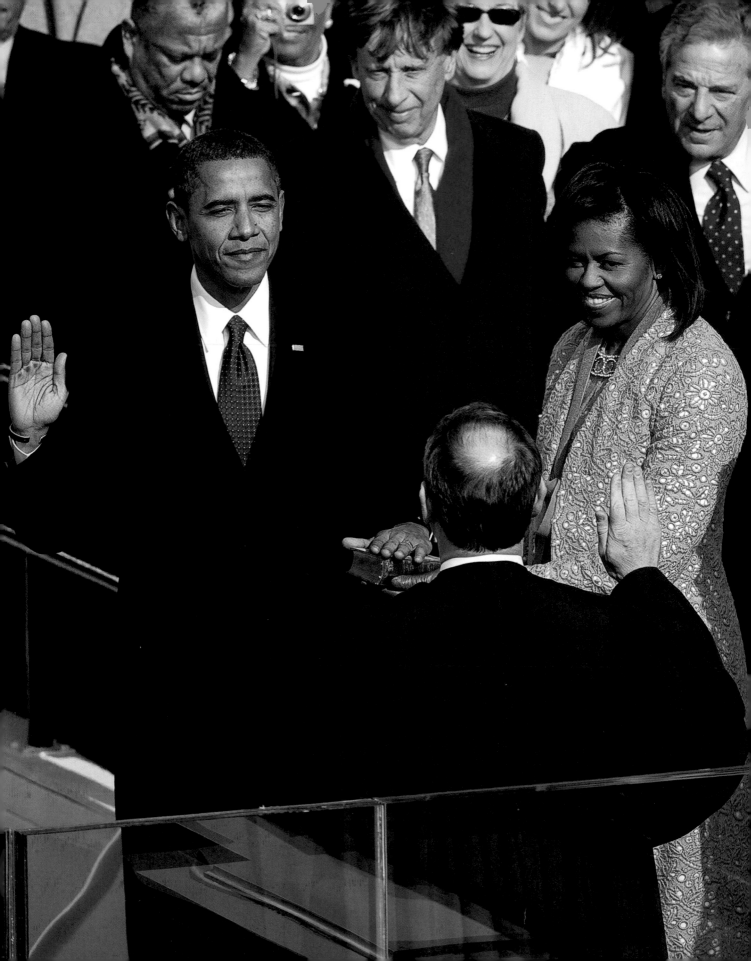

Barack Obama is sworn in by Chief Justice of the Supreme Court John Roberts as the forty-fourth president of the United States. Michelle Obama holds Abraham Lincoln's bible for the ceremony; Malia and Sasha Obama look on, January 20, 2009.

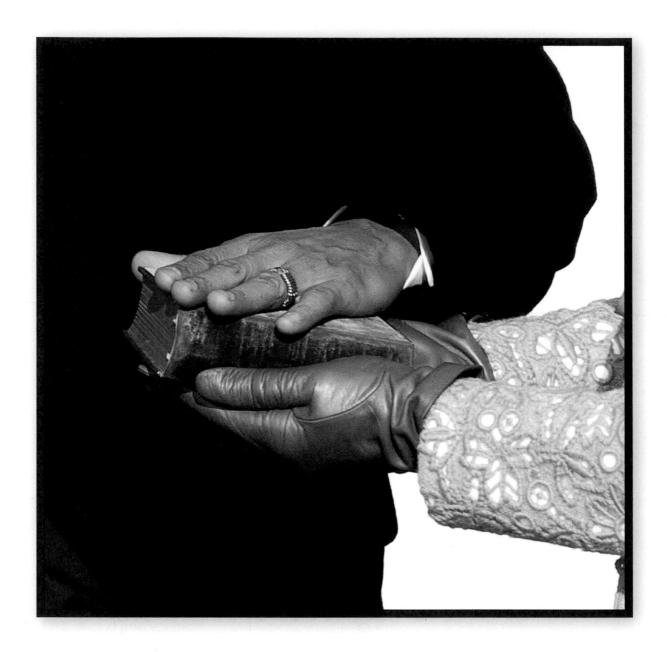

Barack Obama takes the oath of office, placing his hand on the Lincoln bible held by Michelle Obama on the steps of the U.S. Capitol in Washington.

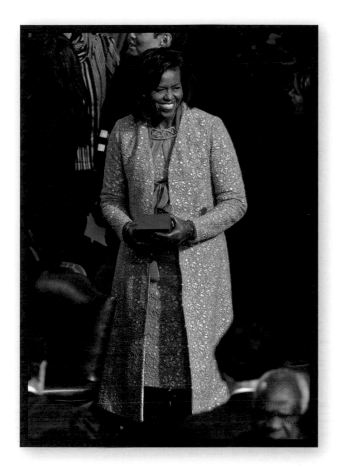

LEFT: Michele Obama waits for her husband to be sworn in.

———————————

BELOW: President Barack Obama and First Lady Michelle Obama walk down Pennsylvania Avenue in Washington, DC, on January 20, 2009. The president greets some of the millions of people from around the world who came to see him be sworn in. The Obamas twice emerged from their limousine in order to walk along the route to the White House.

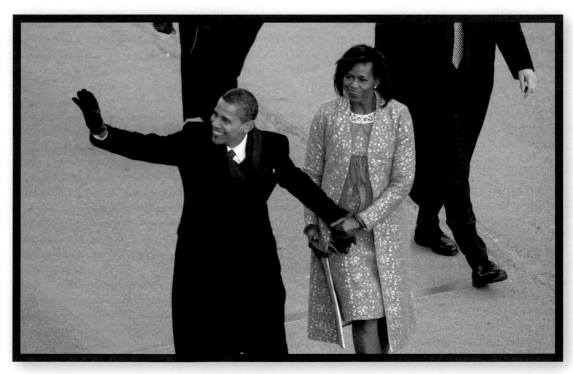

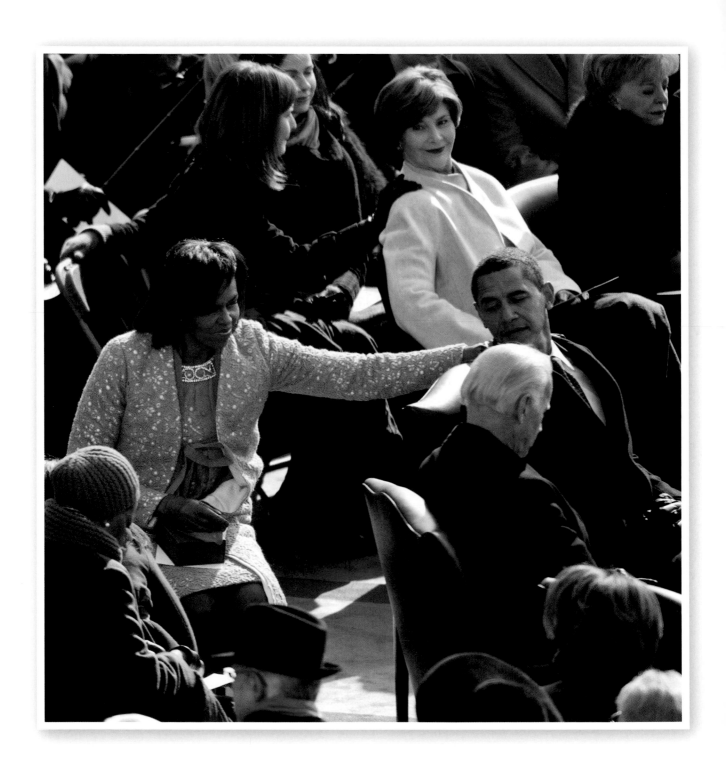

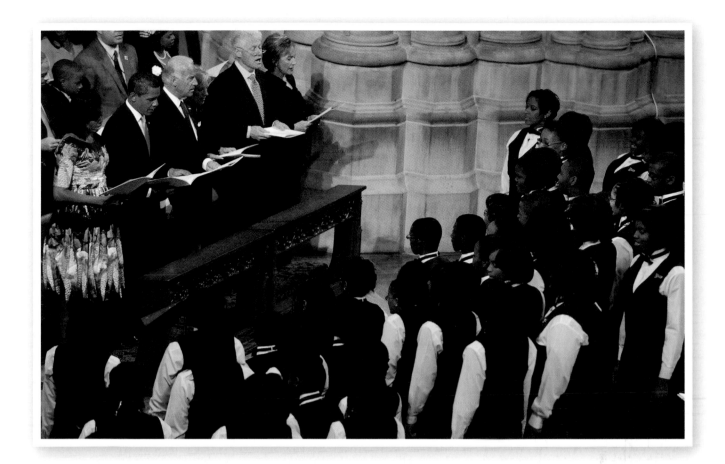

Left to right: First Lady Michelle Obama, President Barack Obama, Vice President Joseph Biden, Jill Biden, former President Bill Clinton, and Secretary of State–designate Hillary Rodham Clinton attend the National Prayer Service at Washington National Cathedral on January 21, 2009. Reverend Sharon E. Watkins was the first woman to deliver the sermon at this traditional inaugural event. "With your inauguration, Mr. President, the flame of America's promise burns just a little brighter for every child of this land!" she said.

OPPOSITE: Michelle Obama puts her hand on the shoulder of her husband before his inauguration as the forty-fourth president of the United States. Outgoing First Lady Laura Bush looks on admiringly.

President Barack Obama
and First Lady Michelle
Obama dance during the
Commander-in-Chief Ball in
downtown Washington on
Tuesday, January 20, 2009.
The Commander-in-Chief Ball
honors the country's active-
duty and reserve military.
More than 5,000 men and
women in uniform provided
military ceremonial support to
the presidential inauguration,
a tradition dating back to
George Washington's 1789
inauguration.

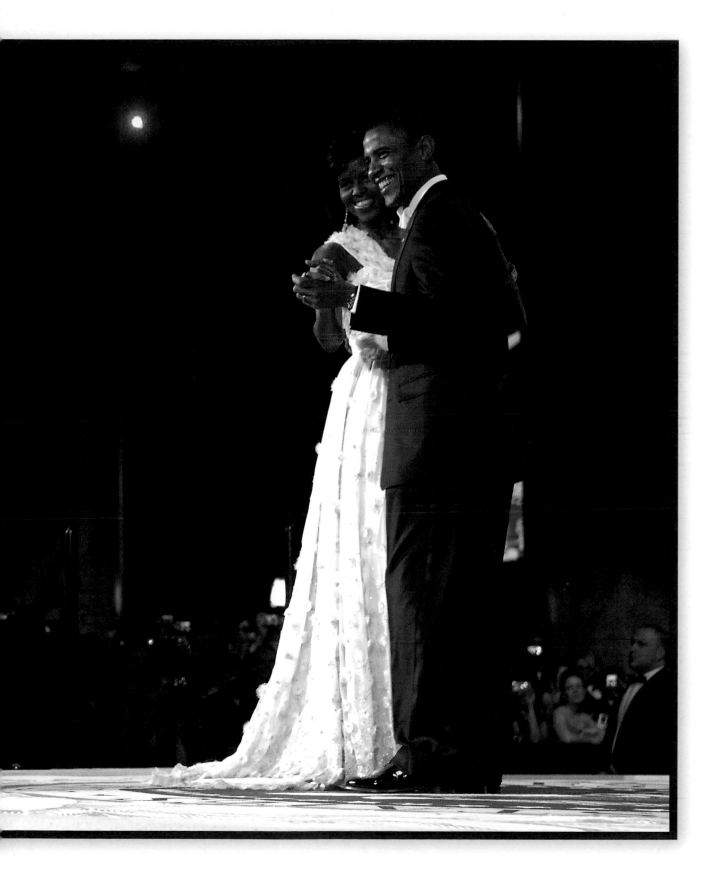

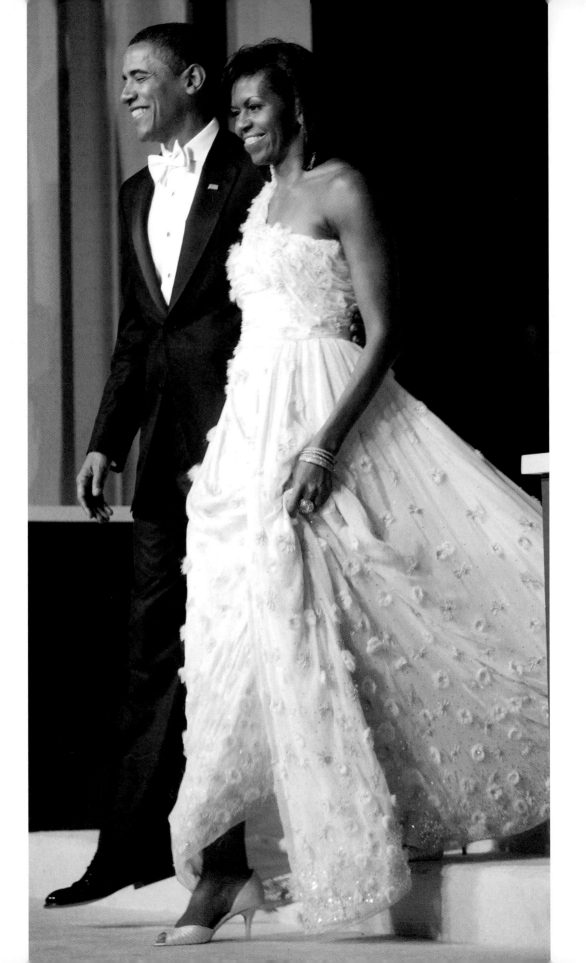

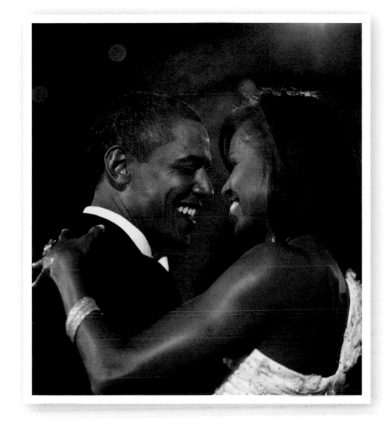

President and Mrs. Obama share their first dance of the night at the Neighborhood Inaugural Ball in Washington on January 20, 2009.

RIGHT: The Obamas dance at the Commander-in-Chief Ball, January 20, 2009.

———————————————————

OPPOSITE: President Barack Obama arrives with his wife at the Mid-Atlantic Inaugural Ball, held at the Washington Convention Center on January 20, 2009.

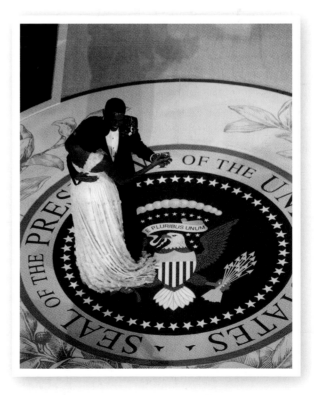

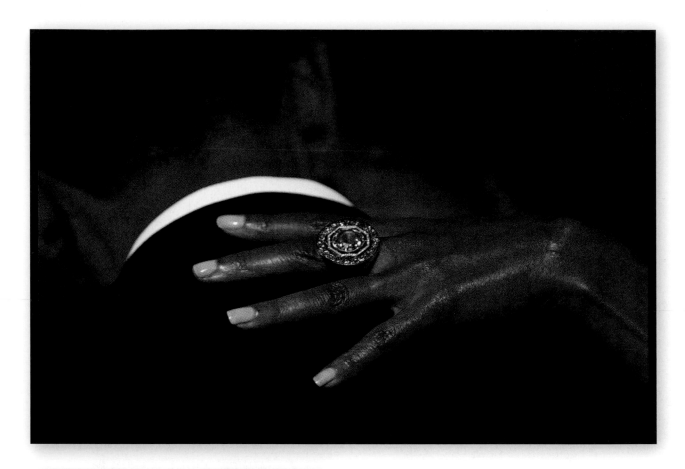

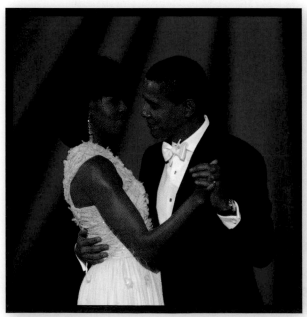

ABOVE: Michelle Obama accessorized her Jason Wu inaugural gown with diamond bangles, chandelier earrings, and this oversize cocktail ring, all designed by jeweler Loree Rodkin.

LEFT: President and Mrs. Obama dance at the Neighborhood Inaugural Ball, the first of ten inauguration balls they attended on the evening of January 20, 2009. The Neighborhood Inaugural Ball was the first inaugural ball ever to provide free or affordable tickets, some of which were set aside for local Washington residents. The Obamas danced to the Etta James classic "At Last," performed by singer Beyoncé Knowles.

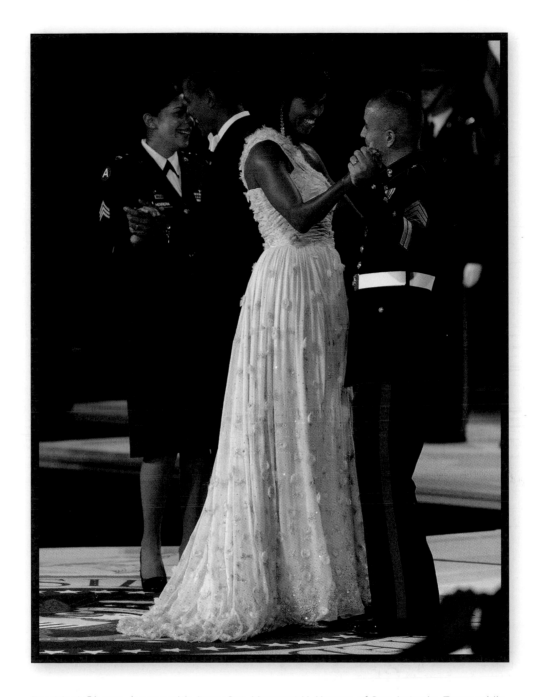

President Obama dances with Army Sgt. Margaret H. Herrera of San Antonio, Texas, while Michelle Obama dances with Marine Corps Sgt. Elidio Guillen of Madera, California, at the Commander-in-Chief Ball. Mr. Obama said the ball, held expressly for military personnel, including three hundred wounded veterans, best represented the spirit of his presidential campaign. Army Sgt. Herrera was so moved that she cried in the president's arms.

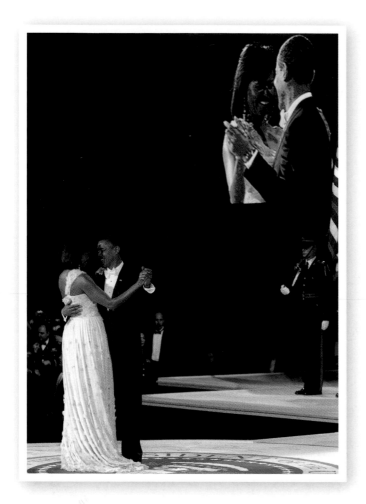

LEFT: The First Couple dances at the Commander-in-Chief Ball, which was held at the National Building Museum.

OPPOSITE: First Lady Michelle Obama dazzles in an off-white, one-shouldered, floor-length couture gown embellished from top to bottom with white floral details. The designer was twenty-six-year-old American Jason Wu. The new president led the First Lady to the dance floor and then stopped to ask the crowd, "First of all, how good-looking is my wife?"

Michelle Obama and her daughter Sasha attend the "Kids' Inaugural: We Are the Future" concert in Washington on January 19, 2009.

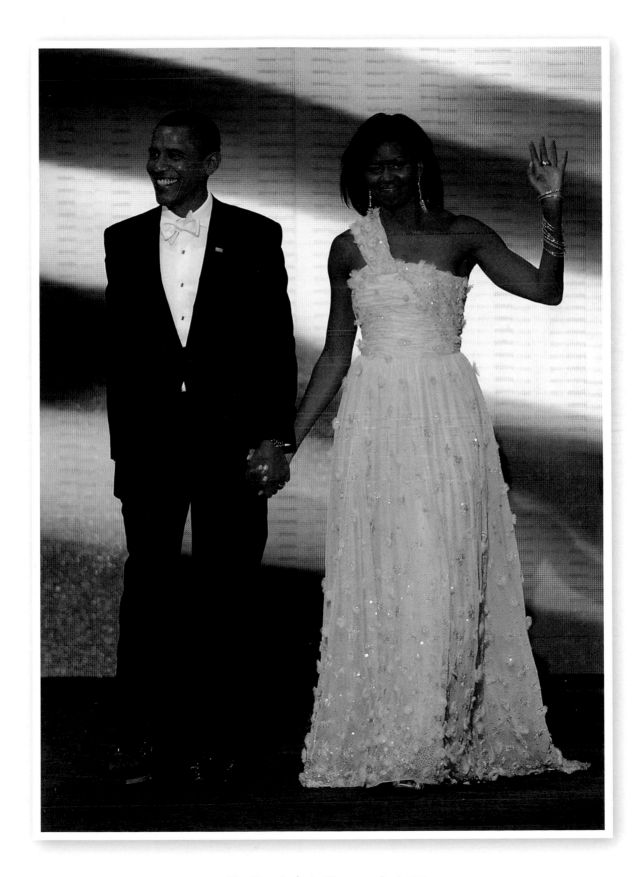

Michelle Obama cheers as she takes the stage during the "Kids' Inaugural: We Are the Future" concert, which she attended with her daughters, Sasha and Malia, in Washington on January 19, 2009. "You are the future of this great nation," Mrs. Obama told the audience, which was filled with members of the military and their families.

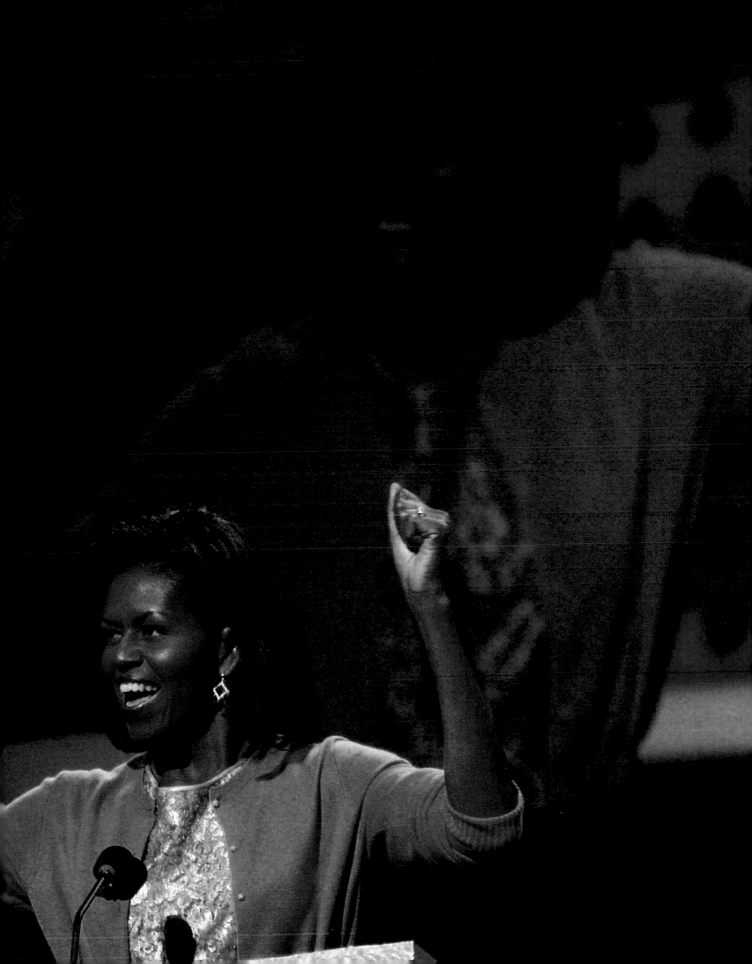

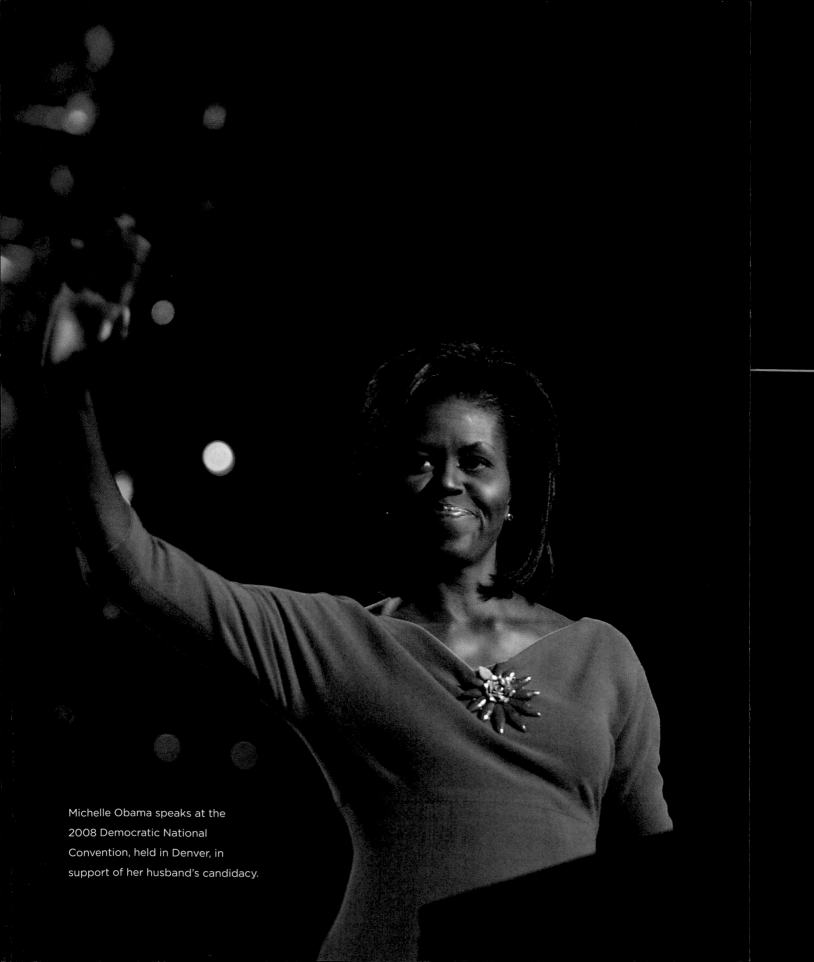

Michelle Obama speaks at the
2008 Democratic National
Convention, held in Denver, in
support of her husband's candidacy.

CAMPAIGN

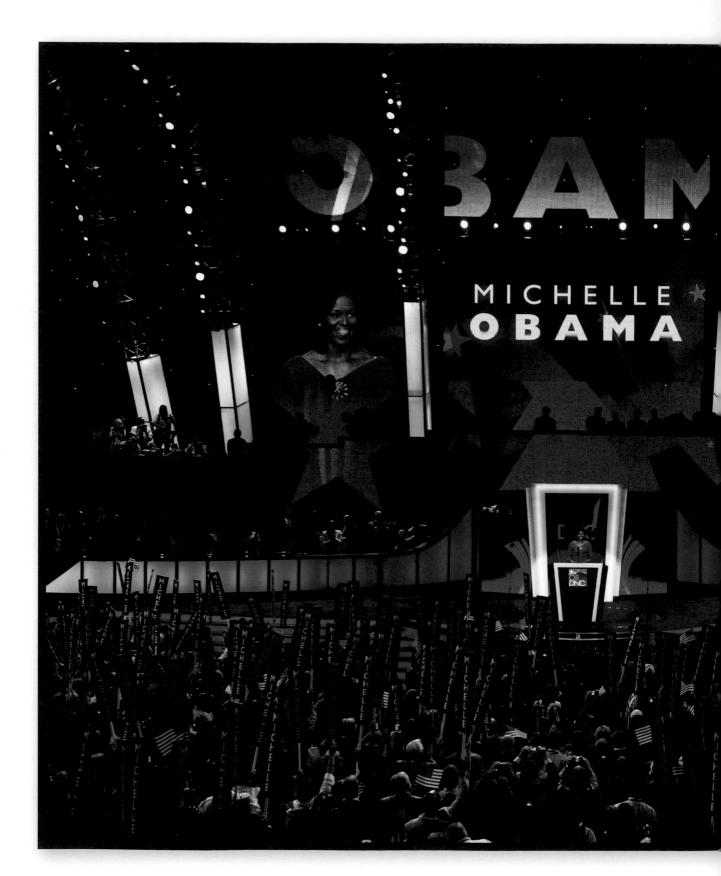

Michelle Obama lights up the stage at the Democratic National Convention in Denver on August 25, 2008, with her "One Nation" speech. Her powerful words of hope, determination, and unity culminated in a single poignant anecdote about her husband: "He's the same man who drove me and our new baby daughter home from the hospital ten years ago this summer, inching along at a snail's pace, peering anxiously at us in the rearview mirror, feeling the whole weight of her future in his hands, determined to give her everything he'd struggled so hard for himself, determined to give her something he never had: the affirming embrace of a father's love."

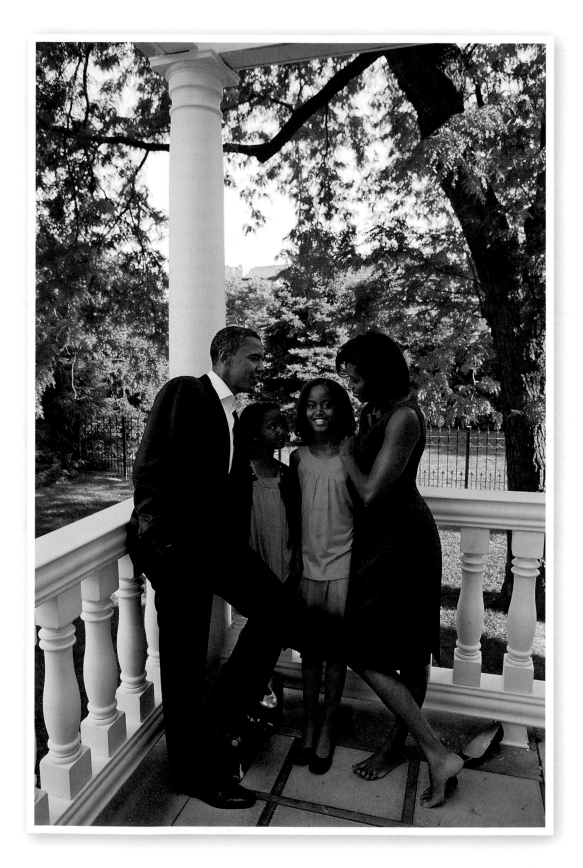

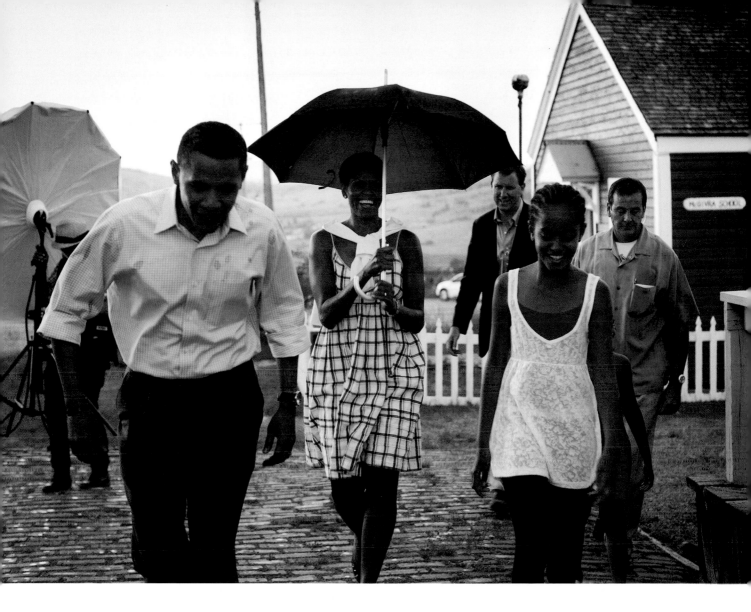

Michelle Obama smiles through the rain in Butte, Montana, on August 4, 2008.

OPPOSITE: The Obama family poses for *Essence* magazine.

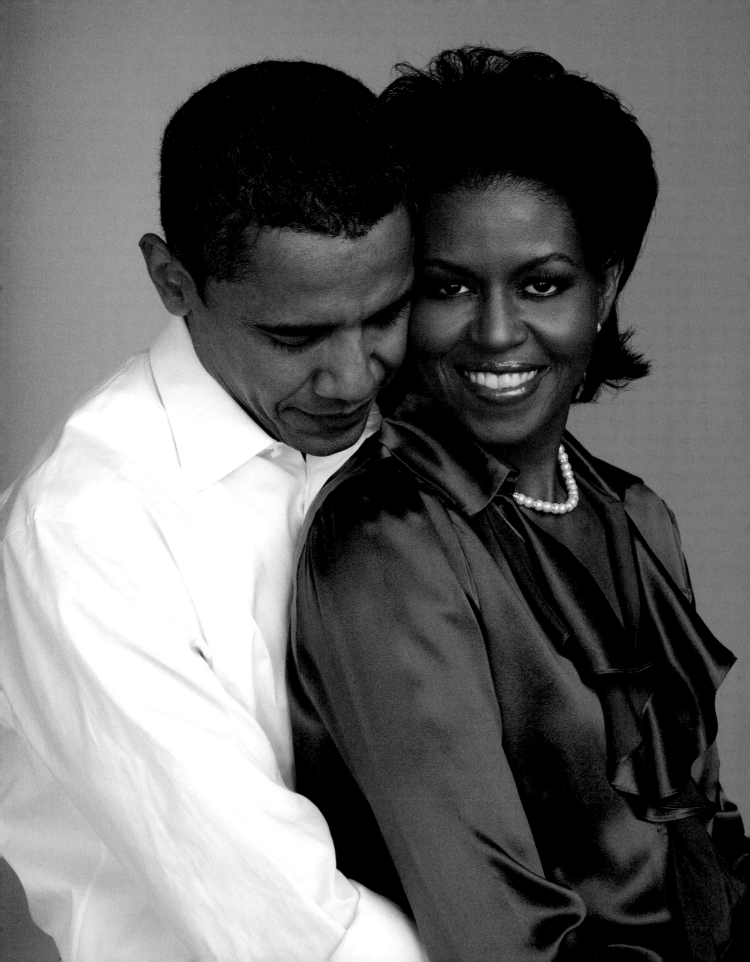

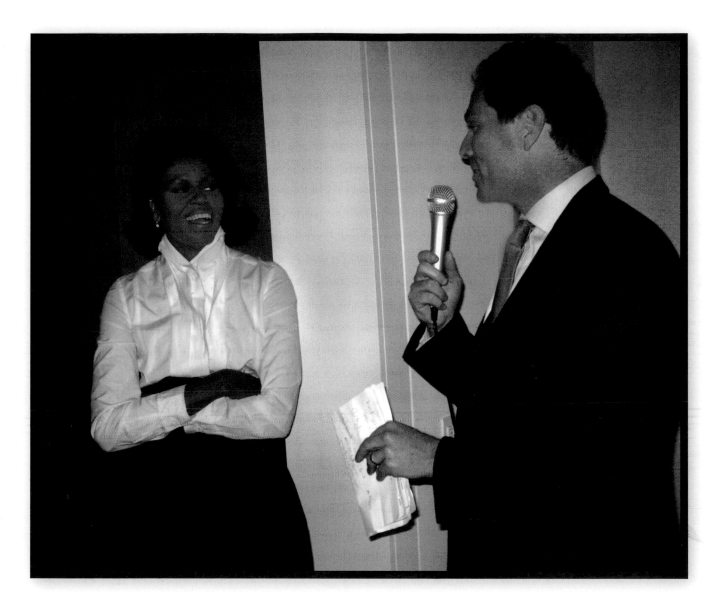

Michelle Obama at a campaign fundraiser in 2008.

OPPOSITE: Michelle and Barack Obama in 2006.

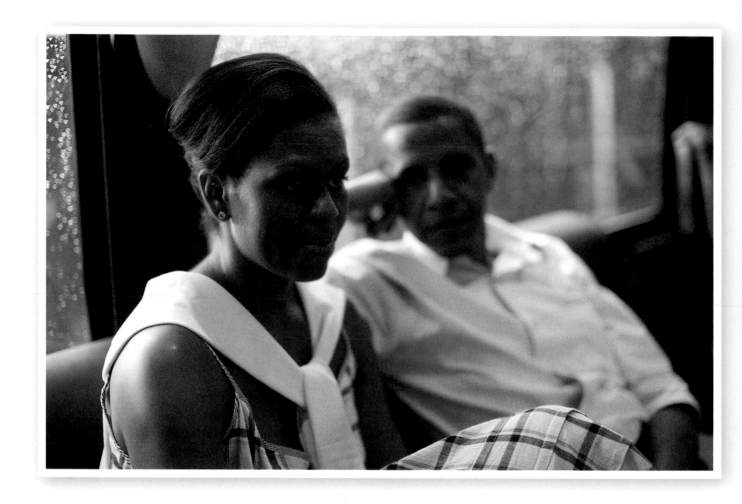

Barack Obama looks on as Michelle speaks.

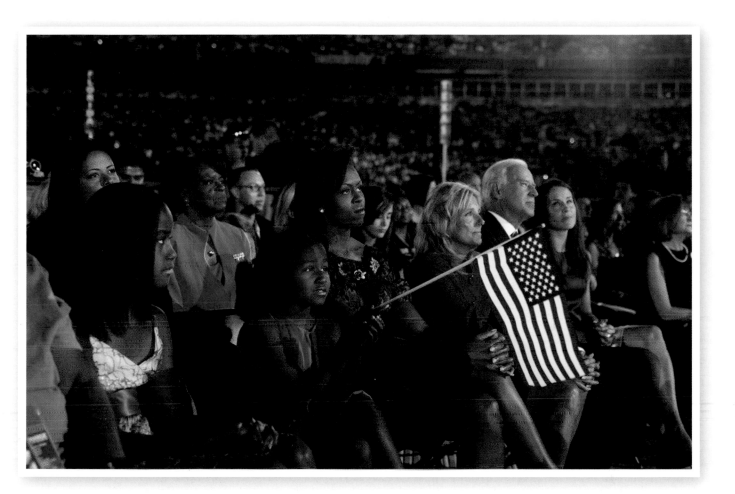

Democratic National Convention, Denver, 2008: Michelle Obama, with her daughters, Malia and Sasha, sit next to the Biden family as Barack Obama accepts the Democratic Party's nomination as its presidential candidate.

On the campaign trail in Rhode Island.

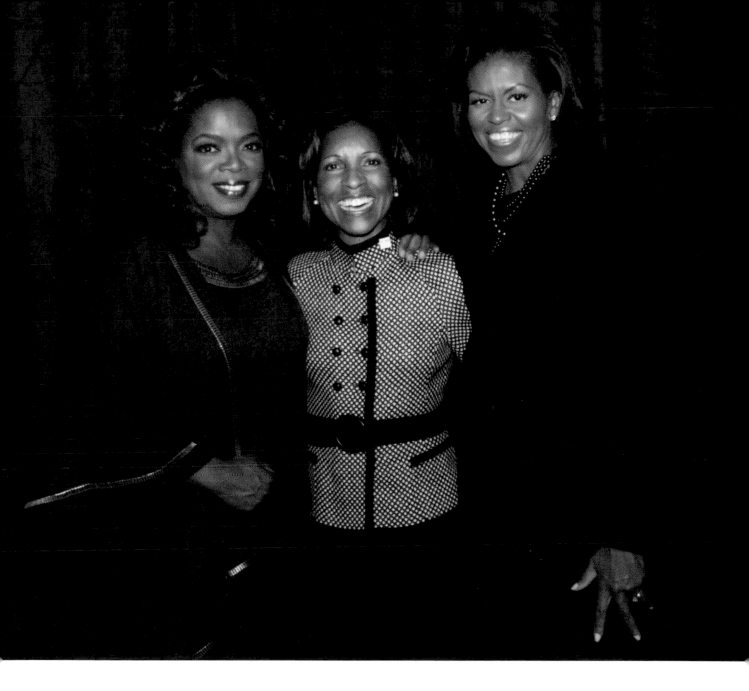

Oprah Winfrey, Deborah Brittain, and Michelle Obama at the National Women's Leadership Issues Conference, Chicago, October 10, 2008.

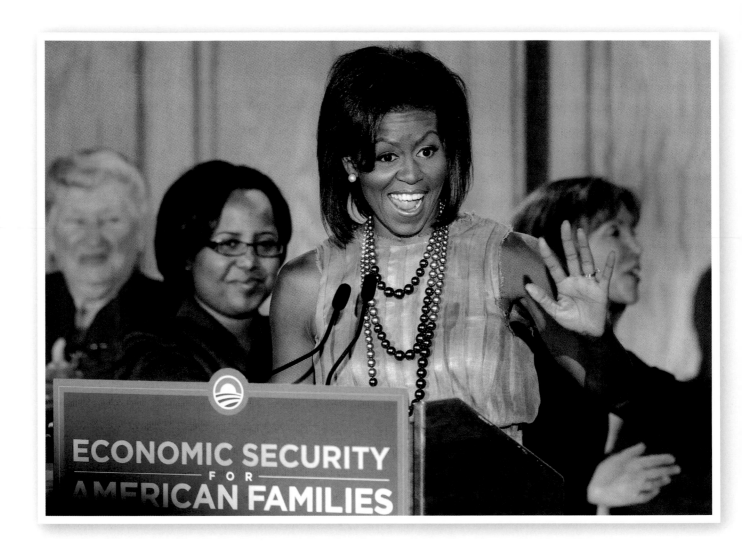

Michelle Obama, wife of the presumptive Democratic presidential candidate, waves to the crowd on August 26, 2008, in Denver, Colorado, where the Democratic National Convention was already underway. Mrs. Obama had just been introduced to a discussion group on working women and families.

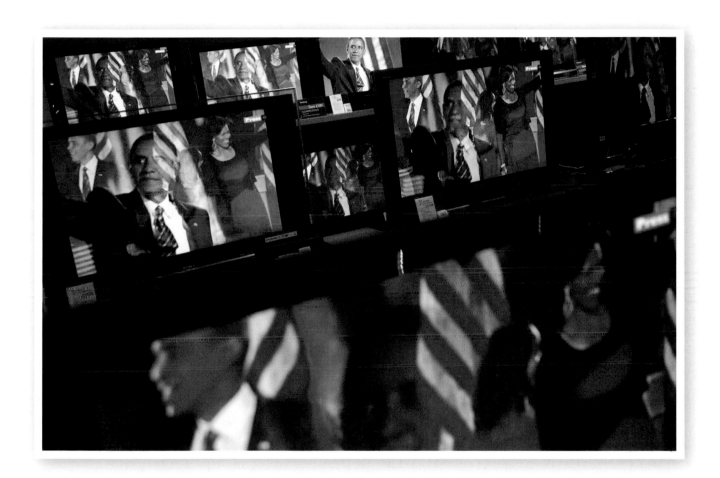

The John Lewis department store on Oxford Street in London broadcasts President Obama's election-night victory on November 4, 2008.

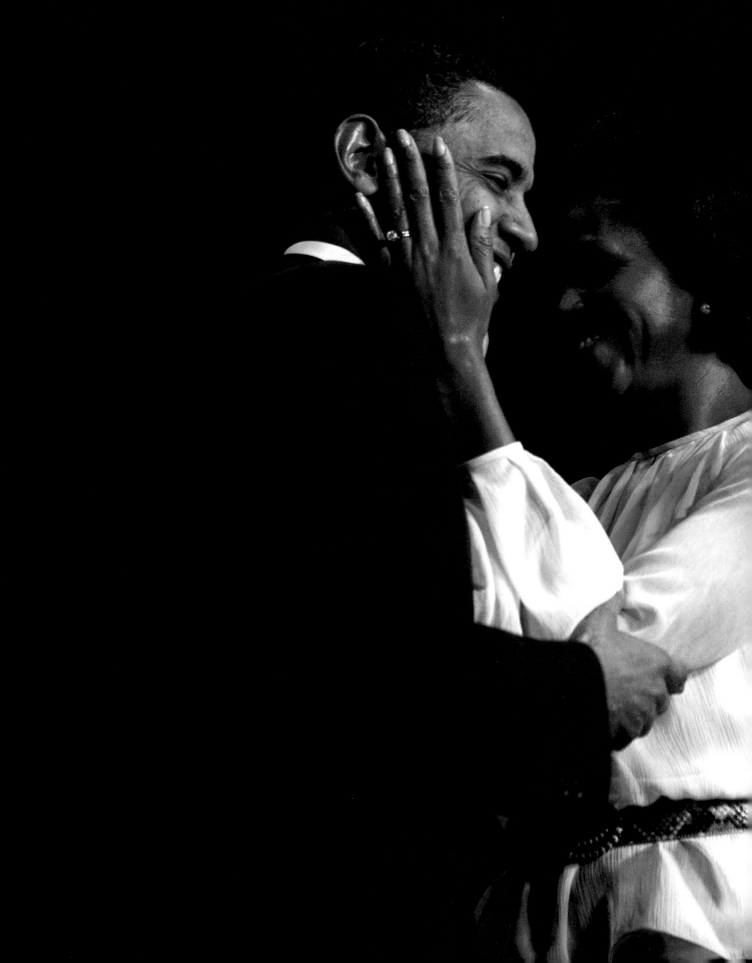

Michelle Obama greets
Democratic presidential hopeful
Barack Obama on stage at
a town hall event in Reno,
Nevada, on January 18, 2008.

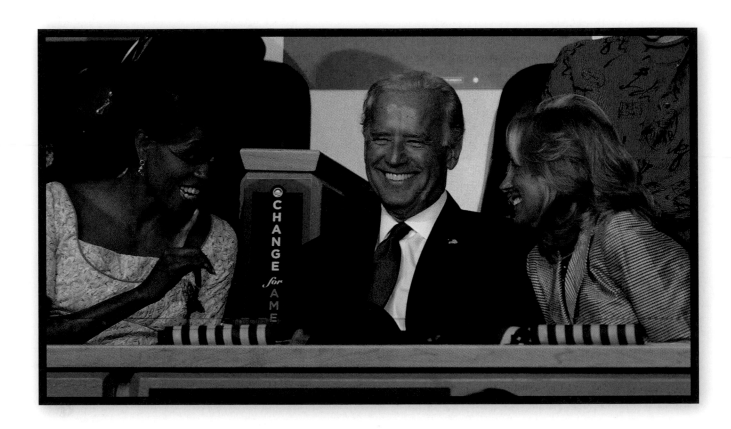

Michelle Obama elicits grins from vice-presidential candidate Joseph Biden and his wife, Jill, during the Democratic National Convention at the Pepsi Center in Denver, Colorado.

Craig Robinson introduces his younger sister, Michelle Obama, at the 2008 Democratic National Convention at Denver's Pepsi Center. In his remarks, Robinson revealed his sister's passion for *The Brady Bunch,* the popular sitcom that aired from 1969 to 1974.

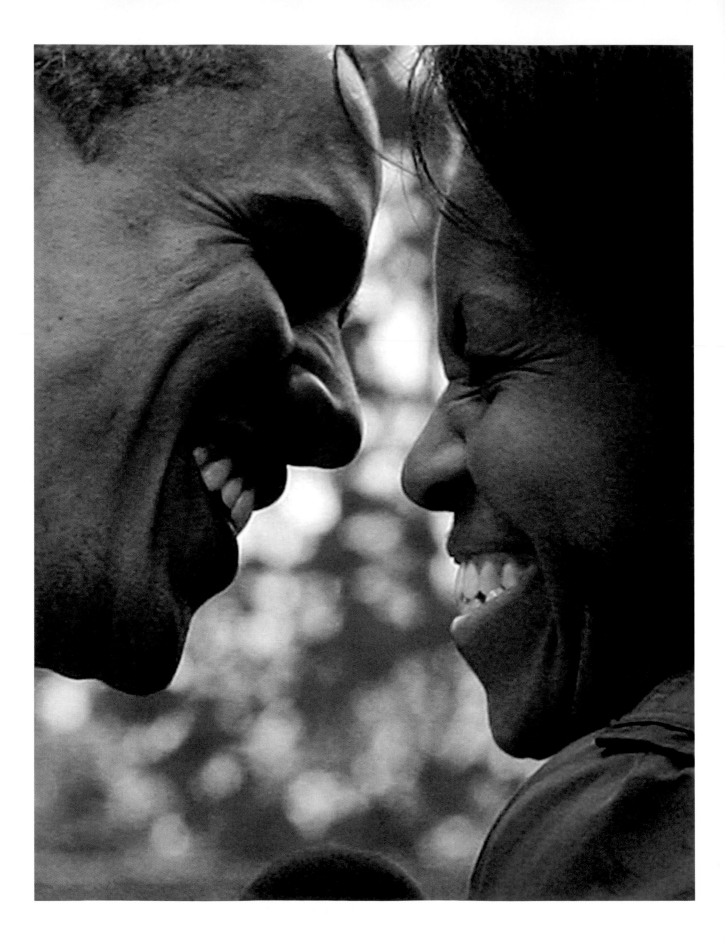

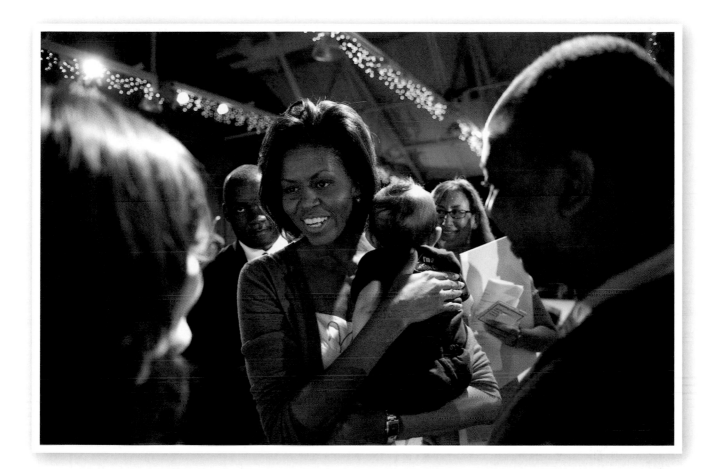

Michelle Obama, campaigning for her husband, greets supporters at a panel discussion with New Hampshire women at the Radisson Hotel in Manchester on June 26, 2008.

OPPOSITE: Democratic presidential candidate Senator Barack Obama laughs with Michelle during a Hamilton County family picnic in Noblesville, Indiana, on May 3, 2008, three days before the Indiana Democratic Primary.

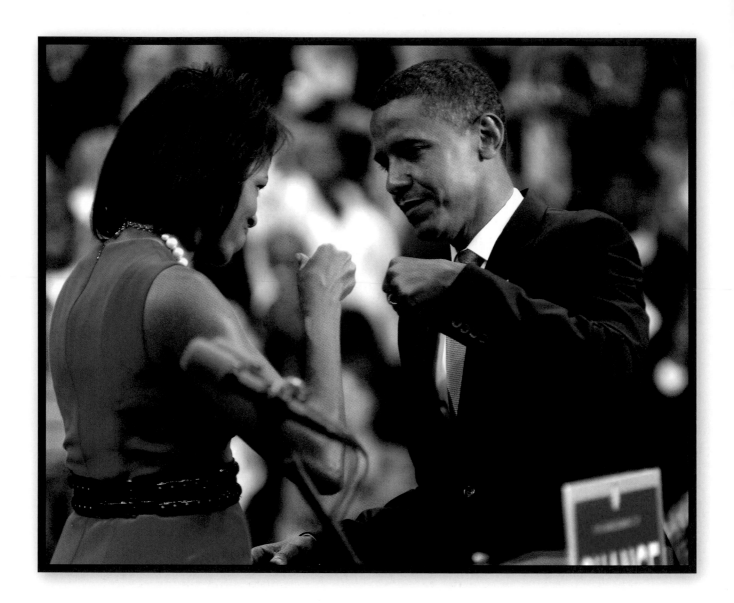

Michelle Obama bumps fists with her husband, Senator Barack Obama, as a playful sign of encouragement before he speaks to campaign supporters at the Xcel Energy Center in Saint Paul, Minnesota, June 3, 2008.

OPPOSITE: Michelle Obama introduces Senator Obama to an audience at Rancho High School in Las Vegas on January 17, 2008, two days before the Nevada caucuses. Coincidentally, January 17 is the First Lady's birthday.

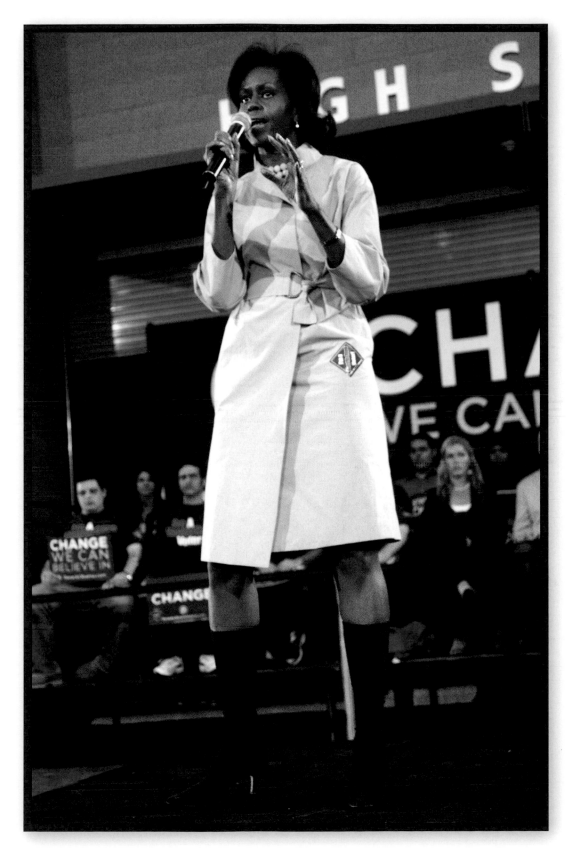

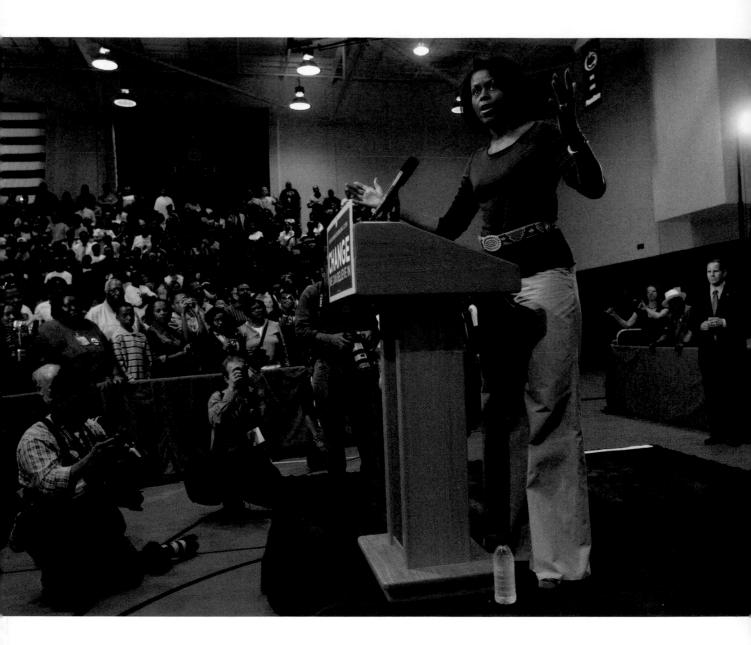

Michelle Obama speaks to a crowd of Barack Obama's supporters at the Wunderlay Gymnasium on the Penn State Greater Allegheny campus in McKeesport, Pennsylvania, April 22, 2008.

<hr />

OPPOSITE: Democratic presidential hopeful Senator Barack Obama and Michelle Obama wave to the crowd in front of the San Antonio Municipal Auditorium in San Antonio, Texas, March 4, 2008.

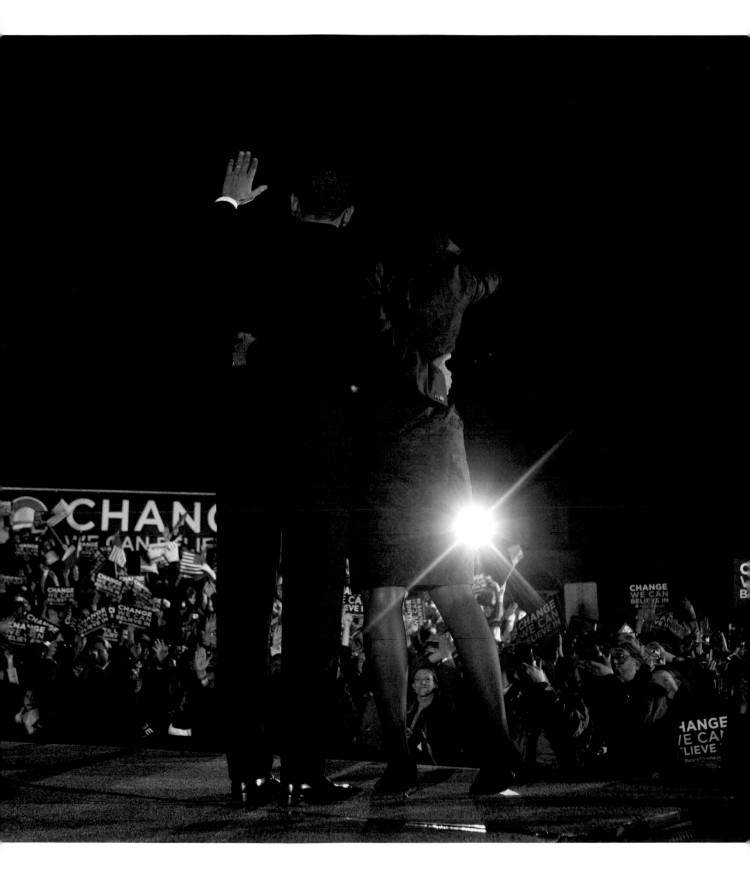

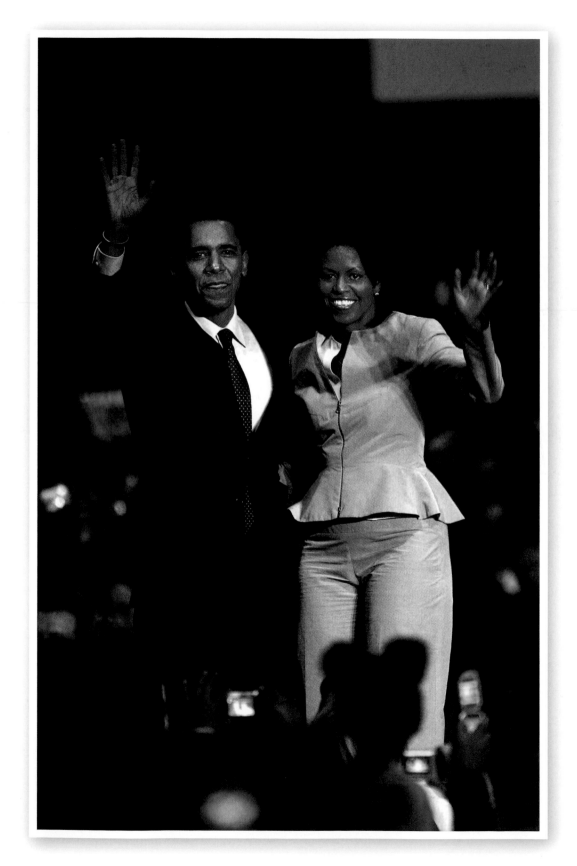

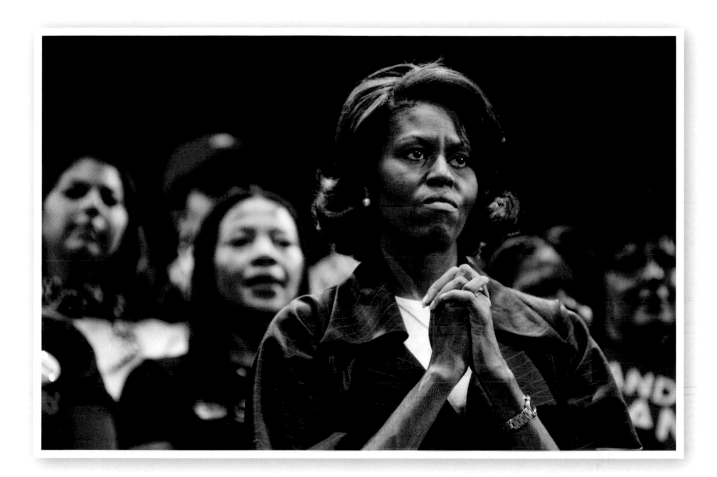

Michelle Obama listens to her husband at a campaign stop in Columbia, South Carolina, January 25, 2008.

———————————————

OPPOSITE: Senator Barack Obama and Michelle Obama wave to the crowd prior to his speech at the "Stand for Change" Rally in the George R. Brown Convention Center, Houston, Texas, March 3, 2008.

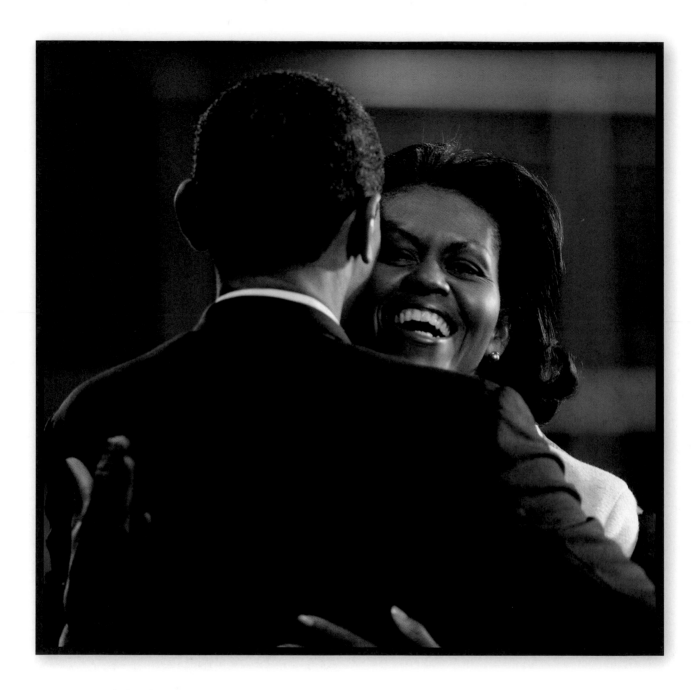

Michelle Obama embraces her husband after introducing him during a campaign rally at Dartmouth College in Hanover, New Hampshire, on January 8, 2008, the day of the nation's first presidential primary.

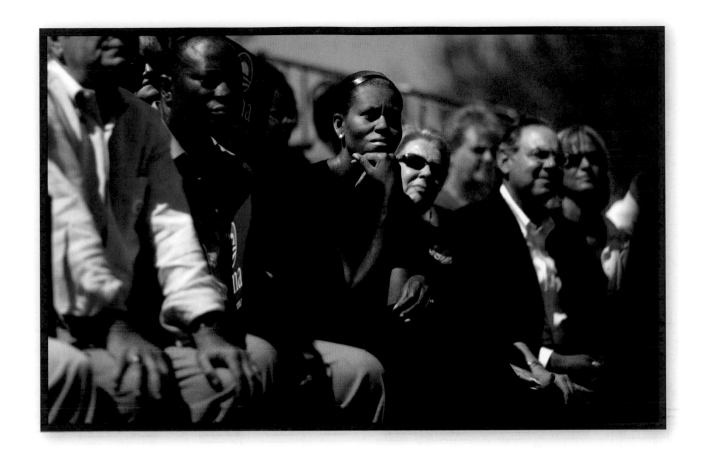

ABOVE: Michelle Obama at a Labor Day campaign rally in Manchester, New Hampshire, September 3, 2007.

RIGHT: Michelle Obama speaks before introducing her husband during a campaign rally at Williams-Brice Stadium in Columbia, South Carolina, December 9, 2007.

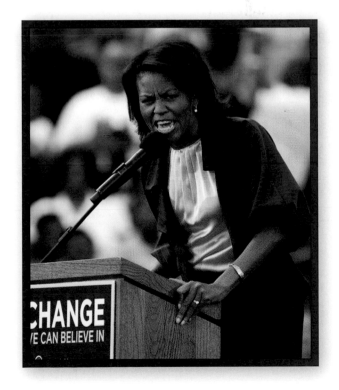

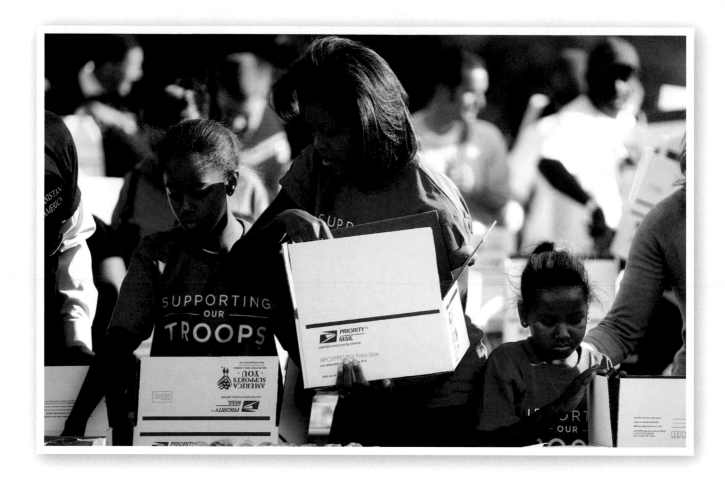

Michelle Obama and her daughters, Malia (left) and Sasha (right), assemble care packages for troops serving in Iraq and Afghanistan. Denver, Colorado, August 27, 2008. They were participating in Delegate Service Day, an initiative sponsored by the Democratic National Convention Committee (DNCC). Mrs. Obama and Colorado First Lady Jeannie Ritter served as cochairs for the day.

Michelle Obama and her brother, Craig Robinson, at the Democratic National Convention in Denver, August 27, 2008.

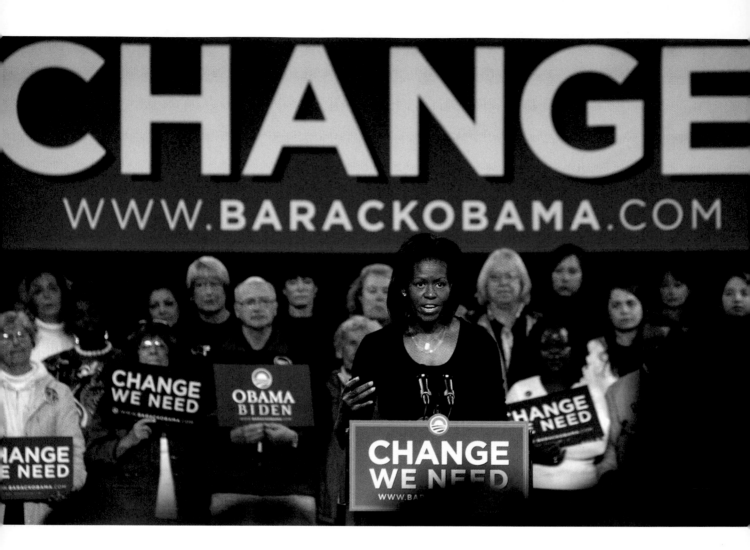

Michelle Obama speaks to a crowd of supporters during a campaign stop in Bexley, Ohio, near Columbus. Mrs. Obama filled in for her husband while he traveled to Hawaii to visit his ailing grandmother, October 24, 2008.

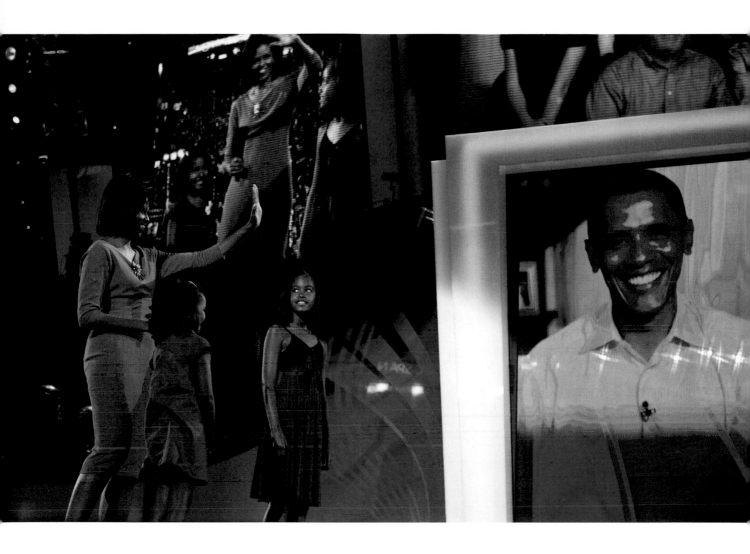

Michelle Obama and her daughters, Sasha and Malia, greet their husband and father via video feed after Mrs. Obama's speech on the first night of the Democratic National Convention in Denver, August 25, 2008.

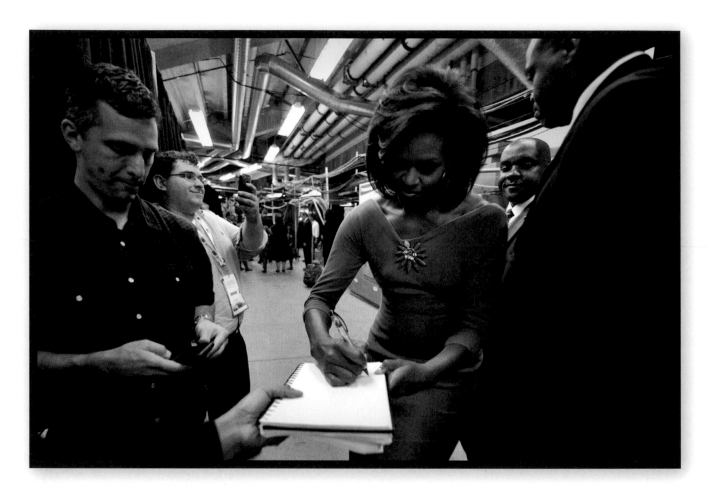

Michelle Obama signs autographs backstage following her speech at the Democratic National Convention in Denver, Colorado, August 25, 2008.

Michelle Obama embraces seven-year-old Sasha as they await the arrival of Barack Obama's campaign plane in Pueblo, Colorado, November 1, 2008.

Michelle Obama at a rally at the College of Southern Nevada Cheyenne Campus in North Las Vegas, November 3, 2008.

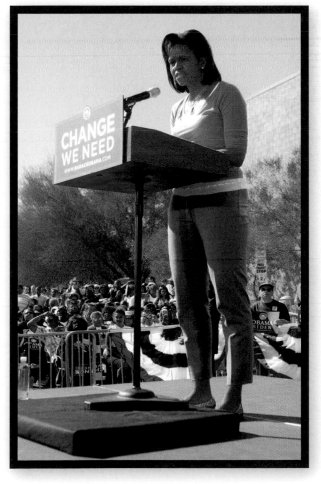

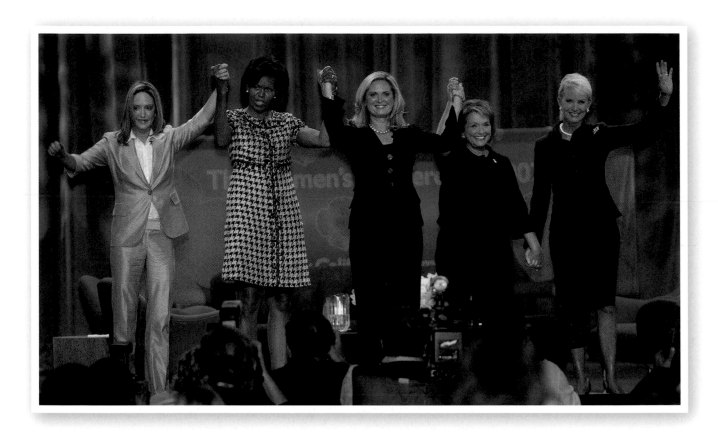

Presidential candidates' wives Jeri Thompson, Michelle Obama, Ann Romney, Elizabeth Edwards, and Cindy Hensley McCain acknowledge applause on October 23, 2007, at the Women's Conference in Long Beach, California.

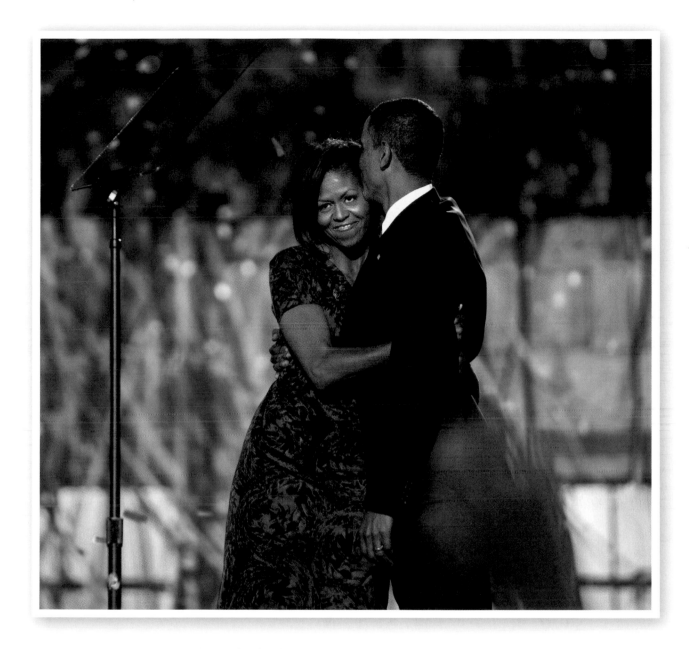

Michelle Obama embraces her husband after his acceptance speech at the Democratic
National Convention at Invesco Field in Denver, August 28, 2008.

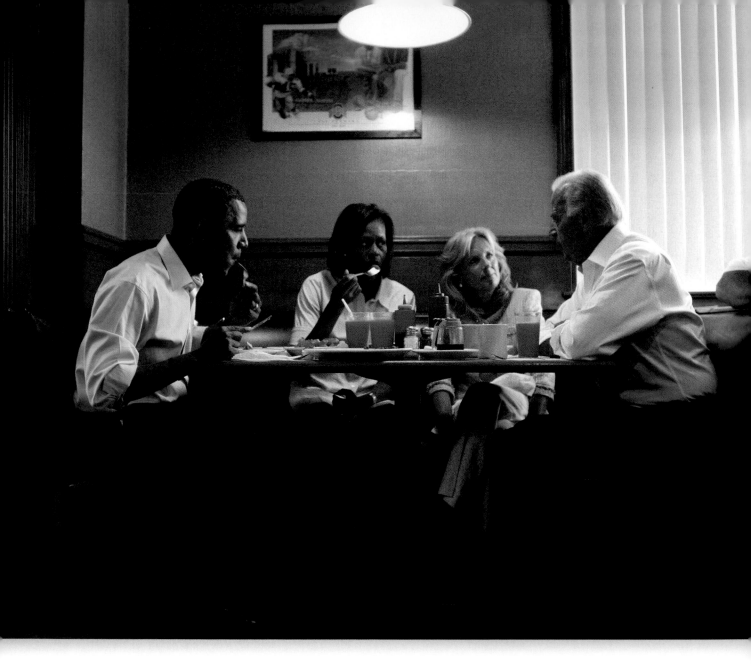

Democratic presidential candidate Barack Obama and his vice-presidential running mate, Senator Joe Biden, have breakfast with their wives, Michelle and Jill, at Yankee Kitchen Family Restaurant during a campaign stop in Boardman, Ohio, August 30, 2008.

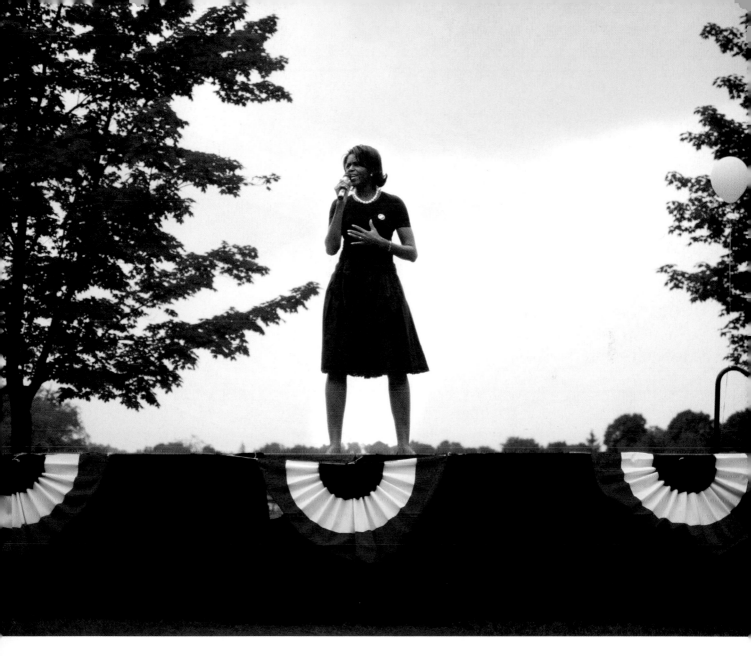

Michelle Obama speaks during a campaign event in Manchester, New Hampshire, June 2, 2007.

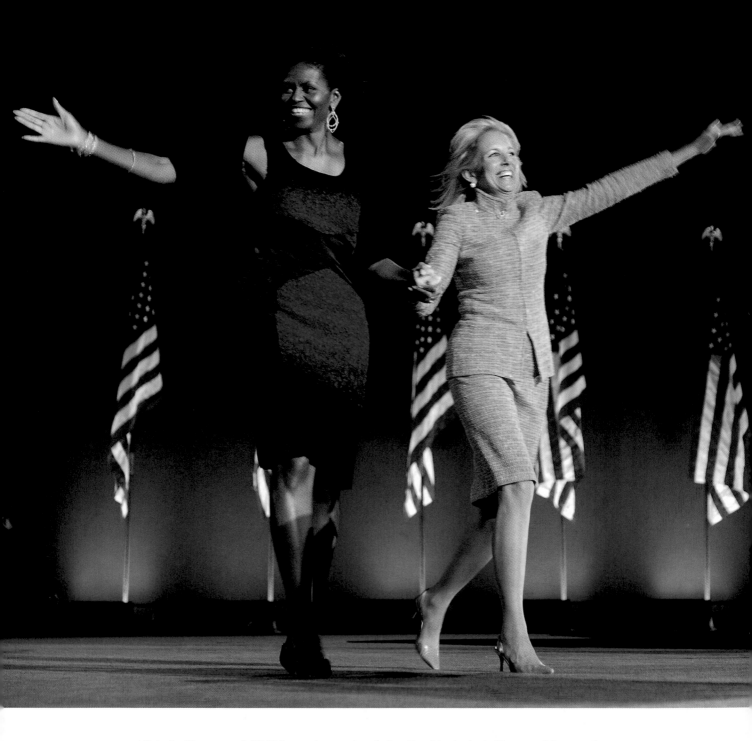

Michelle Obama and Jill Biden arrive onstage after President-elect Obama addresses the crowd in Chicago's Grant Park, November 4, 2008.

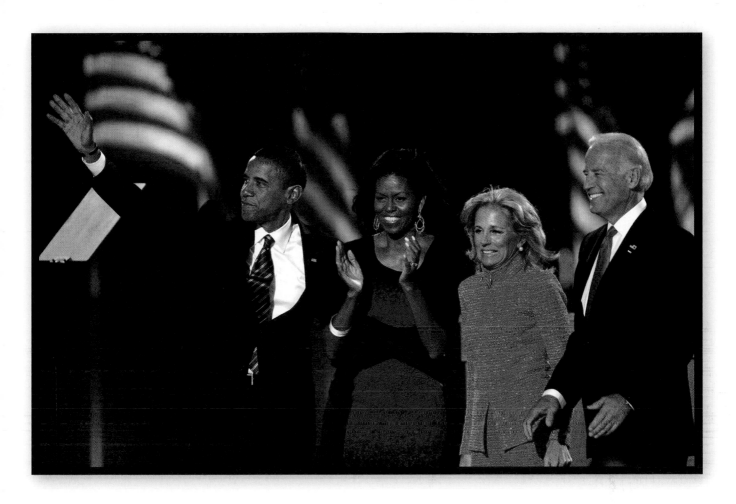

President-elect Barack Obama acknowledges the cheers of supporters after speaking in Grant Park, Chicago, on November 4, 2008. Michelle Obama, Jill Biden, and Vice President–elect Joseph Biden stand with him.

President-elect
Barack Obama and
his family wave to the
Grant Park crowd in
Chicago on election night,
November 4, 2008.

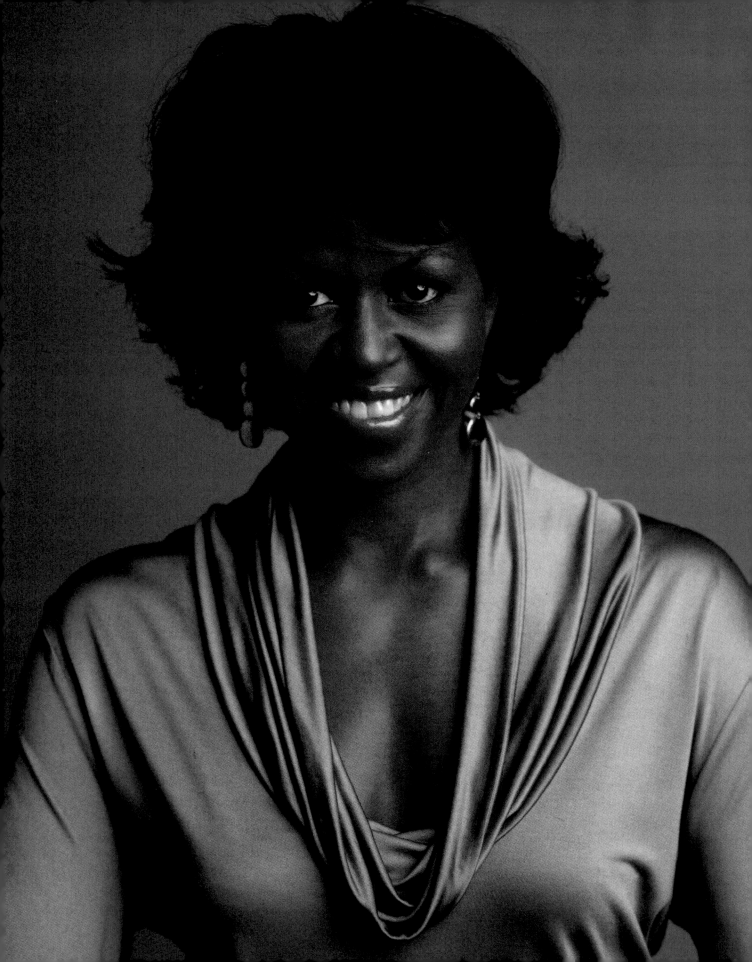

NATIVE DAUGHTER: MICHELLE OBAMA IN CONTEXT

EMILY BERNARD

THE TRUTH ABOUT MICHELLE OBAMA

The cover of a popular tabloid promises to reveal the truth about Michelle Obama and provide a list of all the people she "vows to destroy" as well as the details of her "ruthless White House rampage." On the cover, one of the First Lady's perfectly groomed eyebrows is shown raised, cocked, and loaded. Her mouth, lightly dusted with lipstick, is partly open—clearly, the photographer caught her mid–murderous sentence. Michelle Obama has a hit list, it appears. The words *SECRET HIT LIST!* are emblazoned across her expertly coiffed hair. I pick up the tabloid for a closer look.

"I never read those," says the cashier.

"Neither do I," I respond. "I need this one for research."

I tried to read the article. I really did. At first, it was difficult simply to locate it; I kept getting lost in the sea of gossip. A report on a scrape between a reality-television star and a police officer, and a tell-all by the mistress of a dead Hollywood icon led me astray. When I finally found the article— turgid prose detailing Obama's blowups and withering stares—it failed to hold my attention. It was boring.

Perhaps the best news about Michelle Obama is that there is no news about Michelle Obama— at least not the kind of news featured in the tabloids. Obama herself, in fact, is fairly boring, and certainly out of place, in a society in which sensational exposés and "straight" journalism bear an

uncomfortable resemblance to each other. She is called direct, a straight shooter. Yet Michelle Obama, like all of the Obamas, is an oasis of reserve in a shameless culture in which so many of us seem driven by the need to expose, divulge, and consume. The hunger for news about Michelle Obama, in particular, may set new records; according to a 2008 report published by the Pew Research Center for the People and the Press, Michelle Obama received four times the media coverage given to Cindy McCain.[1] Our bottomless need to digest stories about the Obamas begins with the anomaly they represent, starting with the very peculiar figure they cut as the first black family in the White House.

The photographs that Deborah Willis has collected here reveal that the Obamas are both peculiar and familiar. Michelle Obama, alone, is a walking medley of contradictions. She represents a story so curious, so puzzling, that we have developed a seemingly insatiable need for more information about a woman with a reputation for nothing if not frankness. She has told us a lot about herself. We want more.

At a moment in which it is possible to find out virtually anything about anyone at any given time, the Obamas are composed and private. Even the people closest to them seem disinclined to dish about the First Family. When Michelle Obama's ex–high school boyfriend recently gave an interview, it was only to say that he had not been good enough for Michelle, and to wish her well. The restraint the Obamas inspire in those who surround them is as reassuring as it is disquieting. It is a relief: they are the real deal, as dignified and as kind as they seem. But these days, news outlets continuously ripple with the stories behind the stories behind the stories. There *must* be something else about the Obamas, something that does not meet the eye—the world holds them in suspicion as much as in reverence.

Because what we see does not seem to satisfy, we make up stories about them and slide those stories into tabloids between articles about anorexic movie stars and gun-crazed singers. A Google search for the interview with Michelle Obama's ex-boyfriend pulls up a headline, "Michelle Obama's prom date tells all." Beneath that is a picture of Obama in her graduation cap and gown, looking then as she does now. The interview—tame and sweet—with her former prom date tells the same story as does the photograph: with Michelle Obama, what you see is what you get.

Bloggers, tweeters, Internet gossips, and traditional journalists: in this country, everybody has a story to tell. Michelle Obama has a story, too, one that she has only, at best, coauthored. "She's one of our own," is the way an eighty-one-year-old white female fan of the First Lady's put it when she met Obama on the campaign trail. "I'm no different from you," is a refrain Obama herself repeats often. The truth about Michelle Obama is that the claim to sameness is simultaneously accurate and inaccurate. She is foreign and familiar, a citizen and a stranger.

Obama is just like us, and unlike anyone we have ever seen before. She is both wholly knowable and a mystery. We have been making her up as we go along.

WELCOME TO MY COUNTRY

In his 1940 novel *Native Son,* Richard Wright immortalized Chicago as a city whose racial hypocrisies were embedded in its concrete. Set in the 1930s, the novel depicts two different Chicagos. On the South Side, black people pay exorbitant rents for substandard housing and inflated prices for day-old bread. Bigger Thomas, and readers that beneath the high fashion and the fancy degrees, Obama is home-grown, the real article. But the South Side has many faces, as the extreme stories told by Wright and Obama demonstrate. In *Native Son,* Bigger is alienated and alone, even though the shabby one-room apartment he shares with his mother and two siblings affords no privacy. Michelle Obama's South Side memories are suffused with pleasure, comfort, and a stable, happy family around the dinner table. In her nostalgia, Obama reveals something that many of us didn't know before but that has always been true: inner-city life includes white picket fences, too.

"I'm no different from you," is a refrain Obama herself repeats often.

the main character, gets a job on the other side of town as a chauffeur for Mary Dalton, the daughter of the real-estate titan responsible for the Thomas family's crowded, shabby conditions. From Bigger's perspective, the well-appointed Dalton home is a foreign country. Wright's best-selling novel indicted Chicago's unfair housing practices, which made poor blacks desperate victims of a systematic white racism that robbed their lives of joy, intimacy, and even hope.

"I'm just a girl from the South Side," Michelle Obama has said. It is a way of reminding watchers Chicago is an important city in the annals of African American history. The Great Migration is the name historians have given to the northward pilgrimage made by millions of black Americans, beginning around the turn of the twentieth century. Big cities boasted new industries that beckoned. Like Chicago, New York, Philadelphia, and Detroit were among the cities that promised safe harbor to black people determined to escape the violence and poverty that riddled the Southern landscape. Chicago drew more than half a million of the nearly seven

million African Americans who made the journey to points East and West during those years. The numbers continued to increase well into the twentieth century and would include the family that eventually produced Michelle Obama. Her grandfather, Fraser Robinson II, moved his family from South Carolina to Chicago in the early 1930s. The Great Migration promised good news for black people and bad news for some whites. Waves of white flight from neighborhoods that were quickly becoming home to black families would split the city in two, making Chicago one of the most segregated cities in America.

The Great Migration is a black American story, but it also is a larger American story. The move from South to North, like the move from a small city to a large one, is nothing less than an immigrant experience, including radical shifts in custom and idiom, an abrupt and disorienting landing onto foreign soil.

"Finally, I feel like an American," she sighed. The "she" I quote here is not Michelle Obama but a middle-aged, conservatively dressed Italian-American woman with whom I spoke at an Italian American Studies conference three days after the election. (I have an Italian-American husband and am a frequent attendee at this conference.) She wasn't the only one. In a room full of white men and women who identify themselves as immigrants first, a pervasive feeling of connection to the election was electric. "Barack is Beautiful!" boomed a performance artist reciting a poem she wrote about the election-night victory. A lawyer told me about traveling to Ohio to make sure the vote count would be legitimate. He called it the most significant and moving moment of his career. To these hyphenated Americans, the Obama victory was an immigrant's victory, a story in which they easily and immediately found themselves.

There has been a popular emphasis on the president as a shining example of the American dream. But the Robinson family, as well, represents what it means to arrive on alien shores and work for that proverbial dream to come true, and make America your own.

IT'S ALL IN A NAME

Both of the Obamas earned a great deal of mileage by emphasizing the president's "otherness" on the campaign trail. Barack Obama has been referring to himself as "the skinny kid with the funny name" since he gave the keynote address at the 2004 Democratic National Convention. It's a joke he tells on himself, and it's a joke he tells on us, too, as Americans, who may be cosmopolitan by definition but parochial in practice. The joke goes like this: What do you call someone who speaks three languages? Trilingual. Two languages? Bilingual. One language? American.

The joke is on Michelle Obama, too, as she herself likes to recall. Obama adopted the "funny name" refrain while on the campaign trail, and she has revealed in interviews that initially, she considered everything she heard about Barack uncomfortably alien. At the New Hampshire State Democratic Convention, she described her early suspicions about the man who would

become her husband. There was the funny name, and the fact that he was raised in Hawaii. "And I have to tell you I kind of thought any black guy who was raised in Hawaii had to be a little off!" There were the years in Indonesia and the fact that he had a white grandmother from Kansas. "I can't believe he's got a *white grandmother from Kansas!*" a friend and colleague remembers her saying. It was all so weird and sensational—the stuff of tabloids.

But in New Hampshire and everywhere else, Michelle Obama played the joke for something bigger than a laugh. As she mocks her own parochialism, she tells a story with an essential lesson, which is that difference is inessential. "I based my first assumption on our differences," she said. She soon discovered that Barack had similar values and aspirations. It was a revelation. "Listen to him as I listened to him, and you will see how he is just like us," she said. Us, not you. The man who would become her husband seemed as foreign to her as the man who may well become your president seems to you, she told her audience in 2007. She offered up her love story to her audience, so that it might become their love story, too.

There is nothing funny about the name Michelle Robinson. According to the 2000 census, Robinson is the twenty-seventh most common surname in the United States. Michelle ranks 103 among popular female first names. LaVaughn is a family name, the first name of her paternal grandmother. Her father was third in a line of Fraser Robinsons. Michelle LaVaughn Robinson's name grounds her as irrefutably as

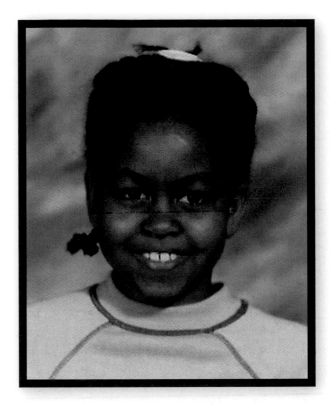

Portrait of Michelle Robinson Obama as a child.

any passport. The name Barack Obama spurs a question: Where? The name Michelle Robinson provides an answer: Here.

The maiden name of our First Lady invites a comparison with the name of another presidential spouse to whom she's often compared: Jackie Kennedy, whose maiden name, Bouvier, sounds the bells of privilege and luxury as much as Robinson evokes the everyday. Marriage transformed both women into international celebrities. But while Jackie Bouvier remains imprinted in the public imagination as the widow of President Kennedy who spent later years lounging on Aristotle Onassis's yacht, the unfolding story of Michelle Obama includes

glimpses of her at home, trying—and failing—to convince her husband to put away the butter after he's made his toast.

Michelle Obama's domestic complaints peg her marriage as mundane, not exotic. They serve as everyday examples of the transparency the new administration has promised. Her playful carping has earned Michelle Obama the labels "frank," "down to earth," and "authentic." In March 2008, *The New Yorker* applauded her "politics of candor." Obama's open personal style is as thrilling to her ever-growing fan base as it has been a fertile point of criticism for her detractors.

AUTHENTICALLY BLACK

"She's *not* a black June Cleaver!" rails an Internet reader, indignant at a blogger's comparison, apparently because, in the mind of the reader, the comparison undermines Michelle Obama's professional chops as well as her racial

Taping an episode of *The Dick Van Dyke Show*.

authenticity. In her introduction to this book, Deborah Willis reminds us that many pundits have tried to make sense of the Obamas by recalling *The Cosby Show*, casting the First Lady as Clair Huxtable, also a lawyer, who was played by Phylicia Rashad in the long-running sitcom. But if we were to ask Michelle Obama which sitcom best reflects her sensibilities, we might discover that *The Dick Van Dyke Show* of the early 1960s is closer to her heart. She admitted to taking comfort in reruns of the sitcom when it became too uncomfortable to watch the pre-election debates. Craig Robinson, the First Lady's brother, has said that his sister has committed to memory every episode of *The Brady Bunch*, which aired from 1969 to 1974. Both of these classic sitcoms look like standard-issue television fare today, but for those of us who, like Michelle Obama, grew up with them, *The Brady Bunch* and *The Dick Van Dyke Show* offered new stories for American viewers. With

Bill Cosby with the cast of *The Cosby Show*.

Moore and Matthews in *The Dick Van Dyke Show*.

Michelle Obama who is still keen on Mary Tyler Moore and Florence Henderson.

Is Barack Obama really black? This question is still bandied about in public forums and private conversations, among people of all races. In January 2007, writer Debra Dickerson sought to put the question to rest: "Obama isn't black," she stated bluntly, justifying her racial diagnosis on the grounds that he came to these shores by way of voluntary immigration, and not slavery. Some have speculated that the fact that Barack was not "really" black helped him attract white voters who took comfort in his light skin and international lineage, as if they represented a racial identity that was generated somewhere outside of the American black–white racial divide. But in the genetically complex nature of his heritage,

episodes revolving around the challenges of blended families and modern marriages, they represented American society as it was changing as much as they assured audiences that nothing had really changed at all. To acknowledge Michelle Obama's passion for these shows, with their all-white casts, is not to deprive her of racial authenticity. Instead, it is to understand the First Lady as a full person with an integrated identity, both personal and public.

It's difficult to reconcile media portraits of Michelle Obama as an angry black militant with the self-portrait of the First Lady losing herself in the whimsical repartee of *The Dick Van Dyke Show*'s Rob and Laura Petrie and the tidy chaos generated by the Brady clan. But in fact, the Michelle Obama who raised public ire by daring to admit to having once harbored some disappointment in her country is the same

The cast of *The Brady Bunch* gathers for a "family" Easter portrait on March 12, 1972.

there is no one more authentically black than Barack Obama. Frederick Douglass, Booker T. Washington, W. E. B. Du Bois, Malcolm X—each of these redoubtable black leaders had multiple white ancestors in his family tree. To put it simply, if we are going to question the racial authenticity of Barack Obama, then we might also call into question the authenticity of Frederick Douglass, whose father was white. For generations of black leaders, "blackness" was as much of a political and social category as it was a consequence of biology.

While some cringe at Michelle Obama's sitcom preferences, for most people her racial authenticity is indisputable. Commentators have pointed out that the president's romance with the First Lady could not have been smarter in political terms. They suggest that Michelle's relatively unadulterated racial heritage lent her husband legitimacy to those on the fence in the "black enough" debate that dogged him in his early political life. The same commentators believe that Michelle Obama's cachet aided her husband in worlds beyond the strictly racial ones. It was through his then-fiancée that the president became well acquainted with the intricate and powerful world of Chicago mayor Richard Daley, when Valerie Jarrett hired Michelle as Daley's assistant. Jarrett is, of course, now a White House senior advisor.

Ultimately, *both* Michelle and Barack Obama are authentically black, and at every turn the First Couple challenges traditional notions of what an authentic black story is and does. But authenticity can be a double-edged sword. If the question swirling around the president has been: Is he black enough? then the question that dogs the First Lady is: Is she too black?

The New Yorker mocked white American anxiety about Michelle Obama when it caricatured her as a fear-inspiring race radical on its July 2008 cover. This same anxiety fueled a false Internet rumor that claimed the First Lady had used the term *whitey* in a speech. If Barack Obama's light skin and funny name signal a foreignness that jump-starts American suspicion, then Michelle Obama's brown skin evokes, for some white Americans, the alien world of blackness and represents the fact that we inhabit different Americas after all.

Michelle Obama is too black not only for some white Americans; some black Americans feel the same way. In *New York* magazine, the cultural critic Touré reported on a classic intraracial dustup. "She is basically a ghetto girl," sniffed a member of the black elite community that vacations on Martha's Vineyard, describing Michelle Obama. "She hasn't reached out to the social community of Washington, and people are waiting to see what they'll do about that," she continued.

Poet Langston Hughes had something to say about the black social community of Washington. "They were on the whole as unbearable and snobbish a group of people as I have ever come in contact with anywhere," he wrote in his 1940 autobiography, *The Big Sea*. He described the black Washington elite as drawing rigid class and color lines "against Negroes who worked with their hands, or who were dark in complexion and had no degrees from colleges."[3] Color prejudice

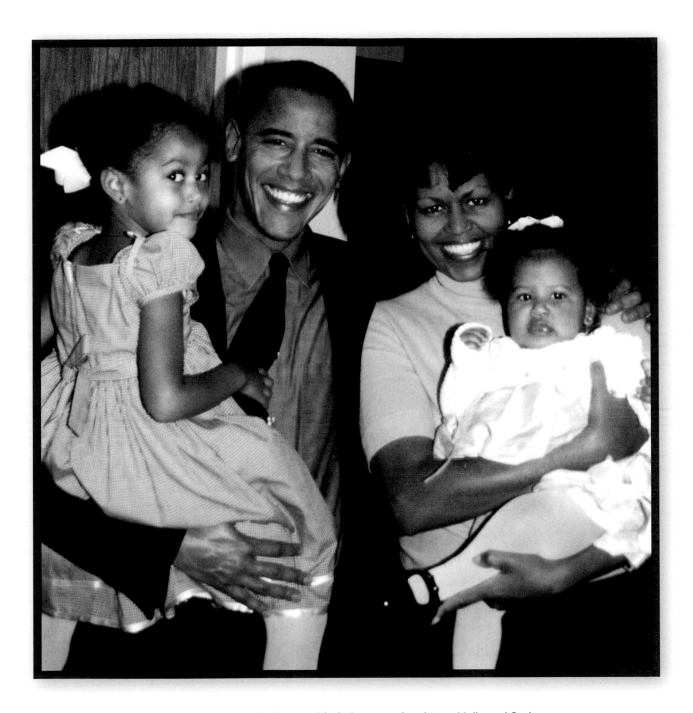

Michelle and Barack Obama with their young daughters, Malia and Sasha.

is not a new story, and color prejudice among black people is nearly as old as the presence of black people in this country. It's evident in the slave narratives of Frederick Douglass and Harriet Brent Jacobs. In an 1898 story by Charles W. Chesnutt, the author describes "the Blue Vein Society," a black organization for which a prospective candidate had to have skin light enough to show his blue veins. It's documented in early black fiction. "We ought to lighten up de race," says a character in Zora Neale Hurston's classic 1937 novel *Their Eyes Were Watching God*.[4] In his book *The Future of the Race*, Henry Louis Gates Jr. recalls a party at Yale (where he received his B.A. in 1973) in which no one whose skin was darker than a brown paper bag was allowed entry. (This is known as the "brown paper bag test," and, like all stories about colorism, it's an old story.) Today, any day, the Internet is aflame with discussions about colorism among blacks, and people from all over the country write in to share stories of the pain that intraracial prejudice has caused them.

Michelle Obama is black, really black—"one of us," explains Kim McLarin in the online journal TheRoot.com. By "one of us," she refers not so much to Michelle's blackness as her brownness, along with her womanly curves. Some Internet analysts have gone so far as to argue that Barack Obama would not have been electable, at least among black people, had his wife resembled the tawny-skinned, flowing-locked Beyoncé Knowles or Halle Berry.

For better or worse, to whites and blacks, fans and critics, Michelle Obama is "authentic"

in multiple meanings of the word. A watchword like *authentic* may not have much currency in everyday life in the Obama household, but it means a great deal to the people peering inside.

BODY LANGUAGE

Michelle Obama quite literally embodies narratives about authenticity and beauty, about American aspirations and inspirations. In these photos, her body tells multiple stories. First, there are the oft-discussed arms, which represent contemporary America as much as anything else about her. Some pundits have said they represent her seriousness; others debate whether or not she should cover them up. In a March 2009 *New York Times* column, Maureen Dowd reminds readers that recently the First Lady sported a sleeveless dress with a V-neck that inspired one Republican congressman to refer to her as a "babe." For some, Obama's arms represent sexuality; for others, they look scary. In the same column, Dowd quotes columnist David Brooks on the First Lady's arms: "She's made her point," he said. "Now she should put away Thunder and Lightning."

The First Biceps also tell a story about American aspirations. Even those who can't identify with Obama's pedigree have, somewhere in their pasts, I would venture to bet, a lapsed gym membership. Not every American goes to Princeton and Harvard, but millions of Americans put "Get in Shape" at the top of each year's list of resolutions.

Michelle Obama's body and wardrobe work in tandem to tell a story about elegance

Michelle Obama speaks to a supporter in Concord at the New Hampshire Women for Obama Kickoff Fair, June 2, 2007.

and fitness, as Deborah Willis explains in her introduction. If Nancy Reagan represented the extremes of the eighties (Mrs. Reagan may always be associated with the maxim, "You can never be too rich or too thin," which has been attributed to socialite Babe Paley)—then Michelle Obama represents where we are and want to be in the twenty-first century. Michelle Obama ranks exercise as one of her favorite hobbies. She also calls to mind the old American ideal of the scholar-athlete, of excellence in mind and body. It's another core value she shares with her husband. Stories about John McCain on the campaign trail have him filling up on leftover junk food on the tour bus while Barack Obama got up religiously every day to work out.

Obama tells stories with her body—not only in how she decorates it but also in how she uses it. The litany of complaints about Michelle Obama's coldness or militancy becomes even

more curious when juxtaposed against reports of her actual behavior. "She's a hugger," sighed one of her staffers to Rebecca Traister of Salon.com in November 2007. On the campaign trail, she exhibited an unwavering degree of affection that had her staffers tapping their feet, and she recently unleashed waves of shock in the wake of her embrace of the queen. Her penchant for touching marks her as Southern. "My people are from South Carolina," she reminded the congregation at a Baptist church in that state in January 2008. The South is in the cadence of her walk and her speech. Her Southern rhythm reminds us that, Northern Ivy League degrees notwithstanding, Obama's native tongue is South Carolinian. Beneath her wardrobe, she is draped with the markers of her region as well as her race and gender. No one understands the multiple layers of stories within her body better than Michelle Obama herself.

"It's fun to look pretty," Obama told the hosts of *The View* in June 2008. Michelle Obama can make these rounds, and say these things. Just like her husband, she can dance on *The Ellen DeGeneres Show* when dancing is called for. She wears top designers when that's called for, too. But it's pretty obvious that she's more comfortable in J. Crew. And it's indisputably clear that she's not thinking about her clothes at all when she's talking to Larry King or improvising with Katie Couric.

The February 2008 Katie Couric interview is riveting, if for no other reason than that it stands in vivid contrast to Couric's excruciating exchange seven months later with then–vice-

presidential hopeful Sarah Palin. Palin was never my candidate, but, like many people, I did recognize her demonic brilliance as she commanded the podium at the Republican National Convention. The comparison between the RNC performance and the Couric interview is painful. Palin's discomfort during the latter is written on her body. Palin sits across from Couric, shoulders back, neck craned forward, looking as if she's struggling to understand Couric's questions. She drops one word, picks up the next one awkwardly, playing at a role Couric inhabits easily. "I get lost when she talks," confessed one YouTube commentator. Me, too. As with the tabloid promising details of Michelle Obama's hit list, I have a hard time finding my way out of the sentences Palin drops like mazes without exits, bridges to nowhere.

On the other hand, watching Couric and Michelle Obama is like watching an expert pair of jazz musicians trade fours. Couric doesn't change style between the two interviews; she serves up similar hardballs in each conversation. But like a performer in a duet with an equally talented partner, we can really hear Couric swing in her interview with Obama. The First Lady swings right back.

Obama delivers a stunning spectacle, as usual, in a sleeveless periwinkle sheath and her now-signature oversize pearls. But she seems to forget all about fashion as she talks to Couric, leaning forward, unafraid of the questions and sure of her answers. "I love clothes," Obama told *Vogue* in March 2009. But Editor-at-Large André Leon Talley sees through her. While he is clearly

in agreement with the many who trumpet Obama as a new fashion icon, "that really isn't her," he writes. "Pragmatism, not glamour, is what matters when she gets dressed."

Of all the interviews that I have read and watched, nothing was as captivating to me as Obama's interview with Couric. Obama seems relaxed, as if here and now, temporarily free of the caricatures and stereotypes, fantasies and fears of the American public, she is for once able to zero in on something more concrete and pressing than her image. She punctuates Couric's questions with a steady stream of "mmm hmmms," a Southern inflection that says, "I'm listening. I'm with you." Her sentences are lean; she knows how to use words so that they are not in the way, and listeners can hear a story that is, somehow, not dominated by language. She may be in pearls, but she's all business. Her business is our pleasure.

LADIES FIRST

"Ain't I a woman?" bellowed Sojourner Truth, whose bust is now on permanent display at the Capitol Visitor Center, courtesy of the Obama administration. "Ain't I a woman?" Truth demanded of the audience at the 1851 Women's Rights Convention in Akron, Ohio. Born in 1757, Truth was a former slave and powerful advocate for abolitionism and feminism. She took to the floor at the 1851 convention after listening to several ministers lecture about male superiority over women. Truth singled out one of the ministers, and challenged him in her famous speech, "Ain't I a Woman?" "That man over

there says that women need to be helped into carriages, and lifted over ditches, and to have the best place everywhere. Nobody helps *me* any best place. *And ain't I a woman?*"

Like Michelle Obama, Sojourner Truth was unusually tall, reaching nearly six feet in height. She made a similar physical impression. During her speech, she impelled the audience, "Look at me! Look at my arm!" Frances Gage, feminist, abolitionist, and president of the convention, wrote in her chronicle of the event that Truth then "bared her right arm and flexed her powerful muscles."[5] Many white people had a hard time reconciling Truth's physical power, as well as the formidable timbre of her voice, with her womanhood. At an 1858 meeting of the Progressive Friends, a religious group with whom she became affiliated, someone in the audience accused her of being a man. Famously, Truth bared her breasts in response. Sojourner Truth dumbfounded those who considered black rights and women's rights to be totally disparate causes.

There is a nasty strain of commentary out there that seeks to portray Michelle Obama in masculine terms. These comments can only be understood in the context of a culture in which "black" has almost always meant "male." Again, Michelle Obama's very brownness is what makes her undeniably black, and it confuses those who associate darkness with masculinity. Black women, in general, have struggled historically with the title of "lady." Slavery deprived black women of the opportunity to practice virtue. Not even considered human, they could not be counted among the delicate, fainting feminine idols of their

time, even as they may have detested what those fainting heroines represented.

Women (read: white and middle-class) dropped the whole charade of fragility and dependence during the second wave of feminism in the 1970s, the era in which Hillary Clinton came of age. When Hillary kept her maiden name and her coke-bottle glasses, the press castigated her relentlessly. The public denouncement was more than a dislike for the personal choices of the then–first lady of Arkansas; it was a backlash against the feminism that had produced her. Americans may have benefited from what feminism did, but they didn't like what it looked like, not on Clinton. As a teacher, I find that young women tread very carefully around the term *feminist*. The backlash has proved quite effective, and to generations of women born in the 1980s and afterward, feminist equals "man-hater" rather than "equal pay for equal work."

Hillary Clinton made some concessions to the backlash. She traded the glasses for contacts. She took her husband's name, colored her hair blonde, and put on some makeup. She adopted a smile. And in the 2008 presidential campaign, she cried. By many accounts, most of these changes have not substantially improved Clinton's public image. She continues to be the whipping girl for snarly commentators who lob veiled and unambiguous sexist attacks in her direction.

Tough. It's a word that fans and critics alike use to describe Hillary Clinton as well as Michelle Obama. Age and race may separate them, but their profiles are similar. Both have Ivy League educations and impressive résumés. Both married powerful men in whose careers they have played pivotal roles. But as First Lady, Michelle Obama resembles Laura Bush as much as she does Clinton. Michelle was introduced to us as an Obama in the same way that Laura was always a Bush. Obama has talked directly and without regret about putting aside her career—calling any other alternative "unreasonable"—as long as her husband remains in the White House.

Perhaps Michelle Obama represents an incarnation of modern feminism. Her feminism is practical—less doctrinaire and more about choices. Her story about her life is a story that Feminism, writ large—in its headlines and speeches and broad strokes—continues to neglect. And that is, no matter how equal is the relationship between the First Couple, the president is still the one who gets to leave the house in the morning when the toilet overflows.

FIRST, MARRIAGE

Michelle and Barack Obama sit on a couch to be interviewed by Barbara Walters. Not five minutes into the interview, our president stops to inform his wife that she has lipstick on her teeth. The First Lady rubs her finger over them. Walters tells them that she doesn't plan to delete this bit. Michelle Obama is unfazed. She turns toward her husband and asks him, "Well, is it gone?"

The abundant truth about Michelle and Barack Obama is that they like each other. Their mutual regard is something that would be difficult to manufacture. It's written on their bodies and

charges back and forth in the air between them. It's the way they lean into each other on Barbara Walters's couch. It's the way they touch foreheads in a freight elevator on Inauguration Night, his jacket draped around her shoulders, the two of them looking directly into each other's eyes.

Their mutual regard goes deeper than the pronouncement they each make about being the other's "best friend." (After all, Cindy McCain has called herself her husband's "best friend," but does your best friend call you a misogynist expletive in public?) That kind of sentiment can sound treacly. The hand-holding, too, could be read as over the top, a public performance. But even as the cameras roll, and we watch avidly, they seem to forget us.

Of course, no one really knows what goes on in any marriage. Ultimately, these images say more about us than they do about the Obamas. They speak to a longing for greater intimacy in our culture; this longing is the generator that keeps our multiple information networks running. When we look at the Obamas, maybe we see what we want in our insatiable society: to be closer to each other. Isn't this what we project onto the Obamas, and what the Clintons—as fascinating as they were and continue to be—left us wanting? What undergirds our cultural hunger is, perhaps, a common desire to understand and know ourselves more. "Obamas' marriage is a good thing for all of us," reads the title of a blog entry. The portrait of the First Marriage has given many of us a vocabulary for what we all crave—to be closer, to be eye to eye, to have our partners put away the butter.

During Michelle Obama's visit to *The Ellen DeGeneres Show*, a viewer wrote in to ask the First Lady to describe herself in three words. Obama chose: *mom, down-to-earth,* and then, much later, *wife.* "For now. This year," she said, laughing. Meaning that Wife with a capital "W" was what, at that point, the campaign, and now the presidency, required of her. But this is what marriage requires for many of us who sign up for the institution: to assume roles that were made up long before us, and that we also reinvent on a daily basis.

Marriage is a country. It's a place in the world and brings with it certain customs, privileges, and limits. It is a metaphor, in some ways, for nationhood. The Obama marriage, reduced to sound bites, rehearses the "Men Are from Mars, Women Are from Venus" routine, popularized in the nineties by a book of that name. But the friendliness of the sparring between the First Couple is fresh, even as it recalls the flirtatious bickering of Spencer Tracy and Katharine Hepburn in the 1949 comedy *Adam's Rib.* For those of us who pledge allegiance to the country of marriage as well as the United States, the Obamas offer an example of the best we can hope for—a language that accommodates differences as opposed to pretending that they don't exist.

JUST A WOMAN

One thing we know for sure about Michelle Obama is how much she likes to tease her husband, how little she stands in awe of him. "I

am always a little amazed at the response that people get when they hear Barack," she confessed at the Beverly Hilton in 2007. "He's a gifted man, but in the end, just a man," Obama has said of the president. She has explained that Barack Obama, as much as he has been cheered as a modern-day Messiah, will inevitably say things with which we don't agree. He will disappoint—forget to put the twist tie on the bread on a national scale. She cautions us that not even Barack Obama can always be "Barack Obama."

Michelle Obama wants to prepare us for her husband's humanity. She wants us to know her, too, as human, as one of us. We want this and we don't. We want to believe the White House will be a contemporary Camelot, and we want to know whether her husband has figured out how to put his laundry in the hamper yet. We swoon when the First Lady dons haute couture, and we applaud her for wearing off-the-rack. As Americans, we love convention and invention, the traditional and the exotic. This is why so many of us embrace Michelle Obama. She looks like us, in all of our contradictions.

NOTES

1 Liza Mundy, *Michelle: A Biography* (New York: Simon & Schuster, 2008), 3.

2 Mundy, 107.

3 Langston Hughes, *The Big Sea* (New York: Knopf, 1940), 207.

4 Zora Neale Hurston, *Their Eyes Were Watching God* (New York: HarperCollins, 1990), 140.

5 http://www.kyphilom.com/www/truth.html.

OPPOSITE: First Lady Michelle Obama acknowledges her guests at a White House dinner during Women's History Month.

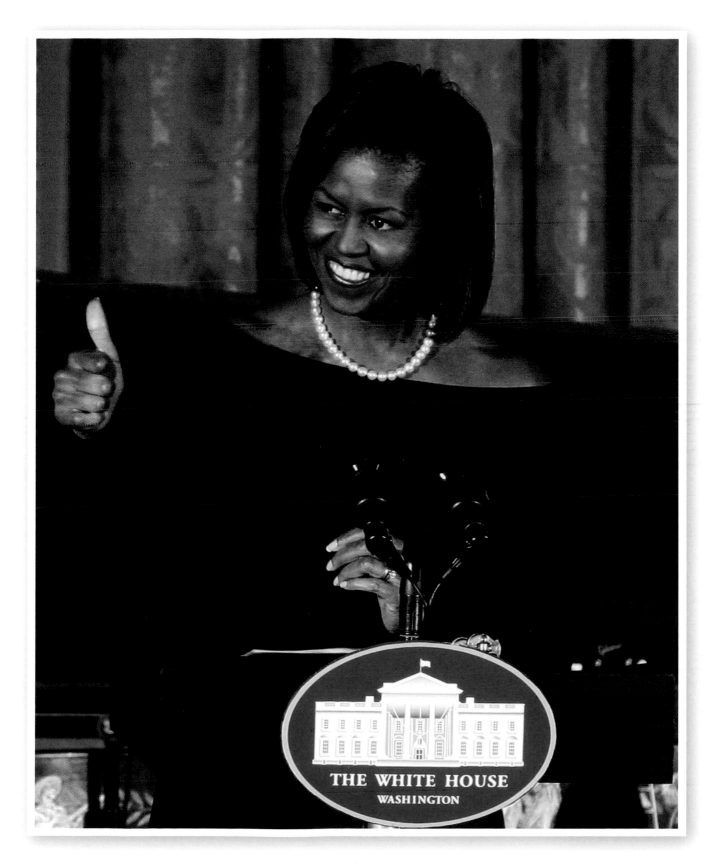

PHOTO CREDITS

2: Jim Young / Reuters / Corbis. 6–7: David Burnett / Contact Press Images. 8: Mandel Ngan / AFP / Getty Images. 12: Brooks Kraft / Corbis. 14: Jonathan Ernst / Reuters / Corbis. 15: Pool/Reuters/Corbis. 16: Saul Loeb / AFP / Getty Images. 18–19: David Burnett / Contact Press Images. 20–21: Saul Loeb / AFP / Getty Images. 22: Princeton University Archives. 23: Yuri Gripas / AFP / Getty Images. 24: Win McNamee / Getty Images. 25: Mandel Ngan / AFP / Getty Images. 27: Courtesy of the artist. 30: Joyce N. Boghosian (The White House) / Getty Images News. 32: David Burnett / Contact Press Images. 34: Saul Loeb / AFP / Getty Images. 35: Kwaku Alston / Ebony Magazine. 36: (top) Mandel Ngan / AFP / Getty Images; (bottom) Saul Loeb / AFP / Getty Images. 37: Mandel Ngan / AFP / Getty Images. 38–39: Charles Ommanney / Getty Images. 40: (top) Alex Wong / Getty Images; (bottom) Brendan Smialowski / Getty Images. 41: Alex Wong / Getty Images. 42–43: David Paul Morris / Getty Images. 44: Michael Reynolds / EPA / Corbis. 45: Martin H. Simon / Corbis. 46: Joshua Roberts / Reuters / Corbis. 47: (top) Nicholas Kamm / AFP / Getty Images; (bottom) Win McNamee / Getty Images. 48: Chris Kleponis / AFP / Getty Images. 49: Win McNamee / Getty Images. 50: Chris Kleponis / AFP / Getty Images. 51: Saul Loeb / AFP / Getty Images. 52: (top) Tim Sloan / AFP / Getty Images; (bottom) Mandel Ngan / AFP / Getty Images. 53: Yuri Gripas / AFP / Getty Images. 54–55: Yuri Gripas / AFP / Getty Images. 56: (top) Yuri Gripas / AFP / Getty Images; (bottom) Mandel Ngan / AFP / Getty Images. 57: Brooks Kraft / Corbis. 58: Gary Fabiano / Corbis. 59: Kevin Mazur / WireImage. 60: Kevin Mazur / WireImage. 61: WWD / Condé Nast / Corbis. 62: WWD / Condé Nast / Corbis. 63: Yuri Gripas / AFP / Getty Images. 64: Larry Downing / Reuters / Corbis. 66: Mandel Ngan / AFP / Getty Images. 67: Charles Ommanney / Getty Images. 68: Getty Images. 69: Jim Young / Reuters / Corbis. 70: Paul J. Richards / AFP / Getty Images. 71: Alex Wong / Getty Images. 72: Paul J. Richards / AFP / Getty Images. 73: Paul J. Richards / AFP / Getty Images. 74: Paul J. Richards / AFP / Getty Images. 75: Jonathan Ernst / Reuters / Corbis. 76–77: Saul Loeb / AFP / Getty Images. 78: Saul Loeb / AFP / Getty Images. 79: (top) Saul Loeb / AFP / Getty Images; (bottom) Jim Young / Reuters / Corbis. 80–81: Getty Images. 82: (top, bottom) Getty Images. 83: Getty Images. 84: Daniel Deme / EPA / Corbis. 85: John Stillwell / AFP / Getty Images. 86: Getty Images. 87: Lionel

Bonaventure / AFP / Getty Images. **88:** Pascal Le Segretain / Getty Images. **89:** Saul Loeb / AFP / Getty Images. **90:** Getty Images. **91:** (top) Getty Images; (bottom) Alex Grimm / Getty Images. **92–93:** Getty Images. **94:** Mychele Daniau / AFP / Getty Images. **95:** Sean Gallup / Getty Images. **96:** (top) Mandel Ngan / AFP / Getty Images; (bottom) Eric Feferberg / AFP / Getty Images. **97:** Joe Klamar / AFP / Getty Images. **98:** Pascal Le Segretain / Getty Images. **99:** Toby Melville / Reuters / Corbis. **100:** (top) Eric Gaillard / Reuters / Corbis; (bottom) Jason Reed / Reuters / Corbis. **101:** Toby Melville / Reuters / Corbis. **102–3:** Reuters/Corbis. **104:** Horacio Villalobos / EPA / Corbis. **105:** Petr Josek / Reuters / Corbis. **106–7:** Getty Images. **108:** Srdjan Suki / EPA / Corbis. **109:** Leon Neal / EPA / Corbis. **110:** Ron Sachs / CNP / Corbis. **112:** Mike Segar / Reuters / Corbis. **113:** (top) Mark Wilson / Corbis; (bottom) Ron Sachs / CNP / Corbis. **114–15:** Ralf-Finn Hestoft / Corbis. **116:** Rick Friedman / Corbis. **117:** (top) Ralf-Finn Hestoft / Corbis; (bottom) Emmanuel Dunand / AFP / Getty Images. **118:** David Bergman / Corbis. **119:** Jewel Samad / AFP / Getty Images. **120–21:** Katherine McDowell / DoD / Handout / CNP / Corbis. **122:** Mark Wilson / Getty Images North America / Corbis. **123:** (top) Jason Reed / Reuters / Corbis; (bottom) Mark Wilson / Getty Images North America / Corbis. **124:** (top) Chip Somodevilla / Corbis; (bottom) Stan Honda / AFP / Getty Images. **125:** Timothy A. Clary / AFP / Getty Images. **126:** (top) Timothy A. Clary / AFP / Getty Images; (bottom) Mike Segar / Reuters / Corbis. **127:** Stan Honda / AFP / Getty Images. **128–29:** Mike Segar / Reuters / Corbis. **130:** David Burnett / Contact Press Images. **132–33:** Ralf-Finn Hestoft / Corbis. **134:** Kwaku Alston / Essence Magazine. **135:** Kwaku Alston / Essence Magazine. **136:** Kwaku Alston / Ebony Magazine. **137:** Jeanne Moutoussamy-Ashe. **138:** David Burnett / Contact Press Images. **139:** David Burnett / Contact Press Images. **140:** David Burnett / Contact Press Images. **141:** Bannor Photography. **142:** Rick Giase / EPA / Corbis. **143:** Richard Baker / Corbis. **144–45:** Max Whittaker / Reuters / Corbis. **146:** Matthew Cavanaugh / EPA / Corbis. **147:** Tannen Maury / EPA / Corbis. **148:** Jason Reed / Reuters / Corbis. **149:** Rick Friedman / Corbis. **150:** Craig Lassig / EPA / Corbis. **151:** Rick Wilking / Reuters / Corbis. **152:** Jason Cohn / Reuters / Corbis. **153:** Vernon Bryant / Dallas Morning News / Corbis. **154:** Aaron M. Spencer / EPA / Corbis. **155:** Michael Czerwonka / EPA / Corbis. **156:** CJ Gunther / EPA / Corbis. **157:** (top) Brooks Kraft / Corbis; (bottom) Chris Keane / Reuters / Corbis. **158:** Eric Thayer / Reuters / Corbis. **159:** Rick Friedman / Corbis. **160:** Jay LaPrete / Reuters / Corbis. **161:** Lynn Goldsmith / Corbis. **162:** Ken Cedeno / Corbis. **163:** (top) Jason Reed / Reuters / Corbis; (bottom) Daniel Gluskoter / Icon SMI / Corbis. **164:** Tim Rue / Corbis. **165:** Brooks Kraft / Corbis. **166:** Jim Young / Reuters / Corbis. **167:** Brooks Kraft / Corbis. **168:** Shawn Thew / EPA / Corbis. **169:** Rob Sachs / CNP / Corbis. **170–71:** Brooks Kraft / Corbis. **172:** Courtesy of Timothy Greenfield-Sanders. **177:** Splash News. **178:** (top) CBS Photo Archive / Contributor / Getty Images; (bottom) CBS Photo Archive / Contributor / Getty Images. **179:** (top) CBS Photo Archive; (bottom) Bettmann/Corbis. **181:** Splash News. **183:** Tim Llewllyn / Corbis / Corbis News / Standard RM. **189:** Jim Young / Reuters / Corbis.

ACKNOWLEDGMENTS

We thank the photographers whose works appear in this book; we would also like to thank Kwaku Alston, Jeanne Moutoussamy-Ashe, Timothy Greenfield-Sanders, David Burnett and Jeffrey Smith of Contact Press Images, Inc., Emily Aronson from Princeton University Media Services, Mark S. Grishaber of the Whitney M. Young Magnet High School, Amanda Barbour Hromadka from Splash News and Picture Agency, Polaris Images, Corbis, and Getty Images.

Deb especially thanks Leslie Willis-Lowry, Kalia Brooks, Deborah Brittain, Kellie Jones, Hank Willis Thomas, Sharon Harley, Carla Williams, Cheryl Finley, Jane Lusaka, Derrick Biney-Amissah, Lisa Jones Brown, Sharon Howard, Rachelle Browne, Irene Cho, Caran Hartsfield, Sara Lynch, Stephanie Broad, Karl Peterson, Michael Berlin, and her students in the Black Body and the Lens seminar, especially Carmen Phillips, Liz Andrews, Sherrae Hayes, Kathe Sandler, Nicole Harris, Geneva Thomas, Anne Friedensen, and Brendan Wattenberg. Each provided advice, shared information, and engaged in long discussions about this project.

Emily thanks Edi Giunta and John Gennari for their generous assistance.

Faith Childs supported this project from the start by coordinating us and keeping us balanced; we cannot thank her enough for introducing us. Additionally, we thank Bob Weil and Lucas Wittmann from W. W. Norton for providing us the opportunity to reflect on the image and the First Lady.